The Art Presence

Sanford Schwartz

The Art Presence

HORIZON PRESS NEW YORK

To Pauline Kael

▶▶▶▶

Note

Except for "Helen Levitt's New Color Work" and the second piece on Lucas Samaras, which are being published here for the first time, these articles and reviews appeared in *The Nation, The New Yorker, Artforum, Art in America, Art International,* and in brochures for the Zabriskie, Washburn, and Brooke Alexander Galleries. I want to thank the editors and gallery owners for permission to reprint, and, in some cases, for having suggested that I write on these subjects. Many of the pieces, especially the earlier ones, have been rewritten in spots where my original points weren't made clearly enough, or where a little more descriptive flesh was called for. Where my amplifications have given the article a somewhat different tone, I've added a second date.

For their encouragement—and for making me persevere with articles that wouldn't come, or that needed an extra shove—I am especially indebted to Elizabeth Baker, editor of *Art in America,* Ben Raeburn, of Horizon Press, and William Shawn, editor of *The New Yorker.* I also want to thank Lucas Samaras for letting me use his pastel, "Untitled (upside-down head—March 12, 1962)," for the jacket cover and for generously giving me the freedom to use it in any way I saw fit.

▶▶▶▶
Contents

9

►►►►
Illustrations

11

Painters and Sculptors

Anshutz and His Ironworkers

THOMAS P. ANSHUTZ's painting "Ironworkers: Noontime" has long been one of the textbook classics of American 19th-century art history. Recently the picture—often incorrectly entitled "Steelworkers: Noontime"—made itself lively current history when, at auction, it passed from one set of private hands into another for a quarter of a million dollars. In January and February the newly significant picture was the star attraction (it had the label "An American Masterpiece" hanging over it on the wall) at a small Anshutz exhibition at the Pennsylvania Academy of the Fine Arts, Philadelphia. The other Anshutz paintings, drawings, watercolors and photographs on view were present mostly to fill in information on the painter (1851-1912) and his prize work; none of them except for the two oil sketches for it has the same living light in it that "Ironworkers" has. The portraits at the Academy were especially disappointing. They showed little of that desire to penetrate the surface life of the sitter that is in so many portraits by Anshutz's teacher, Thomas Eakins. The human personality, which brought out Eakins's deepest feelings as a painter, seems to have meant little to Anshutz. His portraits are competently done but, compared with Eakins's, they're evasive. What Anshutz took most seriously from Eakins was a faith in a precisely observed, scientifically exact realism. This scrupulousness didn't help him in his portraits, and it made for a lot of plodding indoor genre scenes; in "Ironworkers" (ca. 1880-82), though, a sunlit panorama-like picture of factory hands in various stages of a midday break—washing, playing tag, strolling, posing, lounging, flexing muscles, daydreaming—it was at the service of a subject organically suited to such an approach.

How Anshutz came to paint "Ironworkers" is still a mystery. It was probably a mystery to him. He was just turning thirty

15

when he made it. He had recently gone from the Philadelphia Sketch Club, where Eakins had been his instructor, to the then new Pennsylvania Academy of the Fine Arts. Eakins had gone to the Academy too, and Anshutz had become his assistant. Considering the authority with which "Ironworkers" is painted, Anshutz must have been happy with his new position; certainly he must have felt that he was something of an ambassador of Eakins's principles. Anshutz may even have felt he resembled his teacher. Eakins was known for his inability to tolerate fools; Anshutz wasn't as comfortable being contemptuous, but he was sharp-tongued. His letters show him to have taken pride, as his teacher did, in being candid. "The National Academy of Design," Anshutz wrote home, around age twenty, "is a rotten old institution supported and controlled by lovers of art and by artists who desire to create just as few artists as possible." The tone didn't change much as he grew older. Unlike Eakins, though, he seems to have had no vision of his own to put in place of the "rotten" one old institutions give us. He enjoyed spotting fake artwork and fake people, but he didn't want to change the way people saw things. As a teacher, he was known as much for his approachability as his sarcasm, which apparently wasn't of the withering variety.

Right at the time of his greatest comradeship with Eakins, he saw an iron foundry, on a trip to Wheeling, West Virginia, that he felt had—as Sandra Denney Heard, author of the show's catalogue, quotes him as saying—"picturesque possibilities." According to Heard, Anshutz had never painted the industrial milieu before. Depressed by the picture's lukewarm reception (he long kept it in his studio with the intention of painting over it), he never went back to this material. And he never again, by all evidence, went on to anything that tested his talents. He settled in, for the remaining thirty years of his life, as a Philadelphia art teacher, first succeeding Eakins as Instructor in Anatomy, Drawing and Painting, and eventually succeeding William Merritt Chase as Head of the Academy. Anshutz continued to produce paintings, which often won honors, and he made watercolors and drawings that are still sought after by collectors; but

essentially he was a teacher. By all accounts, he wasn't a great man, as were Eakins and Robert Henri, the other preeminent American art teachers of the time; but Anshutz was probably as good a teacher—maybe a better one, if that can be judged on the basis of the men who studied under him: Henri, John Sloan, Glackens, Demuth, Marin, Arthur B. Carles, Charles Sheeler. Sloan and Henri were honorary pallbearers at his funeral.

"Ironworkers" is so much smaller in size than reproduction leads you to expect—it is 17 by 24-inches—and there is so much warm, white light shed from the limbs and torsos of its many distinct, sculpturally solid figures, that when you see it for the first time you feel you are being drawn to a diorama of the painting rather than the painting. The outdoor scene seems as if it would have called for a larger canvas to fulfill itself, but sheer size was irrelevant to Anshutz. He wasn't thinking about the social and historic implications of the moment. His goal was so purely the lucid arrangement of figures in a lucid space, and he came to his work so well prepared—he was so adept at anatomy, perspective, unity of light and space, and felt these technical tasks as so many challenges to his integrity—that he rode through the realist style he thought he was serving. No identifiable style clings to "Ironworkers"—that, along with its small size, is what is so surprising about it. It's what makes the picture so fresh. In its stiffness and unmodulated, almost naive frankness about detail, it resembles, if anything, the work of a self-taught painter, from any period.

Meanwhile, it is impossible for us not to look at the painting as something more than this. In his unrhetorical, plain way, Anshutz captured the sleeping-giant strength of post-Civil War America as no historically self-conscious painter did, or, perhaps, could have. His terms matched those of his Wheeling, West Virginia factory hands. He was as self-confident and as emotionally unformed—even blank—as they were. Eakins, with his more complicated feelings about American society and his bohemian personal style, perhaps knew too much to be able to look at ironworkers as anything other than remote figures—animated, at best, by a dour persistence in doing their work

right. As a picture of the American industrial scene, that would have been subtly wrong. It would have given that scene a quality of underlying tragedy that wasn't there. It would never have occurred to Eakins to render facial expressions comically, exaggeratedly, as Anshutz has done, with his one young ironworker, who has been thrown to the ground and glares back at the youth who has pulled him down. Even Winslow Homer, who made his early living as an illustrator, would never have gone this far into comic Currier-and-Ives terrain. But Anshutz gets away with it. We can imagine even more of his factory workers having theatrical poses and mask-like faces, and the picture keeping its spell. Probably because, for all its surface realism, it is as abstract a painting, as much a fabrication of the artist's willful mind, as any Peaceable Kingdom.

From reproduction, "Ironworkers" looks as if it's a blood relative of the naturalistic American novels, but the painting's spirit is closer to later, more modern writing, to the chaste, word-perfect symbolic naturalism of Stephen Crane and Hemingway. Like these writers, Anshutz's first loyalty is to his exalted idea of craft, which pressures him into accepting the scope of a miniaturist. I think there is also a connection between the picture's deliberate "smallness" of vision, its self-conscious refinement of means, its fastidiousness of paint handling, and the fact that it presents a world made up only of what one 19th-century writer called "a group of half-naked men," most of whom are in their late teens, twenties and early thirties. Anshutz was on the track of a picture that could measure up to Eakins; along the way, he knew he was doffing his cap to infant American industrialism; but his truest subject for us, buried possibly from his conscious mind, was his own burgeoning self-confidence as a young man about to step into full manhood. His painting is almost an emblem of that moment when young men, whether artists, mechanics, athletes or scholars, flex their muscles in public for the first time, when they feel they can exhibit the strengths that have been welling up within them since adolescence. Their world may still be virginal technically, but in their minds they have conquered all. This is a fastidious mo-

ment: it is a time when you want to feel your skin, you want to feel unhampered and lean, whether in work or in life. It may be the first time a man acknowledges to himself that he is physically beautiful, and perceives that there is a sensuous strength in being a man, in a world of other men. For most, it is a moment that, once past, is never regained. You go on to other senses of yourself. You come to feel the world in other ways than as it touches on your bodily self. Some men never get over the loss of that purity and assurance. Others are not certain that they ever experienced it. Crane, in *The Red Badge of Courage*, and Hemingway, in his early stories, caught that crisp time, and Anshutz did too, in his "Ironworkers." It is the great "young man's" painting of American art.

1973, '81

▶▶▶▶

Blakelock

"AMERICAN HISTORY IS haunted by nightbirds in the nineteenth century," wrote Lewis Mumford in *The Brown Decades*. Mumford was writing specifically about Albert Pinkham Ryder, but he had in mind all the American painters and writers who, especially in the last third of the century, made their work in a romantic, sometimes painful, obscurity. Mumford didn't include Ralph Albert Blakelock in his survey—he was more interested in a little-known painter named George Fuller, a forerunner of Ryder. Blakelock (1849-1919), though, can certainly be considered a nightbird of the 19th-century imagination. His archetypal picture is a forest nocturne, with a glowing moon, foliage silhouetted in the pale light, and, possibly, some Indians camped about a fire. The large exhibition at Knoedler

made clear that, from his apprentice years on until his surprising last phase, when he was confined to an institution, Blakelock saw nature as a site of moody, imprecise, enveloping darkness. The exhibition didn't have a scholarly completeness and couldn't be taken as the last word, but it was extensive enough to give a sense of him. It showed why he has been regarded as a second-string Ryder. There is a fixed, formula-like quality about his best-known works. They are more of their time than you imagine they would be.

Blakelock was a professional from the beginning. His early style was a woodsy, sentimentalized version of Corot. Later, he added more light and a more spacious view, courtesy of the Hudson River School at its most mechanical. But he didn't want the sunny, affirmative look other American landscapists got, nor did he want to handle genre. He found his own approach by going back to European painting, not only Corot but the less distinguished, more popular Barbizon masters, who gave him the heavily glazed, brown and yellow tones he was most comfortable with. Blakelock never put his stamp on the figure. Ryder didn't either, but he at least stylized the figure into the same world of form as his trees, waves and clouds. Ryder's literary and symbolical imagination, which fed off ideas and images from the Bible, Shakespeare and Wagner, needed the figure. Blakelock was neither literary nor symbolical. His Indian hunters, or Indians encamped, aren't much more than window dressing. According to an article in the Knoedler catalogue by Susielies M. Blakelock, the artist made trips to the west in 1869 and 1872, when he was in his early twenties. His father, "an English-born homeopathic physician of comfortable means," financed the trips. Blakelock traveled industriously and adventurously, often wandering far from the railroad and its path of settlements. He "made friends with several of the western tribes and spent much time among them," but when it came time to paint them he didn't make it seem as if they were personally important to him. His Indians have an affecting stiffness; they look to be toys or children. Their being idealized in such a way is touching. But are they any different from the skipping, playful

Gypsy picnickers in the Barbizon forest scenes? They serve a similar, stock function.

The last twenty years of Blakelock's life were spent in Middletown State Hospital for the Insane, Middletown, New York. The Knoedler catalogue's account of this "Confinement Period," by David D. Blakelock, doesn't explain as much as you might want. He writes that the newspaper accounts that described his grandfather as "mad" or "violently insane" were misleading; according to his researches, the painter did "in no way . . . appear to be anything but a frail artistic man, over his prime, who was completely worn out physically and mentally from his earlier struggles for existence." Elsewhere in the catalogue, Jack Tanzer says that while Blakelock "suffered from a split personality and delusions of grandeur, he would not be judged insane by today's standards." Certainly his mental unrest was exasperated by having to provide for a wife and nine children during a twenty-year stretch, from the late seventies on, when the market for his work steadily deteriorated. Blakelock apparently turned the corner in 1891, when a collector named Catholina Lambert, buying pictures to line the walls of her "castle in New Jersey," refused to give him more than half of the $1,000 asking price for "The Brook by Moonlight," which he regarded as one of his best pictures. Catholina Lambert got the picture, and Blakelock, perhaps stricken with a sense of his own weakness in accepting the offer, burned much of the cash payment and was taken to Brooklyn Hospital after a "violent rage."

Nine downhill years later, he was in Middletown State. After a time getting adjusted, he began making art again—straightforward landscapes of trees, shrubs and sky. Judging from the examples in this show, he made some of his best pictures in the hospital. His grandson writes that Blakelock was forced by circumstances to work on "bits and pieces of paper, cardboard, pieces of wood, cloth, windowshades, wallpaper." He had successfully used odd scraps earlier, too; he seems to have been released by employing odd and ignored materials. He obviously didn't have an unlimited range of color to work with in the hospital, but he used color in a deliberate, felt way. His hues,

especially the tans and greens, are brassy and vivid. The greens slide into grays, the tans have pink in them. These small late landscapes—many less than 10 inches on a side—are immediately set apart from Blakelock's well-known work because they're not nocturnes; there are no moons and no Indians. They convey a subtler sense of sadness and isolation than the earlier pictures. In these hospital paintings, the use of pen and ink and ink washes, along with the unhinged, disassociated colors, often spotchily applied in clumps and clusters, sometimes over black, give the views a tremulous, fluttery look. Little in them is expressionistically distorted, but when you look close you feel you're entering a floating world.

Blakelock's view of the forest, in his best-known work, was poetically dark and mysterious, but it wasn't mystical, as Ryder's was, or even enchanted. For Blakelock, the forest setting seems to have represented a haven from this world, not a new one. The wonderful pictures he did in the hospital show what his instincts were when he didn't need that haven. Then, he was spritely, buoyant, rhapsodic—with a thread of frantic uneasiness running through the buoyancy. When you go back and look at the textbook-famous Indian nocturnes with these private sketches in mind, what stands out is how artificial, almost decorative, they are in conception. You are aware of how stylized the tracery of the tree branches is, and feel that, below the surface of these gravy-brown pictures, there is a spriteliness waiting to be called forth. These designs of overlapping light and dark would have made fine models for Tiffany's stained glass lamps and windows.

Blakelock's desire to make images of a romantically uncivilized hiddenness was real. But, possibly because that desire was too strong to come out directly, it was expressed in a distant, abstract way, one that was dependent on the art conventions of the moment. In the hospital, he was released from his burdens as husband, father and distinguished landscapist, and this may have been the isolation he wanted all along. Finally able to show his most spontaneous feelings, he gravitated to bright, not dark, colors to do the job. His career as a painter of imaginative

nocturnes isn't negligible. Still, you feel that his real nightbird spirit, his response to the tenuousness of all things, came out best when he simply looked around him, and recorded what he saw, in the daylight.

1973, '81

▶▶▶▶

Alex Katz So Far

ON THE WNYC RADIO SHOW "Views on Art" the moderator Ruth Bowman was talking with Alex Katz about his flower paintings and his portraits—what was he after in making the blossoms and the faces so huge, so disassociated from the space around them? Katz, in his direct and low-keyed pedagogical manner, talked about how we react to radically unexpected size and scale, about the impossibility of ever getting life-sizeness, about how we see different images that appear simultaneously, about proximity and how it changes our perceptions. Without being heavy, he gave a convincing sense of how complicated his intentions are, and Bowman remarked on it. Their exchange is significant and worth recording, because it tells us a lot about this artist's temperament. Bowman (starting to knit everything together for the listeners): "So, when you decide, when you're working on a painting, or a series of paintings, you *do have* a lot of conscious things that you are concerned about . . . you have schemes and projected ideas." Katz (bland): "I have a lot of ideas . . . you work with a lot of things." Bowman (pitching in): "All painters don't." Katz (still bland): "Well, I like to complicate . . .

my paintings are quite complicated. I like something to keep my mind occupied."

Alex Katz's answer was as deadpan dry as his painting. The line is like his art: it's emotionally flat, but it reverberates in unexpected ways. Like a Buster Keaton performance, the Katz style has a witty economy, so that when you laugh at what's there you're also laughing at what has been left out. His response shows an astute self-awareness which, despite its ring of impersonal professionalism, doesn't seem fatuous. It's closer to being ingenuous, and there's a quality of naive seriousness in his painting too. By any standards, this describes a rich, quirky, special sensibility, and it's all there in the painting. Katz gives his viewers a lot to work with, too.

Alex Katz's art from the beginning—he started showing in 1953—has been of a non-breakthrough variety, very much like a lot of other art in New York, and yet always standing a little elusively by itself. Katz is a purist in his thinking, but not a very doctrinaire one. He has allegiances all over the field—maybe this is what has kept his talents from coming into one clear focus, or what has made many people think of him as shifty, "unserious." You can see where he keeps rubbing shoulders with other New York artists—traditionalist, realist easel painters (of the non-photo-oriented school); Pop artists, particularly those who were attracted to that Pandora's box of visual ambiguities, the comics; and abstract color painters, who are interested, like Katz, in environmental scale and massive simplifications of the image.

Katz conceivably could be included in group shows of all three kinds of painters, but he would look like an interesting sidelight in each one of them. He's brassier than the easel painters and, unlike most of them, temperamentally unable to keep on refining painterly "passages." He wants to achieve show-stopping, immediately stunning images—something that's considered gauche by many New York realist painters. He's willing to risk more, even to look coarse if necessary. And then he isn't, like the pure color painters, determined to arrive at absolutes and stick with them, making them continually more minimal. He has lots of theories, but he can't help scattering them. He's not a concentrator. Most often aligned with the Pops, he's less thematically loaded and

literary than they are; he doesn't trade in images that have accepted meanings to begin with. When he seems banal it derives from an easygoing, considerate familiarity with the terrain he paints—he never suggests banality in the mock-astonished, kitschy put-down way of the Pop artists.

The Pop movement can be seen to have represented a kind of New Journalism for the visual arts, a way to use the raw data of popular culture. Katz toyed with some of the possibilities, but he never joined up seriously. He stayed a far more traditional kind of fictional interpreter—a chronicler of a distinct social milieu, with its own characters, pets, events, places to go to. Without being a literary painter, without concocting situations that are supposed to be "read," he's given us a stock of people and places and sometimes things (mostly flowers) that suggest the relation-ships and gestures of a large, complete world. At this point, his style is so sure that there are faces and flowers, even trees, that could exist only in a Katz—just as there are people who we're sure could exist only in Yoknapatawpha County. This is a remarkable thing in current painting, the ability to keep subject matter on a level of personal, almost novelistic commentary, and not have it interfere with the pursuit of carefully mapped-out formal problems. The mixture is what gives his pictures those levels of complication we don't get from the Pop artists, or from the more abstract figurative painters.

In the past few years, Katz, who's forty-six, has achieved a formal breadth and fullness in his approach that finally makes irrelevant his relationship with larger movements. He's still off by himself, but not so elusively. He no longer looks as if he's circling around what others are doing. His ideas, ranging back now twenty years, have been rethought and intellectually en-larged, and the rough seas he went through in the mid-sixties have been cleared entirely. At his December show at Marl-borough Gallery there will be large group portraits and multiple portraits of the same person, and as a group they represent the most stunning show he has had. The new pictures put Katz in focus as one of the most exciting and satisfying painters in New York, and they also put in focus a lot about his own past.

What's immediately impressive about the new work is how

confidently they carry their grand size—most are in the vicinity of 6 by 8-feet or 6 by 12-feet. The images fill their heroic "Raft of the 'Medusa' "-scale dimensions without appearing, as his earlier big pictures often did, artificially spacious or blown-up. As he told Ruth Bowman, they "scale in your head," which means you can be intimate with them almost immediately. They don't look out-of-proportion—and that's the effect Katz is after.

The ability to deal so effectively with large scale is only one sign of the growing assurance and complexity of his painting. There's a lucidity in the structure of the group portraits that he hasn't always had in his ambitious pictures. The views are all different: in "Evening" five people are seated or standing around a table; in "The Black Jacket" we see the one model, his wife, Ada, in five stages of close-up and medium faraway. Set in the dark, unexplained space, the five Adas nudge each other like a bunch of balloons bobbing around on separate strings, all held together by a single hand (which we don't see). In "Face of a Poet" we're given one face, in back to back profiles, in extreme close-up; in "Portrait of the Lloyd Family" the father and mother and two children are pressed up close to the picture plane, all heads and shoulders (limner-style, everyone in this family appears to be a different size version of the same person). Each view has its own structural setup for carrying the eye along—he makes sure never to step twice into the same problem.

Everything here underlines that Katz isn't working frantically to make us see how abstract a painter he is. The images are more naturalistic—they've lost that jerky cartooniness. The figures are rhythmically related to each other with an unassuming ease, so that the rhythms don't hit you on the head. We're no longer made anxious about where we're supposed to be in relation to the painting's space: spatial ambiguity isn't something he feels he has to spell out any longer—it's inherent, not tacked on. Katz's strategies have always been more satisfying when we've been made to sense what they are than when we've had them spelled out for us. It's for this reason that one of his biggest, most ambitious pictures, "Private Domain," 1969, with its tricky ins and outs, looks like brilliantly engineered field logistics, or a

mechanical painting. He seems less worried now whether we'll recognize the complexity of his decisions, and the decisions seem more masterful.

Katz achieved this evenness earlier in his career, in the collages and paintings of the late fifties and early sixties. His ideas about space and color weren't so bold then but, though less ambitious, they were thought through on all fronts. He was after a style that could account for color, light, space, and what to do with drawing and gesture (two things he was mainly interested in being rid of). The spirit of these pictures is maybe overly modest, but they hold up. They contain wonderful, delicate perceptions about the person or thing before him. The views from studio windows, looking out towards windows across the street, are sober, matter-of-fact studies of indoor and outdoor light, and the many portraits of people walking towards us or sitting on chairs are equally straightforward and commentless. The approach is easygoing, a non-fussy reductivism—no details are included to make us sense the "character" of the model or the "place" of the window views, and yet no matter who or what Katz painted his relationship to the subject is always something private and intimate. His affection is a quality you're made to feel offhandedly; it's there in the homemade-looking touch. Space and color are treated with an awkward, childlike clarity— though his instinct for dealing with empty spaces was from the beginning far from childlike. Color painting of such sweetness of mood and exactness of gesture makes you think of Marquet, or the early Vuillard.

The recent painting has that magic balance again, and this time there's the added power of new scale, which gives some of these pictures, particularly "The Black Jacket," a magisterial weight and solemnity. Scale isn't just a question of canvas size— it's a way of filling the size with expression and handling that has the broadness, the grandeur, even, of the dimensions. Many of the early paintings are nearly as large as the new pictures in literal size, but the expression and handling in the early ones isn't quite equal to the scope. Katz is too perky, too "fine"—he doesn't let go of the oil sketch edge, and this holds him back from

achieving real massiveness. The images don't carry as grand images, and it's always surprising, when you look at reproductions of these early pictures, to see how enormous the canvases are. In reproduction they look as if they should be small paintings. The new work holds its large scale no matter what size the image is reduced to.

Katz has been headed toward the blunt purity of his current approach all along. In the past, his need to keep the faces distant and empty resulted in their having, inadvertantly it seemed, a kind of content: either they looked too "innocent" or too Pop-smiley. The faces in the new pictures, in "Evening" or "Face of a Poet," aren't so straitjacketed by immobile expressions. He's found more successful, certainly less entangling, ways of keeping them blank. Still, the imperturbable, dream-like moods creep in, the way they do in Rousseau—without, you suspect, the artist's being totally conscious of them. Katz's stiff, reductive manner, with its echoes of the directness of primitive artists, has always transformed the model in unaccountable ways, and it continues to happen. The faces in his paintings, encased in their abstract solutions, are turned into icons—sleek, modern, and, like most icons, a little empty-brained. Katz is making his formal deliberations, and meanwhile the real thing is continually being pushed into the corner; what's left of it comes out muffled, like the sound of Poe's cat trapped behind the brick wall.

The hip, no-comment expressions and the slick, glassy finish Katz gets are there to alert viewers not to get too involved with the representation, and generally it works, though he can go overboard with the emotional shinyness. Sometimes his descriptions of milieus and types hang in there too much like illustrations of a certain kind of New York social cool. We read the image as ironic, of course, but the literary attitude expressed makes it hard to look at the painting for anything else. Katz needs the emotional cool, but he doesn't need the chic—that just messes up the meanings. The new "Evening," a picture of four men standing around and smiling at each other while this elegant, out-of-it girl sits in the middle of them, totally ignored, is a wonderfully acidic group portrait, but its milieuness doesn't

swamp it. You don't have to be able to read it, or know the actual stories being told, to appreciate it. "Evening" stays in the mind as a lean, wry version of a Rubens or a Watteau: we're at one of those elegant love parties, though instead of taking place in a garden it's a kitchen. The atmosphere is charged with erotic sensations, and the glances, some sharp, some befuddled, carry the signals. The tones are silvery, luxurious but cool. Like Watteau, Katz suggests the glamorous power of sex—and also its way of making us look clownish.

The content in his painting, ironic or otherwise, is always most satisfying when it's inseparable from the formal things he's after. One of the funniest paintings he has done, one of the funniest paintings in American art, I think, is a portrait of his Skye Terrier, "Sunny," 1971, who's seen sticking his hairy head up out of long beach grasses (aside from the hair and the butterfly ears, the only other part of him you can see is his tongue). The image is powerful and silly—the humor derives from the looming nearness of this charmingly ridiculous animal and the magnificent farness of the beach and bay behind him. Space itself seems funny, a little weird. As Katz said in the Bowman interview, it's a sensational image.

The startlingly impassive presentation of the image and the gestureless handling give Katz the freedom to make sense out of the perceptual problems that most interest him—the simultaneity of different sizes of images; scale dislocations based on near or far distances; how we visualize distance; how space can be rendered. What he said about the flower paintings, in the interview, applies equally to the portraits and the landscapes: "When you blow something up that big," he noted, "in a non-mechanical way, the tendency's for it to become gargantuan rather than to retain its . . . scale; you want a real big flower . . . after you've looked at it, to relate to you like a small flower would, so the size disappears."

He has worked out a dryly glistening color, which lets him be naturalistic and still show the tricks light plays on the way we perceive and remember specific colors. He's interested in how little the real thing is like what it's supposed to be: when we're

out in the midday sun, how much of what we actually see in the sky is blue and how much yellow? how distorted are colors made by changes in proximity? how much does the lack of sun alter the colors of things from the way we know they appear—leaves are green—to the way they actually appear—closer to gray?

As Katz told Bowman, he does paint with a lot of things on his mind (especially if you take his ideas on such a literal level, in which case he sounds like a neo-Renaissance theoretician), but his vision isn't so protean that it's nourished by any sort of idea it's fed. His range is not such that, like, say, Matisse's, his pictures have a rich complication even when he's misguided or confused. At least so far they don't.

Katz was wise in deciding that his early manner was too soft, too defined, too painterly to handle everything he wanted to say. Neat enough as it was for him at the time, it connoted too many extra attitudes, like touch, to allow his ideas to reach their fullest impact. Anyway, considering what he wanted to do with life-sizeness, he had exhausted the manner. It was when he attempted to move on from the early style, when he wanted to find ways of tightening the handling and enlarging the physical size, that the weather got heavy. Pop art was helpful in the change, but he went haywire with its incentive to play with spatial ambiguities.

For a while, he was stuck on faces shoved up to the picture plane, with small bodies walking around in the background. Treated so obviously, his ideas about shifts in scale didn't seem very sophisticated concepts to base a painting style on. In their new, jazzed-up incarnations, they looked stagey, superficial. He was not exactly Uccello in the spatial shifts department. His concerns weren't rendered so demoniacally, or even methodically, that, like Uccello's, they passed over into being a kind of mad, toy-like visual poetry. They were just bizarre. The big heads, with their mechanical, idiot smiles, the flat-footed handling of near and far space, and the billboard color gave the impression that Katz had swallowed Pop, or at least the comics, whole—though he was just using the exaggerated manner, and not too securely, as a ladder to something else.

Katz's art is more commanding now that handling big size isn't such an obstacle, but sheer bigness isn't the fulfillment of his approach, and it certainly doesn't change his "content" much. His collages, which he stopped making by 1960, and the metal cutouts, which he still makes, are sometimes 6 or 10 inches high, or smaller, and they're as expressive of his thinking as the 6 by 12-foot paintings. Both are more consistently successful than the big works, though less pressure rides on their success. The cutouts—attached to slender metal poles which can't be seen at a distance—and the collages are disarmingly small and faraway, even from two or three feet. They're like looking at something through a keyhole—they suck you into their space. The larger, more life-size cutouts aren't so effective. They're a bit mongrelly: they're paintings with a sculptural presence. The confusion they create isn't bad, but it does sidetrack, for us, Katz's intentions. The small ones create their own strange scale, which makes you want to relate yourself to them so that they don't seem so damn small. The problem with the larger ones is that they don't float in space enough.

Over the past twenty years, Katz has been testing his ideas deliberatively. His commitment is impressive, and it hasn't resulted in pompous or pedantic work. Unlike many other first-rate painters in New York, he hasn't been trapped by his ideas; he doesn't operate as if he were his own academician-in-residence. He works patiently, sometimes studiously, exploring every possibility that's open to him, and yet he's always going somewhere with the exploration. You don't get the feeling that in five years he'll just be refining what he's doing now. He has an intellectual liveliness about his hunches, a restlessness to see where any of them will lead, and it's sensed in the way he goes out on a limb perfecting miniature as well as truly enormous size, or in his trying out different versions of images he likes—close-up, medium long shot, long shot. He's open-ended about his goals, and this makes him refreshingly unpredictable.

Between his work of ten or thirteen years ago and the most recent pictures there have been gains in every direction. He has lost only the youthfully assured handling and the doll-like

delicacy of expression, and both of these things were necessary casualties if he was to go anywhere. He has replaced the easy-to-like atmosphere of the one style with a tough and, ultimately, more admirable one. Between "The Black Dress," 1960, and "The Black Jacket," 1972, which is essentially a reworking of the earlier image, the color sense is richer and subtler, the feeling for abstract space more complicated. When he depicts people now he can communicate a wider range of expressions without having to appear more naturalistic; he no longer has to give every face a baby's mask or a cartoon grin. The landscapes are richer, fuller. He has brought in more of what Roger Fry, talking about Cézanne's imagery, called "lively reality"—at the same time as he has strengthened the abstract perceptions he paints from. From one painting to the other he has done that rare thing in American art: he has made good on a gifted earlier manner. And there's no reason to think he won't get stronger. So far, he has always known when to move on, and what to take with him.

1973

▶▶▶▶

Elie Nadelman

S. N. BEHRMAN, IN HIS memoir *People in a Diary*, has this wonderful description of his friend George Gershwin: "George was striking in appearance—handsome, lithe, and well built. Osbert Sitwell has described his looks, in one of his books, as 'streamlined.' This was so; George was streamlined in all his activities: as a composer, as a pianist, as a painter, as a golf and tennis player." Behrman doesn't elaborate too fancily on Sitwell's perfect "streamlined"—he just shows how Gershwin's

style of living was connected to his art, how they can't be separated. If I read Behrman right, "streamlined" isn't only a period sleekness, like Art Deco design; he means something closer to a personal stylishness, an urbane, genial attitude toward contemporary experience. For me, "streamlined," and the way Behrman uses it, suggest a number of figures besides Gershwin: the word pinpoints, with poetic accuracy, a spirit that runs through American culture, in high and popular art, from the late teens up until the early thirties. It's the note of good-natured suavity in those characters named Jerry, or Guy, or Lucky, but all the same type, played by Fred Astaire. It's a quality suited to F. Scott Fitzgerald, with his cool romanticism and his casually elegant, not-a-word-extra polished prose. And it perfectly fits the sculpture of Elie Nadelman. His best work—the figures that look like overgrown dolls, and represent self-satisfied people "in society," or those far too fat, but still remarkably graceful dancers and circus performers—radiates that same aura of su- premely well-bred, debonaire nonchalance.

Nadelman, born in Poland in 1882, a Parisian from 1903 to 1914, and thereafter a New Yorker until his death in 1946, isn't quite the Jazz Age personality that Gershwin or Fitzgerald is; his work isn't hectic in tone, his is a more reflective, conservative sensibility. He has a distinct period look now, and in the best sense: the atmosphere of New York in the teens and twenties floats over his art like an aroma—it's never felt as the point of the work. But the "period" quality we feel in Nadelman is there in spite of his instincts, which obey the laws of classic Greek art. For most of us, Greek art, with its insistence on the beautiful, the perfect and the predictable in every form, is not a very vivid aesthetic issue. Yet there are times in a museum when the head of a Greek athlete, or a headless torso, catches us up: the piece goes beyond that expected "perfection"; it appears to be aware of, and possibly disturbed by, its own physical grace, and we are made to feel all the contradictory emotions that the Greek sculptor must have had in order to arrive at this image of a timeless ideal. When Greek art moves us, its expression of formal containment is felt physically; it becomes similar to those moments in tragic

drama, when the pain is so intense that the only thing the actor registers is a state of exalted, heightened calm. Looking at his work, one believes that Nadelman carried this charged feeling about classic art with him all his life—except that, by temperament, he transformed the emotion into something that is more wryly comic than tragic.

In some of his sculpture, Nadelman only pays homage to the classic rules of symmetry, proportion, and balance; here, he is too literally doing his Greek homework, and he looks like an antiquarian. But in his great pieces, many of which are very small in size, he keeps only the beautiful skeleton of classic art. The rest is his own invention—he clothes the human body, and spirit, with forms that have a wittily extravagant, rubbery elegance. In Elie Nadelman's eyes, people pass through life as if they were playing spookily well-mannered charades.

Besides Nadelman, the only modern artist who lives as intimately with the classic attitude, and makes it as real for us now, is Seurat. Both artists see humanity as a collection of types, graceful puppets, best viewed when they're parading or performing. Both sculptor and painter combine a poet's eye for the comedy of social manners with an instinctively "right" feeling for bodily form and movement. This is a wonderfully balanced combination—the comic temperament enlivens the insistence on classic formalism, which can become glacial if left out on its own, and the preoccupation with ideally rounded volumes keeps the social observation from becoming literary. The mixture is also what makes Nadelman and Seurat seem to be "above" their subjects, and still not patronizing. Maybe this happens because we sense their own absorption in the puppet drama they present to us; they are at home in the atmosphere of icily perfect, non-messy comedy, and they make us at home there. They even create a tempo for us to respond to their art—a slower, more measured tempo than we, or most artists, are normally comfortable with.

Among American sculptors of Nadelman's era—the era between Saint-Gaudens and David Smith—one may feel that only Lachaise is his equal. Lachaise is more powerful, he reaches

greater conclusions than Nadelman. But Nadelman, whose sensibility rejected reaching great conclusions about anything, has more ideas about figural form than Lachaise. Nadelman also makes wider, more inventive use of past styles, plus what was stylish in the fashions of his own time; he refreshes his view more frequently, he's less predictable than Lachaise. And Lachaise can hardly match Nadelman's incredible mastery of so wide a variety of materials (nor can any other of his near-contemporaries, except Brancusi and Noguchi). Nadelman worked on a small scale, he didn't care whether his finished art appeared private or tentative or too much like an "exercise." He never made that grand, imposing work, the summation piece, which modern sculptors have accustomed us to expect as the point of a career. He loved and was erudite about past traditions, and so he risked having people say he was too Mannerist or too Greek or too Hellenistic or too similar to folk art. All this has kept him from being as recognized as he should be.

Nadelman had a nimble mind: he says what he wants to say economically, there's never any flab. Still, it's hard to be equally precise in describing how he affects us. His art isn't willfully difficult or obscure, but, in a satisfying way, it is elusive. His qualities—his old-fashioned finesse in handling materials, his martinet-like, rigid adherence to form, his almost Oriental love for tiny, hidden gestures, his shyly standoffish manner, his ability to roam with such ease and delight over the history of sculptural form, and have this history make sense for pieces sometimes no more than 5 inches high, his sporty, debonaire comedy (not exactly innocent, and not exactly knowing, either)—these qualities don't add up neatly. They can be taken apart, but that doesn't explain his power. Nadelman balances attitudes that one doesn't expect to see balanced; he makes us create new categories in our effort to describe how his mind works. The more he becomes known to us, the more original he seems.

1974

►►►►

Myron Stout

WHILE SOME ARTISTS work slowly because they are methodical and painstaking, others work slowly because their art appears to cast a spell over them. To the spellbound painter, the individual picture seems never to be completely finished; some crucial further adjustment, some essential bit of extra tinkering, is needed, he feels, to make everything fixed, secure. The greatest American example of this type, Albert Pinkham Ryder, was described by a reverent Marsden Hartley as possessing a "strict passivity of mental vision." Hartley had in mind the passivity of mystic experience, when a person believes that he communicates thoughts, even feelings, that pass through him, that he isn't the author of. Hartley's "passivity" is the perfect word for Ryder. It suits all artists who are reluctant to let their work leave the studio, because it suggests their bizarre, even awesome, equanimity of spirit—the ability they have to be confident about their art even when the end is nowhere in sight.

Myron Stout is a painter who has this special confidence. Quietly, among artists, critics, and collectors, he is getting to be a legendary figure, not only because of the originality and force of his abstract, mostly black and white paintings, but because he produces so slowly, and has removed himself, except for scattered group shows, so totally from the world of exhibitions. The smallness of Stout's output is spectacular—he's with Vermeer in that department.

At his first one-man show, at the Stable Gallery, New York, in 1954, he exhibited twelve paintings and fifteen large charcoal drawings—work which represented essentially everything he had completed, that he believed had real merit, since 1947, which was when he first felt sure about his art. At his second—and last—one-man show, at the Hansa Gallery, New York, in 1957, he exhibited five paintings, six or seven charcoals, and a

number of conté pencil drawings. Since that show, he completed, or has been completing, eight paintings. He hasn't, as he would say, "put out" a charcoal in over three years, though he has exhibited and sold around twenty charcoals since the late forties. They're the most widely dispersed part of his work. In the late fifties, he began working with graphite pencil, and he has now produced between ten and fifteen of these abstract drawings, which are rarely bigger than the size of your hand. They are perhaps the most compelling, mysteriously beautiful things he has done. As "finished" as the oils or charcoals, they take almost as long to complete.

Stout is finicky about minuscule, knife-edge fine relationships—the curve of a line, the proportion of black to white—to the degree where his practice goes beyond finickiness, and you wonder if possibly he is in communion with his pictures. Though you aren't immediately aware, looking at his work, of the time that has gone into it. His pictures aren't aged, encrusted objects, records of a prolonged battle. Stout's paintings and drawings have retiring, subtly rich surfaces. It is clear that he wants them to appear unshowy, unagonized-over, effortless. Stout isn't a visionary painter, at least not on the order of Ryder. He is more conscious about his art than Ryder was and, also unlike Ryder, he doesn't keep his pictures around because he's romantically infatuated with them. He is a commonsensical, pragmatic person, and can see the humor in taking so long to complete one of his generally small-size paintings or very small drawings. But then the joking stops, and he peers at the canvas or paper, looking at it as if for the first time. Almost touching the deficient areas with his long, roving, untapering fingers, which firmly circle the air above the work, he realistically describes how much this pearl gray tone, here, needs in order for it to match, in force, that gun-metal gray tone, there. He makes his visitor feel that it is a technical problem, not a spiritual one; it has to do with precise, delicate, insistent application, not inspiration. But someone other than a journeyman is needed to solve the problem and bring the work to its conclusion—Stout doesn't have to say that. You can see that technique without devotion

would be incapable of keeping the overall tone, which is so crucial to him.

There is of course a trace in him of the visionary's "passivity" Hartley was talking about. Stout's eyes have been eating up the painting or drawing, but then, in a split second, he is done with it, ready to put it away and talk with his visitor about something else. His eyes, for a little while, show a slight weariness and wateryness, as if in speaking about the picture's fate he has relived all his experiences with it and is now momentarily depleted. The piece clearly needs more work; he will be going after it again, and then he will lose himself one more time. No date—generally not even the vaguest one—can be given as to when work will be over. He isn't angry or happy about that—he just doesn't know. The piece is ripening on its own timetable, and he will be there, tending it all the way.

Stout was born in Denton, Texas in 1908 and has lived, since the early fifties, in Provincetown, Massachusetts. He played classical piano through the first half of his life, though never intending to be a professional musician; in college, at North Texas State University, he studied literature and ancient history, and was thinking of becoming a historian when, at the end of his senior year, in 1930, he discovered painting. From then on, he was seriously involved with art. He taught painting and drawing in Texas in the early thirties, studied with Carlos Merida in Mexico City in 1933, and four years later got a Master's Degree in art at Teacher's College, Columbia. Up until 1947, though, there were always significant interruptions in his career, as there were prolonged detours and dead-end drives in the careers of his contemporaries, Jackson Pollock, Mark Rothko, Franz Kline and many other American artists born in the years prior to the First World War. Dissatisfaction with his primarily landscape art done in the thirties made Stout reluctant to go on painting at all, and when he was drafted in 1943 he felt that he wouldn't return to his on-again, off-again struggling career as an artist.

When he went back to painting after the War, it was, for the first time, as an abstractionist. Painting abstractly hadn't been a suppressed goal—his chief interests had always been the weight

of shapes and colors, how they balance each other. He just hadn't found the right form to embody his feelings. Hans Hofmann, with whom he studied at the time, at the painter's studio schools in New York and Provincetown, gave Stout the nudge he needed. Within a few years, he produced a number of technically expert, if not fully individual, geometric abstractions, small-size multi-color paintings which have brilliant, staccato-sharp cross patterns, and resemble weavings or tilled fields, and paintings of two or three colors, which contain a few bold angled shapes, or checkerboard motifs.

He also moved to Provincetown on a permanent basis, living alone, as he always has. He speaks about how much he loves the light there, and, without deliberately setting out to do so, he has caught the sometimes watery and veiled, sometimes brilliantly clear light of the oceanfront town in some of his abstract graphite drawings. But it is possible that even more than the light, it is the sharply different seasonal and emotional changes of this fishing town, set at the tip of Cape Cod, that made him feel so much at home. Honky-tonk, overcrowded, tourist-ridden and, if one wants it, a fund of endless social engagements in its prolonged summer months, it is fairly desolate for its equally stretched-out winter months. Full of fine (and some slightly down-at-the-heels) examples of early New England architecture, which are bunched next to not untacky recent creations, it is surrounded by miles of continually shifting dunes and gives out, at almost every angle, to uninterrupted views of bay and ocean. Elegant, cozy, citadel-like and a little threadbare, long visited by artists and writers, it is a cosmopolitan outpost, a kind of American Dieppe or Ostende (where James Ensor lived year-round), in touch with every fad and yet not a place to go to find out what's new. Stout seems to contain all these contradictions. He is hardly a "Provincetown painter": he didn't go to the town for its local color. But he takes full advantage of its sociability and the chance it provides for isolation. Both states are suggested by his art, which is about the meeting of extremes—black and white, dark and light, inside and outside, the curve and the straight line.

Encountering a Stout, your impulse is to read it the way road

signs are read—as a message. The atmosphere he creates in his compact black and white pictures is tense and stark. His forms look as if they have been securely (and also organically) locked into place. They don't give the impression, as Arp's do, of having floated into the picture frame. Following the lines of his curved shapes, you feel your senses sharpened, pinpointed. His charcoal drawings contain wavering, fragile, taut balances.

But there is also an underlying softness and graciousness—and something that, you feel, wants to be softer than it knows how to be—about his milky-white curved shapes. Like Mondrian and Ellsworth Kelly, Stout is an abstractionist because the history of modern art and his own temperament made him realize he could no longer continue to be the landscapist he first was. Yet in the mid-fifties, long after he believed he was finished with representation, he returned to landscape. He was surprised that he still had an urge to work this way; but the situation—a studio with a large window that looked directly out on the dunes, from which he could draw in all weather—tapped an impulse. On and off for a few years, he produced softly shaded conté pencil drawings which emphasize the tumbling, cascading flow of shrubs, sand, trees, clouds. They resemble High Renaissance drawings; they're dreamily atmospheric and make you think you're looking at specific landscape rhythms, not specific places. Many of these rhythms, now isolated and magnified, are the subjects of his major works. These are portraits, really, of beautiful but also somewhat awkward abstract shapes. The shapes don't automatically recall things that are in the world (as Arp's shapes wind up being bowties and forks), nor are they abstractions taken from the world (as are Ellsworth Kelly's sunlight-and-shadow, or architecturally-derived, images). But they have human presence. From picture to picture, they dangle; lift themselves buoyantly; beam out, like a cat's eyes in the night; struggle to attain fullness; sit with a stony immobility; halt us, like a traffic cop's outstretched palm. You want to run your hand around the edges of the shapes, as if they were sculpted forms, feeling the inner solidity. Many have the slightly too-massive, too-broad contour line of a polar bear's domed head.

He makes pencil drawings first, then decides whether to go on to charcoal or oil or to a more finished graphite, and, on these pencil sketches, he occasionally works from the model. He doesn't make figure drawings from the model, though, he makes rough abstract Stouts. In one case, with a male model, he was impressed by the person's fullness, the man's physical and mental poise. Stout immediately knew he could portray this presence by a shape resembling an egg. And yet, while some of his images derive from the character or physical aura of the person before him, there are others which have no distinct relation to any model. Anyway, to be told that a specific model inspired a certain shape won't suddenly give us a clear-cut way to think about that shape.

The shapes are made to sit right by endless small adjustments, all made by the eye, intuitively—he doesn't use graph paper, even when he's after an image of dead centeredness. For most of his career, he has made straight lines without benefit of a straightedge or any mechanical aid. Occasionally, intuition takes things beyond where they were planned to go and, occasionally, he will go along with the unexpected, letting the pictures take their own course. Working, on canvas, on the shape which he intended to resemble an egg, he found that the contours of the shape somehow became fuller, more square, than they should have been—the image began to look more like a shield than an egg, and that was all right with him. He kept the new shield image, developed it along the lines it dictated, and meanwhile also went back to make, on another canvas, the egg-like shape he originally wanted.

Stout's best-known work is a small black and white painting in the Museum of Modern Art. When the museum bought the painting—an image of a white stringless lyre, in a black setting—it had no title; it bore only the label "Number 3, 1954." Stout knew that the image, which also resembles the letter U with its ends slightly blown to one side, was related to the Moon Goddess, yet he was reluctant to call it that. Since then, he has decided that the picture probably ought to be titled "Artemis," and this, for him, is a significant decision; his titles clarify how

he works—they're far from arbitrary.* They all derive from Greek myth, except for two drawings entitled "Adam" and "Eve." There are paintings named after Leto, Demeter, and Artemis; another is associated in his mind with Apollo. Two drawings, done nearly twenty years apart, are called "Teiresias"; they are different images, but one suggests a mask that covers the eyes, the other one an eyeless face with an open mouth—both fit Teiresias, the blind prophet in *Oedipus*, *Antigone*, and *The Bacchae*. A painting of a square shape with rounded edges is entitled "Aegis," which makes sense because the form looks like a shield. A painting of a three-pronged, up-ended form suggests, to Stout, the sacred gesture of hands raised, and he calls it "Hierophant." In the two "Delphi" drawings, where the isolated shape is triangular, the image is understandable as an open mouth, since Delphi was the seat of an oracle (one of the "Delphi" graphites is reproduced in the Whitney Museum's *American Drawings 1963-1973* catalogue as "Untitled"). Stout titles the paintings or the graphites (the charcoals never get titles) only if there is some compelling reason to do so. The titles, he says, are a "feeling connection," they're "one of those things that come up in you." He doesn't intend the images to be taken as illustrations; he uses the titles because they have some metaphoric resonance with the shape, which he also thinks of as a metaphor.

Many of the Abstract Expressionists were drawn to the world of myths, and not only Greek and Biblical myths. The painters were seemingly responsive to all dramas of creation—the birth of vast new things—and of endless, doomed struggle. Stout's feeling for this heroic and impersonal terrain is one of the things that mark him as a man of his time. Though he has registered this feeling in such a distinctive, independent way it comes as a surprise to realize how connected his goals are with, say, Barnett Newman's. Stout's appreciation of the lives of the gods and goddesses and the sacred emblems associated with them seems at first to be that of a learned poet or amateur classicist, and, in part, he is both. He feels that if he hadn't been a painter he would have stuck to his youthful wish and been a historian of the

*But he hasn't officially changed the title. It is still "Untitled (Number 3, 1954)."

ancient world. Except for "Adam" and "Eve," his titles are not of well-known mythical figures and literary characters. The titles present a company of powerful, motherly, sometimes hounded goddesses ("Leto," "Demeter"); the youthful, somewhat vulnerable and saintly god Apollo; and men (and sites) whose power derives from the ability to predict the future, to explain mysteries ("Delphi," "Teiresias," "Hierophant"). What his titles leave out are the Herculean creative forces, the mighty bearded fathers, the power that comes from surrendering oneself to instinct—figures and themes suggested by Newman titles such as "Onement" and "Abraham," and Pollock's "Out of the Web."

Yet, as much as any Abstract Expressionist, he has pulled his best pictures out of his inner web. He began painting rounded forms as a sudden gesture, in September, 1952. He was rereading Aeschylus, after many years of being separated from Greek literature. He had grown up with the history and mythology of ancient cultures, but he dropped that part of his life when he became involved with art, and for a long time assumed that these interests were behind him, things he would never again need. Trying to express what he recalls was the "tragic poignance" he encountered when he reread Aeschylus, he made, almost to his own surprise, two large paintings, both in black and white, of separate, oval shapes. The paintings weren't successful. Their symbolic content is not light-footed: the shapes in them look as if they're individual forces encountering other individual forces in a vast empty space. It would be two years before he made the first paintings of rounded shapes that he believed had any merit, but the September, 1952 experience opened up his art. It made him believe that his work could include something that came from within, spontaneously, and that this could be done without having to sacrifice those qualities of proportion and relation which had come to mean so much to him. When he began making paintings of shapes with rounded edges—all in black and white—he went back to classical literature with a new intensity; his development as a painter, he feels, went hand in hand with what he read. He must have been surprised and delighted that these characters and scenes, which he had known from child-

hood, were speaking to him again. The experience must have been like finding a trunkful of previously unknown family photographs, letters and mementos. And finding them not at any time, but at just the right time, when the past was no longer bothersome or awful or saddening, but stimulating, a private, rich vein waiting to be mined.

The Greek tragedies often show the barbaric, unreasonably cruel life that exists beneath the rules we observe; in the plays, rules put up a valiant fight but they can't hold out against cruel, random forces that erupt and destroy them. The rules and the cruelty are in Stout's art; his feeling for formal precision is as strong as it is because it seems to keep a formless, barbaric underside in place. You sense that in "Artemis," where the white lyre shape, surrounded by black, conveys a mixture of encircling protectiveness with something forever unconnected, barren and spiky. Stout was an accomplished painter of straight edge-type abstractions, but when he set aside the straight edge because it could not express what he felt about Aeschylus, he touched something deeper in himself. The angle-edged abstractions are pictures of felt tension and balance, and he has gone on making them. But when he works with rounded-edge shapes we feel more of his endlessly filling-in, evening-out, building-up methods. The images seem more his own; they stand for more. They show how much fierceness and pride there is in the man, how relentlessly he searches for control and order. Together, they form a many-sided meditation on the state of isolation, powerful, inevitable and sad, as he felt Aeschylus to be. Stout's shapes are forces that sometimes touch one another but never mingle, that swell out yet are forever held in check.

The belief that he can be so precise in defining them has enabled him to continually bring a skeptical and loving eye to pictures he has had in his studio for years, and to forge ahead on them without the encouragement provided by a show—without knowing that there is a public out there, watching what he does. Yet the desire for precision is willful and demanding; it can protect an artist, but it can also suck his freest energy from him, and leave him with an imprisoning energy that keeps feeding

him more and more unresolvable problems. It is a positive power that carries a negative charge within it, and this can be seen in the way Stout uses materials. Trying to illustrate basic, inevitable relations and to give his surfaces the appearance of seamless wholes, he doesn't merely color in the forms, he saturates them. This resolution can be stimulating and inspiring; for artists especially, his pictures are examples of consummate care, the kind of care it is easy to see in an Old Master but less evident in a contemporary. But his need to account for every square inch also leaves things a little lifeless. The world looks clearer and more definite from such a height, yet the air up there is thinner, and our reactions to Stout's art go the same equivocal way. We can sense that his pictures are works of unusual energy, but that energy doesn't come out and liberate us.

One of the most perceptive things written about this predicament is a statement Meyer Schapiro made about Elie Nadelman (it appears in Lincoln Kirstein's biography of the sculptor, where it's quoted as a "profound, if admittedly partial, judgment"). Nadelman, Schapiro says,

is not an uncommon type of modern artist, although distinct as an individual. The dream of a quintessential or supreme art is a mark of his kind; I feel something narcissistic there and a doom. Such a man can hardly grow and his change must appear to him somehow as compromise and adaptation. He could not utilize in his art the conflict and imperfection in his own contemporaries. The *beautiful* has too great finality. And perhaps as a kind of penitence for his youthful pride, he became too humble in his later years; but even in this humility there is a compromise, a lack of energy and whole-heartedness, a reliance upon charm . . .

For all the brilliant aesthetic and psychological observations here, Schapiro sees Nadelman too much in terms of what he feels Nadelman wanted for his art. But what he wanted is different from what he did, and Schapiro doesn't look closely enough at this difference. Schapiro fails to see that, while the beautiful had too great a "finality" for him as a conscious artist, much of his art is not beautiful. Although Nadelman did dream of a quintessential or supreme art, his art isn't entirely "su-

preme"—partly, it's fragile, moody, private, ghoulish, witty, obscure, of a period.

Schapiro is right in saying that Nadelman must have felt that to grow and change would mean, for him, compromise. There is something stagnant about Nadelman's art, and there is a similar quality—of ideas cherished excessively, kept too long in the studio—in Stout. Yet Nadelman, though his principles were clamped in place early, and never got themselves unclamped, moved within those principles: he didn't betray them, but he did subvert them. He is great, not because he is the great classic artist he wanted to be, but because his passion for a perfect, beautiful art was personal and contemporary and unconscious. His passion waylaid his conscious ambition, and in so doing enriched his art, made it more ambiguous and complicated than it would have been had he achieved what he intended.

Like Nadelman, Stout comes close to making a petrified, stillborn art, yet he escapes, and in describing that escape we describe his special tension. His art has not utilized the "conflict and imperfection in his own contemporaries," but the result has not been work which is, as Schapiro might have it, compromised or enervated. The drive of a Stout or a Nadelman is different from that of most artists of stature. Most truly original artists give us the impression that, if they had more time to live, they would keep on succeeding themselves with new ideas. But the artist who works out of an ideal that exists in his head is not in that kind of rush for time. And perhaps because his energy is directed toward foregone conclusions, he is most likely to have those conclusions sidetracked.

Now sixty-six, Stout is at work on five paintings, begun nearly a decade ago, that represent his ultimate sidetrack. The still-unfinished paintings are of dead-centered, white, bisymmetrical shapes; they recall eggs, shields, horns, lyres, prongs. The paintings are either the same size as the earlier, finished ones, or a little larger, but their scale is mammoth because of the looming bisymmetry. The paintings Stout completed with some ease were of asymmetrical—often top-heavy, unintentionally humorous and sometimes charming—shapes. The paintings still in the

studio are of shapes that could be sacred signs from a primordial world, insignia the earliest man might have recognized. They might pass for votive images made for a temple, where each would be set in its own niche. Unpliant and unyielding in mood, they epitomize the august power that Stout camouflages in his other work. This same massive composure is in the graphite drawings of bisymmetrical forms. But there, possibly because he uses sumptuously soft, quivering grays as well as black and white, his centered, balanced images have a haunting, layered inwardness; they're cave-like and beckoning. In the bisymmetrical black and white paintings, though, Stout seems to be making portraits of his most recalcitrant, demanding, never fully satisfied self. They have been difficult for him to complete, not only because of his high technical standards, but because they are his ultimate tests of achieving perfect balance. Part of him must want not to complete them—must feel that that test can never be passed.*

His work is a kind of shrine to honesty. This is what makes it inadvertently presumptuous, bolder and more aggressive than it perhaps intends to be. Although Stout came to the fore after his contemporaries had—arriving on the scene with the generation after his and often mistakenly thought to be one of them—he is really a shyer member of the same family as Rothko, Pollock, Clyfford Still and the rest. Like them, he has attempted to find the deepest note his body can sound, and to create a whole song around that note. Again like them, he has thrashed about and allowed his career to be waylaid in his effort to find, and hold to, that note. He is of the generation that believed that good art had to be about the difficulty, the near-impossibility, of making art at all. If his work is not as graspable as that of some of his contemporaries, it may be because he wants to present us with only the note in its purity. He doesn't use his gifts in what Schapiro calls a whole-hearted way. We are aware that Stout is not freely giving of his talents.

Yet his refusal to be slack anywhere is the source of his power. The responsibility he feels for his every painting and drawing

*Two of these were completed: "Hierophant," 1955-79, and "Aegis," 1955-79.

has kept him from being normally productive, but it has given each of his pictures the weight of many. And while his work may be distant, it has no airs—it is stately by nature. In the end, he wins us over, if not for the largeness of his feeling, then for his conviction, which is another kind of largeness. Stout paints as if his life depended on it. This is what makes his art hit so close to home.

1975, '82

▶▶▶▶

Lachaise

WRITING ABOUT THE "problems of sexuality" and the "erotic content" of Lachaise's art, Gerald Nordland says that "No artist in all the history of the world has dealt with these problems and issues so straightforwardly, so respectfully, or so truthfully." This is a heroic and pleasingly old-fashioned way to talk about art, and it's a fitting spirit in which to write about Lachaise, whose sculpture has the impact of a great big wave rolling in. Nordland is intelligent, and you sense that, in his head, he knows Lachaise is a special figure but his performance—in *Gaston Lachaise: The Man and His Work*—is not the kind to make you feel you're reading about an artist who did something different from any other artist in "all the history of the world."

Nordland, who first became interested in Lachaise in the late forties and was later designated by Madame Lachaise and the Lachaise Foundation to be the sculptor's official biographer, is always on the outside, looking in. Though he is livelier in the "Man and His Art" section than in the "Man and His Life" part, his appreciations of the different pieces can hardly be called anything more than courteous, and the occasional references to

Rodin, Indian temple sculpture and the Venus of Willendorf are more obligatory than fascinating for him. The late work, which shows that when Lachaise died he was going off in a radically new direction, isn't made to seem like the significant turning point that it probably was for the sculptor, and, most amazingly, the drawings are completely ignored. Not one is reproduced. The reader is left with the impression that Lachaise is totally unconnected; his achievement floats off by itself, independent of art history, the life of forms, the cultural spirit of its period.

Essentially what Nordland has done is to borrow from the opinions about Lachaise that circulated during the sculptor's lifetime, hardly modifying them, and not constructing from them his own image of who the sculptor was. In a 1920 article, E. E. Cummings said that Lachaise was "inherently naif, fearlessly intelligent, utterly sincere." George L. K. Morris added that "He was a lovable person . . . like a kid." Lincoln Kirstein characterized the cultural and art-historical point of the work when he said that Lachaise, "above all other sculptors since the Renaissance, is the interpreter of maturity." And Marsden Hartley, in a reminiscence, described the romantic Lachaise better than anyone: the artist, he wrote, "was that singular being of today and of yesterday, the worshipper of beauty, he thought of nothing else, beauty was his meat and bread . . . he was always the consistent and ardent worshipper."

It's strange that Nordland never mentions Lachaise's one great American contemporary, Elie Nadelman. Both sculptors were transplanted Europeans, and both became greater figures once they moved to New York than they would have become had they stayed in Europe. Lachaise and Nadelman are different temperamentally, and they are unlike in the large, over-all patterns of their lives, but as figures of a specific era their fortunes go hand in hand, and from a distance they can almost be thought of as brothers. Certainly, when they arrived here (Lachaise in 1906, Nadelman in 1914) and became known, they must have seemed like natural royalty, princes from the same house. Being artists came naturally and uncomplicatedly to them, they were saturated in the traditions of European art. They had definite, solid

ideas about what they wanted to achieve, but it's hard to see those ideas meaning as much in the Europe of the late teens and twenties as in the New York of that time, which gave them a more naive, open, genteel situation to move in. If circumstances had been different, and they had had to operate in Europe's more intellectually-oriented and competitive post-First World War art climate, it's imaginable that both of them, with their essentially conservative, 19th-century attitudes, would have buckled under, becoming perhaps nothing more than portraitists in marble. But in New York, where there had never been a Rodin or a Maillol or a Lehmbruck, their art was advanced enough, and they had an audience, if they wanted it, of society patrons, new collectors ready to be educated, art enthusiasts, and writers who were willing to give them attention.

Lachaise accepted the adulation of New York all the way through his career, from the teens through the mid-thirties, and it's one of Nordland's great missed opportunities that, with his brief, textbooky account, he fails to make anything out of this New York art and society scene. Figures as diverse as Stieglitz, Edward M. M. Warburg, Kirstein, Hartley, Gilbert Seldes, Hart Crane, Cummings, Marianne Moore, Henry McBride, Marin, A. E. Gallatin, Paul Rosenfeld, Carl Van Vechten, and George Morris were behind Lachaise, and had Nadelman given them the chance, they would have been behind him, too. Lachaise craved this partisan approval; he was the kind of person who had to be spotlit in order to go anywhere. Nadelman preferred to think of himself as a prince in exile, working privately, showing little. He acted in New York exactly the way he had acted in Paris, before the War; after achieving a certain notoriety for his radical conservatism, he removed himself, to become a living legend for the cultured few who had personal ties to him. If Nadelman wanted it, he probably could have continued relations, in modified fashion, with Stieglitz, or with any other New York gallery. He should have stayed. His best, most prepossessing sculpture was made when he was in the thick of his public fame. Not that his work became stale or repetitive when he left the New York art world—his late, small papier-

maché and plaster figures are among the most mesmerizing, subtly beautiful things he did. But they're so private in spirit we feel we're invading someone's reveries when we look at them. They don't have the full man in them. They lack the outgoing qualities that are in his string of masterworks in painted cherry wood: his humor, his love of society and wish to get even with it, his audacity.

If Nadelman is the prince as connoisseur, Lachaise is the prince as impatient adolescent. Nadelman has a disinterested intelligence, too much taste, and not enough energy. With Lachaise, everything he knew went into his art, he never learned anything that he couldn't make art; for him, there was no outside learning. He seems not to have had taste, for older art or for anything, and he had enough energy for four Nadelmans. The spirit of Lachaise is of something powerful and large which is only able to move in tiny, dainty steps. In his best work, which is usually the small, fragmentary sculpture, he makes massive, sensual weight interdependent with the thinnest, sharpest, most jewelry-like line. He knew this contradiction so well that it became one of his chief characteristics as an artist.

Towards the end of his life (the dates are still uncertain, and Nordland doesn't bother much with sorting out the development), Lachaise went in another direction from the look of firmly contoured, imposing maturity—the style he is identified with and the idea Kirstein most admired in him. Privately, he was experimenting with sculpture that has barely any relation to the calm majesty of the "Heroic Woman," the large standing figure in the Museum of Modern Art garden. In the bulging late pieces, he forsakes his clean, precise, Art Nouveau line; he goes from lucid, contained, convex ripeness to a gaping, tremulous surface. There is no longer the definite bounding curve—the mood becomes comic, though with a bubbly, hysterical tone to it. When he died, in 1935, many of these pieces were still left in molds; they have been cast only recently. Crazily contorted and grotesque, pieces such as the "Female Acrobat" and the male "Athlete," which were shown for the first time in 1973 at the Schoelkopf Gallery in New York, make clear that he was

searching for ways to rid himself of his exquisiteness—that fine edge he gave to large forms. He was willing to push his insights further, even if that meant making what might be considered, next to the "Heroic Woman," ugly art.

What sets Lachaise apart from most American sculptors of his period is that he knew that for art to be significant it had to be about personal experience, not style. And for him the only personal experience that mattered was information he got through the body. His art is convincing because no matter how he represents the figure (and with some late pieces it is impossible to know exactly what you're looking at), his bronze has recognizable, human weight to it. With Lachaise, as with few other sculptors, the viewer participates kinesthetically in the way the thing hangs long before he knows what part is hanging where. And yet there is always an empty, cold spot inside him, even in the chaotic late work, where he appears to be digging deeper into himself. Cummings and the others were right when they said that there is a passionate conviction in him, but it's a blind, unresponsive conviction.

The trouble with Lachaise is that he had time only for revelation—he couldn't bother with lesser states of feeling. His identification with beauty, his meat and bread, as Hartley put it, was so complete—identification with something outside himself, which he venerated, was so entirely the point of his art—that there was no room left for thought. Although his work is rarely inert, it never talks back; its inner life is glazed over. Lachaise has no view independent of what is depicted, he's right there inside the image. He can't make that leap from a sculptural to an emotional delicacy, which Lehmbruck achieved in his "Standing Youth" and "Kneeling Woman," both in the Modern. Unlike most large-size Lachaises, which can be coarsely detailed, the Lehmbrucks are large in feeling without being insensitive in any of their parts. And the "Youth" and "Woman" have what Lachaise was unable to imply sculpturally: distinct human character. Each of the Lehmbruck figures seems to have its own past and future, while every Lachaise is caught in an eternal present. In Lachaise's ideal heads, where the women's eyes are downcast

or shut, there is no pensiveness, only repose. In his liveliest portraits, what he responds to is a sharp, gritty, animal vitality in the sitter; the Cummings and the Kirstein, which are among the best, glare out at the viewer like sleek cats, repelling any possible intimacy.

Lachaise's lack of reflectiveness must have been, in the twenties, a sign of his modernity. Hartley liked the way everything was kept instantaneous, nothing was ever symbolized or dramatized. Nadelman never symbolized either, he's breezy and nonchalant in the most voguish twenties way, and yet his work is more mysteriously original and alive than Lachaise's. Nadelman knew something different from what the rest of us know, whereas Lachaise only had more energy than most people. The most personal and distinct part of Lachaise now is his forcefulness and what Cummings called his sincerity. His sense of beauty, the inner life of his art, is far less tangible. When you try to describe it, it slips right through your fingers. Lachaise makes it seem as if he never had to wrestle with his experience in order to make art. He was too much the valiant knight, always in complete control. If his art is distant, it's because, without any hesitation, he answered all his own questions. Nothing is left to be explained. He makes it impossible to wonder, even for a second, about what he meant.

1975

▶▶▶▶

A Northern Seascape

TALL, GAWKY AND NERVOUS as a young man, Marsden Hartley spent nearly his whole lifetime filling out his huge frame and slowing down his pace. In the pencil self-portraits he did in his early thirties, his dangling body and too-narrow head, with its

enormous ears and nose, peer out from the barrage of tiny, jabbing, hit and run·strokes. The images are powerful but they're not appealing or satisfying. Hartley seems to be carrying off a feat without enjoying it himself, and much of his early and middle work feels the same way—it's strained and jerky. Though his art changed, and he lost the jerkiness, he never lost the edgy, live-wire atmosphere of those self-portrait drawings. In his mature, late painting, the trees, with their starched branches and leaves, are always bolt upright, like scarecrows, the sea is always choppy, the clouds tumble, and the hair on the heads of his wrestlers and lobster fishermen always stands up like an exclamation point. Hartley saw everything surrounded by a rushing, slightly frantic air, and it's there even in his most monumental work, the final landscapes and seascapes.

Like Max Beckmann's (whose temperament and painting style are the closest to his of any of his contemporaries), Marsden Hartley's most characteristic urge, in his art, is to reach out and clutch at what's before him, haul it in, alive and kicking, and pin it down, usually at an angle. Hartley couldn't give up the clutching, impetuous response—that was built into him. But in his last years, as he became clearer about what he wanted to paint, and could paint more easily, he was transformed physically. He turned into a slow-moving, massive, rock-like man, his inner rhythms changed, and it shows in his work: there is a weighty, sculptural center to his final style. He achieved what he had been after all his life—his art, for all the froth and spray, became grand, majestic and solemn.

There is no secret that explains Hartley's ability to grow—it took him twenty-five years to get rid of the unnecessary mannerisms in his work and add those parts that helped settle him down. His first distinctly original paintings appeared by 1908, and he continued to be a restless experimenter, with hesitations, brilliant shots that wouldn't go anywhere, backtrackings, and many sour, not-completely-there paintings, until the mid-thirties, when the images, colors, stroke and surface came together in a liberating way. In the last seven or eight years of his life (he died in 1943), the paintings flowed out of him. But if no one

thing explains how this happened, it would be hard to imagine how his life and art would have changed if he hadn't seen the work of Albert Pinkham Ryder, and then gotten to know him. Ryder's painting affected many people in the teens and early twenties, but it gave Hartley, who saw his first Ryder probably in the winter of 1909, in a New York gallery, and described it as "just some sea, some clouds, and a sail boat on the tossing waters," a personal jolt. There were long periods of his life after that when his art had no relation to Ryder at all, and for most of the twenties he thought the sun rose and set with Cézanne, but it's clear from the essays he wrote, from the portrait he made of Ryder in the late thirties, and from his many late pictures which evoke his art, that he never lost sight of Ryder's spirit and always expected to get back to it.

In 1909, looking at the small Ryder seascape, Hartley thought that he was facing his best, deepest self; the painting had a mood of tragedy, and an operatic, larger-than-life presence which he had felt himself and wanted for his own art. More than any of the other figures in the Stieglitz circle—Dove, Marin, O'Keeffe, Demuth and Stieglitz himself—Hartley was moved and elevated by tragedy, but he didn't exactly have a tragic view of experience, or never had it for long—he was too expectant and fervent a personality.

In the well-known photograph Stieglitz took of him in the days of the gallery at 291 Fifth Avenue, Hartley, wearing a broad-brimmed hat, white scarf and dark overcoat, looks as though he's going to run right out of the picture: with his pale, voracious eyes, he gives the impression of someone who can't sit still, and wants to be constantly dazzled. An artist with a tragic view would have to be able to draw back from life, and hold different points of view in his head at the same time, but Hartley didn't have that kind of temperament. He didn't have any philosophical distance on his experience: he was always the center of his world. He felt he had greatness in him, and all his life, without being fully conscious of what he was doing, he estranged people with his insistent vanity—his hope for his art crowded everyone out. And yet, though he was incapable of

acknowledging others seriously, or of convincingly thanking people for what they did for him, he was, as a painter, poet and essayist, an appreciative, admiring person. His essays are either little communiqués on how he feels about art and life, or else they're homages to writers and artists whose work has intersected with his own. In his strongest writing and painting, it was impossible for him to be inspired by disapproval or resentment. He carried the juice of a crushed, lonely and humiliated feeling inside him, and it squirted out whenever he was groping, which was the case for most of the twenties and early thirties, but when he was taking his deepest breaths, when he was most self-confident, he was reverent about the world. No matter how injured and neglected he felt, he instinctively jumped back to life at images—usually mountains, clouds and rocks—that he thought mirrored his own rolling, lumpy bigness. It was generally accepted by people who knew him that his still lifes and landscapes were veiled self-portraits; he chose fruits and plants and landscape sites that suggested his enormous, protuberant face and body, which he was always self-conscious about and which, at the end of his life, he was quietly proud of.

If Hartley doesn't have a tragic view, his spirit is tragic around the edges, and his greatest paintings are the dark ones. His darkness, like Ryder's, isn't gloomy or bleak—it's elegiac. His most powerful pictures are memorials to places, things and people that meant something to him; he digs deepest into himself when he paints his memories of what he loved, and wants to be identified with. And although he adored, conscientiously studied and learned from Cézanne, Courbet, Pissarro, Zurbarán, Rembrandt and many others, he never found in any of them the yearning and nostalgia for things and moods gone by that he found in Ryder.

All during his twenties, he painted in the summer and fall in Maine (where he had been born, in 1877), while, for the rest of the year, he was in New York. Painting mostly landscapes, he lived in a shack in the White Mountains region of the state, on the New Hampshire border. The early Maine landscapes, made at the same time as the self-portrait drawings, are hot and

highly-colored, and they have a dabbed-on, nervous, impasto surface. After seeing that first Ryder, his urge, typically, was to re-do Ryder, to become Ryder himself. He immediately produced a few paintings done directly in Ryder's manner, which Stieglitz called "black" landscapes when he showed them in a group exhibition in March, 1910. The views are of the same landscape Hartley had painted all along—lakes, islands and shacks at the base of mountain sides, the mountain tops capped with clouds—except that the surface of these new paintings is less pasty and ridgy, and the colors, instead of the earlier bright reds, yellows, oranges, light blues, violet and purple, are browns, dark blues and purples, blue-greens, black-greens and black.

Some of the "black" landscapes are rhapsodic; the mountains and clouds and trees flow along like waves breaking from the sea. They combine Hartley's instinctive feeling for a lucid, readable composition and great depth with Ryder's moodier, richer colors. But if Ryder opened Hartley's eyes to a subdued, sweetly melancholic tone, he also tapped the despondent and hysterical sides of Hartley's character. In a few of these new landscapes, broken birches lie on the ground like pathetic victims. Slender and vibrant, set off against the dark glowing colors by their strong black and white patterns, they appear to have been snapped apart from the weight of the mountains, boulders and clouds above them. The few standing trees bob up like crazed, jerkily stiff actors in an Expressionist opera.

As depictions of the awful loneliness and bleakness of nature, there are no paintings like these in our art. As images of New England rural life, they complement O'Neill's *Desire Under the Elms* and Frost poems such as "The Hill Wife" and "Home Burial," where people, frightened by the dark and afraid to be out alone at night, are either indifferent to each other's needs or neurotically, helplessly dependent. And while Hartley's mountain valleys don't look like Wessex, you can imagine Tess stranded there too; as it is with Hardy, nature goes from one extreme to another—it's heroically stirring or indifferent and crushing. In "Deserted Farm," there is nothing to relieve the

depression: the mountains go up from the narrow valleys like walls, giving the night sky and clouds almost no room to breathe. Ryder isn't ever terse like this; he is gentler, he gets lost in his rhythms, there is always buttery yellow, mahogany brown and purple in his black. Hartley, prompted by Ryder to add more somber colors and feelings to his art, went off in another direction from his model: he makes black suffocating.

Except for Demuth, whose appetite for nature was satisfied by what was in the garden, and who is most alive as an artist when he suggests the erotic underlife of things, all the painters in the Stieglitz circle worked from landscape. Like Ryder, they weren't interested, in their art, in society, history or personality. They were private, lyric poets of places and moods that stayed the same regardless of society—Lake George, New Mexico, the Maine coast, Marin's northern New Jersey, Dove's Long Island and his upstate New York. Hartley was the group's roving ambassador. Just as he was a talented mimic of various painting styles, he had the facility to describe the characteristic shapes and colors of any place he spent time in, and between 1918 and the mid-thirties, he traveled to and painted New Mexico, New Hampshire, Gloucester, Massachusetts, Mexico, southern France and Bavaria.

The best of the landscapes he made in his wanderings are learned, lively experiments. They're rarely dreary or inert, and there is usually a touch of his personal quality in them—his love of massive, brusquely outlined forms, and his almost dainty way of filling them in. The only thing they need is a subject, and this puts them in the category of treading water. Compared with his early Ryderesque landscapes and his late Nova Scotia and Maine paintings, they're frequently characterless, cold and empty, especially the French and the New Hampshire series. No one but Hartley could have done them, but he isn't fully in them. Full of his determination and intelligence, they have little of his sympathy. Like the way he looks in photographs taken of him in the teens and twenties, they're hulking in outline and scrawny and pinched in detail.

Uncertain of his instincts, Hartley intellectualized about all

his decisions. He was continually writing papers on where he stood as of the moment, where that was in relation to where he was before, and where he was in relation to everybody else. One year he was for Blake, the next for Cézanne. He proclaimed himself a painter of the imagination, then a painter of ideas. He decided he must be an expressionist, then a formalist. For Dove and Marin, all the decisions were innate—their styles grew out of their untutored receptivity to the natural world. They spent time in Europe and looked at the Old Masters, but their art wasn't built on other art, even though certain modern styles encouraged them to develop what they had in them. Hartley was more abstract and more emotional than either artist. His theories stymied him, but they didn't dry him up, because he didn't have the patience to see theories through; he wasn't wearied by all the art styles he absorbed, as was Max Weber, whose learning grayed his color and personality. Though always apprenticed to a style, Hartley was never so chained to any idea that he couldn't let it slide off him in the next painting if it didn't fit right. Behind his finicky, flighty maneuverings, he was a constant suitor: he was always waiting to give himself away, as he gave himself to Ryder in 1909 and to Cézanne in the twenties, and when he discovered the beauty of Maine in the late thirties, and pledged himself to painting it, he carried on as if he were the bridegroom and the bride—he felt he had chosen and had been chosen.

Nature sustained Dove and Marin, and it didn't matter what "nature" it was. They had no preconceptions about subject-matter; they were able to make "Doves" and "Marins" wherever they were. Hartley needed his preconceptions, though it took him years to find out which were necessary for him. In his eyes, he was a thoroughgoing professional; he liked to announce that specific places were meaningless, subject-matter was irrelevant, and he was all business, only a craftsman. He wrote about "feelings" and "emotions" as if he assumed they equaled senti-mentality, which, though he doesn't exactly say it, you know he felt in himself, and which he was convinced would only get in the way of the Old-Master-like, museum-quality painting he was after. But his painting is only vibrant when he can acknowl-

edge that he is emotionally involved, and then stand a little to the side of that involvement. He's less a lover than a passionate bachelor, sending his love and devotion in a letter. He has to be able to cradle his subjects, to feel that, by painting them, he is understanding and remembering them for a world that has overlooked them.

Hartley wasn't saved simply because he went back to Maine and found his roots there. He always knew that Maine was a great subject, but for most of his life it must have appeared barren and oppressive in his mind, the way it does in those early Ryderesque landscapes. Hartley craved worldliness and cultural fame the way some people pursue money; until his mid-fifties, he dashed about, trying to cram enough sophistication into his life to make up for all he didn't have growing up in a lower-middle-class home in the eighteen-eighties, in Lewiston, not Maine's most dazzlingly sophisticated city. For a solitary, cosmopolitan figure, especially one who worked hard for his cosmopolitan presence, and for someone who no longer had real family ties there, going back to Maine in his middle age would have been an emotional ordeal. He couldn't have faced it until the rest of the world lost its glamour for him, or until he sensed that he carried all the worldliness he needed inside him, so that it didn't matter where he was.

He saw the massive, weighty quality he wanted in his work even before he went to Maine, in paintings he did in the Bavarian Alps in 1933-34, and on his third trip to Gloucester, in 1936, and it was only then that he began to feel he was ready to take on a large, roomy subject. Without sacrificing what for him was an essential idea, that he was decorating a flat surface, he found a way to depict solid forms and natural gravity. All his life he called himself a colorist, never a draftsman, yet it was only when he began visualizing form in sculptural planes, set off in black and white, that his painting became dense and heavy in feeling. He had used black and white as colors in a few of the early Maine landscapes, but it wasn't until "Smelt Brook Falls," "The Old Bars, Dogtown," and "Driftwood on the Bagaduce," among others, all paintings done in the late thirties, that he began to

dramatize black against white as the chief image of the picture, with green, blue, gray, tan, brown and pink functioning as removed, back-up colors. Before he had made paintings like these, no single works had so fully expressed his own contradictory character—his solemnity and delicacy, his stiff, aloof and impersonal manner, and his love of effusive, operatic, extravagant gestures.*

The last turning point in his life was his trip to Nova Scotia in the summer of 1936, where he stayed with a lobster fisherman's family, a father, daughter, mother and two sons. Hartley was always less demanding and more appreciative when he was with strangers, especially people he didn't feel he had to be competitive with, and in Nova Scotia he was taken in as a member of the family. During the summer, both sons and a cousin of theirs were drowned. Hartley, deeply shaken, wanted to leave immediately, but he was urged to stay for the funeral services. A few years later, he used his memories of the family for paintings such as "The Lost Felice," "Fishermen's Last Supper," and "Adelard, the Drowned, Master of the Phantom," but his immediate response to the catastrophe was a seascape, "Northern Seascape—Off the Banks," which is less a memorial for the drowned men (which is what "The Lost Felice" is) than a sprig of flowers to be placed on their graves.

Whether he deliberately intended to recall Ryder, or the

*This is not correct. He made at least two paintings organized around the contrast of black and white much earlier: "Pears," formerly in the collection of Florence and Melville Cane and reproduced in the Museum of Modern Art's 1944 Hartley retrospective catalogue, and "Still Life No. 2," formerly in the Ferdinand Howald collection of the Columbus Gallery of Fine Arts. Both are dated 1913, but were probably done in 1911. "Pears," vaguely related to two Hartley still lifes owned by Paul Rosenfeld and now in the Vassar College Art Gallery, but much stronger than either, easily matches, in its dignity and massive sculptural and erotic presence, any late still life—any late painting. In its black, white, earth colors, reds and apple-green, it has a Spanish cast and could hang, as a work among equals, with the Zurbaráns in the Prado. "Still Life No. 2," a more buoyant picture, uses the white cloth, set on its black background, in a flying, pennant-like way. The painting has the streaming, charging appearance and the decorative lucidity of the German Officer abstractions that followed it. Hartley's career is full of isolated moments such as this still-life one, when he made a few works of peerless beauty and formal control, then—satisfied that he had gone to the heights, or perhaps afraid to push on, or a combination of both feelings—wiped his hands of the matter and moved on to entirely different concerns.

memory of Ryder welled up in him instinctively, "Northern Seascape" is the most Ryder-like painting he had made in twenty-five years, and it is his first in a long series of seascapes. It's different from the early Ryder-like paintings, which are touched with morose, self-pitying gloom; "Northern Seascape" is breezier and rougher and less precious, as Hartley, in his sixties, had become. The rocks and sea are more violent and upsetting than any image he had been capable of earlier, and the soft, consoling, cloudy sky, which takes up the top half of the picture, has a majestic largeness that is new for him, too. Hartley had memorialized Hart Crane's suicide by drowning a few years before, but that painting, for all its anger, is a bit creaky with symbols, and it's painted in a hard, gleaming, unattractive way. Some of Hartley's distaste and fear of Crane's behavior comes through, and it's a harsh, off-putting picture. In Nova Scotia, Hartley was commemorating people he hardly knew and had little in common with, and this released some of the tight wires inside him. His experience in Nova Scotia was awful, but "Northern Seascape" is a spontaneous-looking, instinctively made painting, and Hartley must have felt relieved and, later, even elated. For the first time, he felt he wanted to go to Maine, which he had been so much reminded of when he was in Nova Scotia. "Northern Seascape" shows that he was already living within Ryder's spirit; in the picture, he seems to be looking back on Ryder and thanking him from across the years.

In the late thirties and early forties, Hartley himself was like the clouds in "Northern Seascape." People who knew him in Maine, where he would go in the late spring, and stay until the early fall, felt him swaddled, closed-in on himself; he mumbled and was hard of hearing, and this put the finishing touches on his annoying and baffling way of hanging around people, just to be near them, and then appearing oblivious of them. But as an artist he was freer and more buoyant than he had ever been. Where his earlier landscapes look like limited variations on a few mountain images, and you feel, as an undercurrent, Hartley's anger at his own rigidity, the late landscapes and seascapes, like the late still lifes, are records of astonishingly different moods, colors and

shapes. He found every aspect of life endearing and moving; after years of cautious waiting he even began to do figures and portraits. One of the first, and best, is the "Portrait of Albert Pinkham Ryder." He shows the painter in the rough, light-colored workman's clothes and wool seaman's cap which Ryder wore on those occasions when Hartley, who lived a block away from him, in the West Teens in New York, would see him. Hartley's Ryder peeks out at the world. If his eyes are innocent, shy and withdrawn, and if he seems barely awake, it's because he doesn't have to see much: his vision is so entirely within. Physically massive, he appears to be like his pictures—gliding slowly by, going nowhere, in tune with the largest rhythms of the sea and clouds.

Ryder's imaginative juices stopped flowing almost twenty years before he died; from the turn of the century until his death in 1917, he was lost to the world, a gentle, fumbling, once-visionary figure who could only re-work, and thereby hopelessly ruin, the pictures he had done years before. But when, looking like a 19th-century sea captain, he left his rooms at night, the only hour that he came out, and walked up and down lower 8th Avenue, he was far from a wreck. The large, mysterious content of his art, no longer in his painting, had passed into his body. Hartley saw the young Ryder of the paintings and the old, majestic presence and fell in love with both. Part of the glowing strength of Hartley's late art must have come from his knowing that something of both Ryders had come together in him.

1976

►►►►

Dove

IF IN JOHN MARIN's mind it's always one o'clock in the afternoon on a glitteringly bright day, a world without shadows, and Marsden Hartley is most himself when he conveys the threat and lordly grandeur of the world at night, Arthur Dove (1880-1946) is the painter of the softly radiant, half-buried, in-between times. In the ample, though not exhaustive Dove retrospective, which Barbara Haskell organized for the San Francisco Museum of Art, and which came to the Whitney as the last stop on its tour, many of the images are of overlapping patterns of light and dark. Dove is chiefly after the light, not darkness, but, though there are exceptions, like "Snow and Water," 1928, which is dazzlingly bright, he doesn't depict the presence of light shining forth on its own. His light most often seeps out from behind dark forms; it's a partially hidden, immanent light. Even in "Golden Sunlight," 1937, where bright light should be the subject, it isn't the intensity of pure light that you take away from the picture, it's the dull, absorbent glint of light—sunny warmth being soaked up by space, shrub and earth.

Whether his images recall sails, clouds, waves, animals in a pasture, or they're more abstract, and seem to embody the forces and urges of the natural world, the spirit of Dove's art is like his hidden light: it's shy and tentative, even wistful. And yet, except for the last ten years of his life, when his painting gradually became more thin and washy, there's nothing muffled or fuzzy about Dove. His world seems as if it's underwater, the forms are waiting to come up to the surface air, but Dove himself doesn't flounder underneath feelings he can't fully bring to the surface. Nothing gets between what he wants and what he is able to do. In the photographs Alfred Stieglitz took of him, there's a sweet, feathery look about his eyes, but his closed mouth—a precise,

even line—ends the face firmly. The gentle, withdrawn atmosphere of Dove's paintings comes out of a modest and supple assurance.

Dove's art easily holds your attention for a full floor of the Whitney, but it isn't as intense or complex as Marin's or Hartley's—members, like Dove, of the Stieglitz circle, and, along with Stieglitz, probably his most significant contemporaries. There's a vein of rash, unruly exhibitionism in Marin, and a large, passionate brusqueness in Hartley that takes these artists to levels of feeling that Dove doesn't get to. He doesn't have their many-layered, unrelenting drive, and though he's a warmer, more likeable personality than either of them, and his pictures have more physical presence than Marin's, he's never quite as invigorating or as majestic as either Marin or Hartley can be. There isn't much drama in Dove's mind; he doesn't think about stretching feelings to extremes, he thinks about resolving opposites. He understands the connections and balances between things—the overtones, echoes, shadings, reverberations and glimmerings—more than the things themselves.

In some of the strongest pictures at the Whitney, "Alfie's Delight," 1929, the small "Waterfall," 1925, in the Phillips Collection, "Fields of Grain as Seen from a Train," 1931, "Life Goes On," 1934, "Sea Gull Motif," 1926, and in the wonderful series of pastels from 1911-14, Dove makes light and dark fold back on each other, just the way, with his looping, spongy shapes and arching, circling-back-on-themselves patterns, he makes small forms peer out of large containers. Dove doesn't believe in pure, absolute qualities. He delivers his color already mixed and blended. His pale colors have a gritty, weathered bite to them, and he conceives dark colors as containers—they're there to nestle light ones within them. Unlike Hartley, who saturates forms with black, and makes dark colors dense, permanent-feeling, even chilly, Dove's darkness is more like necessary outer protection—it's warm and it covers the forms like a translucent glove. In many color reproductions, or when his pictures are seen from a distance, his tones congeal; they hover over each other like murky, dank growths. Though some Doves,

like the majestic "Fields of Grain," stand out from any distance, with the majority of them, in order to see the flickering life, you have to get up close.

When Dove's work is at its best, which is from the early teens through the mid-thirties, his shapes are large and they have believable contours (later on the shapes become flat, like playing cards). But even when he draws sculpturally-rounded shapes, he's not satisfied until he creates the sensation that the weight is set free. Dove floats weight. His forms rise or sink or glide in and out of each other, they never take root. In "Alfie's Delight" (which got its name because the painter Alfred Maurer, a close friend of Dove's, loved the painting), the concentric rings, one of which looks like the underside of a mushroom, billow out, and yet they don't seem to be going anywhere, nor is it clear how heavy they are. There's such a weathered lushness to the woody colors in "Alfie's Delight," and the light in it has such an embered sparkle, that it hardly matters that the weight and movement of the shapes are indistinct. But it matters elsewhere, when Dove doesn't paint as vibrantly.

It's always hard to tell whether Dove's forms are empty or dense, and usually you wind up thinking that they occupy a neutralized inbetween zone. Real heaviness or real lightness, like roughness or smoothness, or light and dark on their own, aren't qualities that mean much to him. Marin, for all his crinkly, shallow space, has the gravity of a lightweight. When he sprays his forms out, you feel the airy suspension, and when the markings sag in the lower center, you feel the pile-up. Marin balances the elements of nature against each other, and the balance is precarious, taut and witty—he gets every part up on its toes. Dove's world is so drowsily graceful, the object and its atmosphere have been so puréed together, that there is no balance or weight to feel.

It's not as if Dove disembodies or theorizes solid forms out of existence, it's that he catches the balances in nature even before they've fully come into being. His instincts are so sharp that he has an answer for you even before you have fully enunciated the question. What would be a blink for most of us is an eyeful for

him. He doesn't give the contradictions in every experience a chance to develop, and it's this temperamental quickness that enables him, in his best pictures, to make something real out of a floating, insubstantial aura. It's also what reduces many of his pictures to a baby-food softness. He doesn't rub out the distinctions, he's oblivious of them to begin with.

If Dove is a nature visionary—and that might explain his weightless lift and hallucinatory mood—he is a unique one. Was there ever a visionary of the budding moment of vision—that still-cold split-second before things get warmed up? Dove expresses the adolescent, waking-up strength of things; Paul Rosenfeld, in his essay on Dove in *Port of New York*, 1924, which is still the most perceptive piece on the painter, called him a "cub." Dove's rounded, pointy, undulant shapes have an about-to-be peppy, though still vaguely sluggish, inner tempo. They always appear to be in the process of becoming more complete, mature versions of themselves. Their tugging movements remind you of foggy, barely awake actions like yawning, blinking, stretching, throwing off the sheets and blankets. Artists such as Klee and Dubuffet have taken a child's view of drawing—and experience—and worked back from it; they've used children's perceptions to make ironic, double-sided art. Dove doesn't get behind the moment of adolescent awakening and play with it: he's too much inside it to be able to reflect on it. His art embodies it. Like the other figures in the Stieglitz circle, he is too fervent a believer in nature's beauty and sexual beauty to have the extra energy for irony. Dove saves the irony for his life, not his art. There's no edge between what he knows and what he depicts (whereas with Dubuffet the edge is the whole point). Dove isn't conscious of what he's leaving out.

One of the most poetically significant events in Dove's biography is his resignation, at the age of twelve, which would have been in 1892, from the Presbyterian church he and his parents belonged to. Barbara Haskell says this was "due apparently to the clergy's refusal to allow an atheist the right to his opinions." That quiet, intent spirit of independence and self-knowledge, and the ability to act on it, never left Dove. He had a realistic,

calm sense of his own stature, and out of it he produced a painting style as serenely deliberative and as independent as he was.

No one has ever painted quite like Dove. His manner might not be able to record a great range of feeling. It isn't built for glamour or emotional intensity—it has no sheen (it doesn't reflect light, it absorbs it), and it can't sustain its mood in a roughened-out state. But there is a tart, fibrous individuality to it. Reminiscent of damp fur or the peach-fuzz beard on teenagers in the period just before they begin shaving, the brushy style personifies all the moisture and stickiness in oil painting. His surface is so alive-looking, and so raw, it seems as if it's capable of growing another coat on its own. Dove separates his brushstrokes with a childlike concentrativeness, lines them up in neat bands, and sends them off side by side. The conception answers his need with a classic simplicity and directness. How better, and how more literally, could he have painted the effect of fog horns or spreading sunlight?

Dove makes his art, which depicts the ephemeral, as physically present and object-like as possible, and the strongest paintings have a woven, carpentered and constructed appearance. It was inevitable that he would make collages and assemblages. They're the natural extension of what he was doing in paint, and his are delightful. They're as precious and delicate as Cornell, and they don't have any of Cornell's fussy, knick-knack side. Dove's feeling is broader. The collages show Dove's instinctive ability to animate objects—among those he uses are steel wool, clock springs, twigs, hair and shells. But the unity of different odd materials doesn't add up to any special tension. It's impossible to get around their toy-like, happy mood. When Dove paints, something more happens. His desire to get that up-front, tangible realness intersects with a more neutral material and the pressure brings out more of his feeling. And in the collages he rarely gets his filtered light, his most personal quality.

Dove's life story, sketched in somewhat dryly by Barbara Haskell (it's told with a little more flavor by Frederick S. Wight in his book-length essay *Arthur G. Dove*, which accompanied the

1958 Berkeley retrospective), is of unrelenting physical and mental trials and misfortunes, almost nothing of which comes out in his work. Though his family sent him through Hobart College, in Geneva, New York, where they had come to live, and, later, to Cornell, his father begrudged his son's desire to be a painter (he wanted him to be a lawyer), and Dove fought uphill all the rest of the way. Like Hartley, he lived almost entirely off his art, and while he was lucky in having the support and encouragement of Stieglitz, O'Keeffe, Duncan Phillips and Paul Rosenfeld, for most of his career his prices were low and his sales were terrible. It's hard to imagine him even having the full-fledged career he had without Stieglitz's persistence in showing him. Money only began to come in at the very end, when the checks, nice as they were, didn't really matter.

After college, Dove drifted into commercial illustrating and cartooning but, though this work paid for his only trip to Europe, in 1907-9, he realized that it would kill all the energy he needed for his own painting, and he was right, as he never became prolific. He dropped it, and, always made restless by city life, he was, by 1910, muddling through as a chicken farmer, with a wife and child, in Westport, Connecticut. In 1920, he split off from his wife (who died in 1929 without having given him the divorce he wanted), and spent the next thirteen years either living on a boat on Long Island Sound or, if he and the painter Helen Torr, who had been living with him since 1920, were able to, they'd caretake, for the winters, in yacht clubs or big houses on the Sound.

In 1933, he and Torr, now his wife, moved back to Geneva, where he attempted to manage the almost bankrupt family properties. At first, he began farming again, but that went nowhere, and he wasn't too successful in selling much of the family land. He expected to have to be in Geneva for a year, but he was there until 1938, when he finally decided that if he stayed any longer he would be crushed by the life of rural, small town upstate New York. Dove and Torr moved back to Long Island for the last eight years of his life, living in a one-room abandoned post office in Centerport. Shortly after moving in, they were hit

by a hurricane, not the first physical catastrophe he and his wife had lived through. "The trees all missed us but one that went through the roof. Water to our waists," Haskell quotes Dove, writing to Stieglitz.

Like one of Thornton Wilder's small town omniscient doctors or the character John Ashley in *The Eighth Day*, Dove is a mild-mannered fatalist, an ordinary man with the friendly confidence of a seer. Every setback, frustration and annoyance is recounted with a shoulder-shrugging irony; he turns his lack of good fortune into a mild, lightly important joke. To preserve his vision, Dove let a great deal of reality slip off him. Always living in some ramshackle, uncomfortable, often cold and wet and temporary situation, he could only imagine images of cozy, organically meshed relationships. His language, in his letters and as a painter, isn't geared to expressing the loose, dangling ends of his life, and none of his forms dangle, either—they're always safely tucked in.

The white areas representing snow in "Cars in Sleet Storm," 1925, and floating foam in "Waterfall" appear to be icy cold, and there's a suggestion that they could melt right out of Dove's world. But the fragility and preciousness, even the slipperyness, of forms in nature never amount to more than a whiff of feeling. Nothing breaks out of his healthy, even-tempered glow, and this makes you restless with his art, for all its sleepy, fragrant beauty.

Dove's early and middle paintings are saturated with a mellowed luminosity, but his late work doesn't have the texture of mellowness—it's only mild. He was ill for many of his last years, and perhaps this has something to do with the slackening off of his work. There aren't many strong pictures after 1935. Based on the pictures at the Whitney, his turning point is "Flour Mill II," 1938, one of his best-known works. It has a unified pale yellow ground which, as in Oriental painting, is ambiguously either deep space or a neutral flat backboard; placed on it are black, green, yellow and earth markings. "Flour Mill" is a lovely, elegant painting (it looks like a chunky version of the langorous stain paintings of the fifties and sixties), but there is no elegance in Dove's soul, or at least there isn't enough of it to make this

more than a one-shot deal, a beautiful stranger in his work. Dove's touch isn't made for decorating a surface. Marin can glance off ground and make space even as he glances, but Dove isn't convincing when his forms are as unanchored as they are in "Flour Mill." He needs his fur-lined crevices. That's where his burrowed-in life is.

In the late paintings, he returns to his embracing, dark webbings but, from the time of "Flour Mill" on, he rarely goes back to his furry gradations. He doesn't describe the elements in shadowed low relief; there's no light-to-dark modeling in the late work. All the shifts take place in a thin, sloshy zone just behind the surface.

"Flour Mill," though it's in the exhibition, isn't illustrated in the catalogue, but practically every other work is, and in color, too. The catalogue is peculiar in other respects: the paintings aren't illustrated chronologically but, after the late twenties, they're placed randomly, as if Dove's work were all of a piece, which it isn't (Frederick Wight made the same mistake). There is no index in Haskell's book, and no catalogue listing of the exhibition, though there is an elaborate year-by-year chart that aligns Dove's "Personal Events" with "Historical Events," so that you can check out, along with the details of Dove's life, such dates as when, picking at random, the NAACP was founded (1909), Lenin died (1924), the Dionne quintuplets were born (1934), Hahn and Strassman split the uranium atom (1938) and Mondrian arrived in New York (same year). It's interesting to get all this, but it's a little wacky, since Dove's art takes place outside of world history and art history.

Dove succeeded on his own terms but he could never have won by the world's standards. He didn't make art for the museums, and it's a sign of the strength of his character that his painting is still fresh, and still looks homemade and out of place in the company of, say, Hartley, Davis, Rothko or the Europeans. Dove's scruffy awkwardness is his special bloom.

Ambition made Marin and Hartley go further in their work, but ambition didn't faze Dove. The life of art (and its own rewards) wasn't in his blood. After a certain point in his early

thirties, his experience didn't deepen as he made his paintings. Dove's temperament was poetic and philosophic. It's the kind of temperament that makes you feel he might have been able to feel complete and fulfilled as a person even if he hadn't made art. With his typically understated, comradely affection, he once wrote to Stieglitz, "Hope you are working hard. That seems to be one of the few roads to gladness."* Always clear about his own goals, Dove chose exactly the right word for himself. Gladness is what his pictures give. When he is most forceful— when he is at his deepest level—he's in the middle register of feeling, and he invented a style to express that middleness of feeling. His art might give only a small cup of emotion, but he fills it to the brim. Though you can't be in awe of him, it's hard not to be fond of him.

1976

▶▶▶▶

Little Big Sculpture

THE REDUCED, BLOCKY SCULPTURE Joel Shapiro showed at the Paula Cooper Gallery last fall has the look of Minimal art, but it's a Minimal art clouded over with messier, less predictable feelings. Shapiro removes the shiny, immaculate beauty, the gray philosophy and the aristocratic grandness from Minimal sculpture and gives it a punchy strength. He doesn't have Donald Judd's elegant taste—he couldn't make a piece either as physically stunning or as emotionally standoffish as a Judd—and he doesn't have Carl Andre's intellectual clarity or Tony Smith's

*Quotation used by permission of William Dove and Georgia O'Keeffe for the Alfred Stieglitz Archive, Collection of American Literature, Beinecke Rare Book and Manuscript Library, Yale University.

massive dignity. Though it's heavyset and massive in scale, Shapiro's work doesn't have the assurance of heavyset things. This sculpture isn't wrapped in the certainty of its own strength and beauty—it's defensive and scrappy. It has the spirit of something that's under seige and has a snarl in it, too.

Shapiro, who is thirty-five and has been showing since 1969, is best known for the plain and simple objects, all extraordinarily small in size (some no more than 4 inches high), that he has been making for roughly the past five years. Working in the early seventies somewhat in the style of Eva Hesse, he was interested in sculpture that represented only a gesture of the hand— sculpture where, in his version of it, a row of fired porcelain sticks, or a pile of potato-like wood carvings, set out on the counter or the floor, might be the result. "Process" art such as this often produced raw, unfinished pieces, but Shapiro's were stiff and formal—they had a prim, neatly collected appearance. Around the end of 1972, he began to make representational sculpture. He picked such objects as a coffin, a bridge, a chair, a horse, a ladder, objects full of connotations, and then muffled those connotations with the tiny size of the pieces and the severely simple and anonymous treatment. Shifting about in a variety of styles and mixing them as he goes, Shapiro works at an angle from everybody else, as he's doing now, with sculpture that resembles Minimal art. He has a competitive interest in contemporary styles and is competitive with past art, too. But he isn't the kind of eclectic artist who, like, say, Elie Nadelman, looks at other styles because he believes in a tradition and wants to make his own alterations to that tradition. Shapiro is more like the young Giacometti: looking continually and restlessly at other art, he pulls out what he needs, leaves his imprint on it, then goes on to the next source. What stays distinctive and constant, what ties up the different phases, is his expressive tone. Shapiro's instinct is to seal up itchy and explosive feelings with a mute, impassive coating. Right now, the stripped-to-the-bone spirit of Minimal art gives him the coating he needs.

Most of the sculpture Shapiro showed in October was in a matte, gray-black cast iron, though some iron pieces had a shiny,

light finish, and one work was in bronze. Although a few of the pieces, which are roughly 6 to 8 inches high, had plaster or wood pedestals, and two of the pieces were mounted on projections from the wall, most of the sculpture was placed on the floor. At any distance, the exhibition looked like so many squat, dark blocks. From the dates of the pieces, which were made in 1974 and 1975, Shapiro has been moving from recognizable images (in this case houses) to more abstract forms. His houses are primitive, windowless and doorless boxes, similar to children's block toys. He also showed houses that are more geometrically simplified than the toy-like ones. The most recent pieces, and the ones closest in feeling to Minimal art, are variations on open-top boxes. These three types of form relate like distant cousins— each has a different outer appearance but they share the same blood.

Although Shapiro wants a blunt and primitive (and inexpensive) look to his sculpture, he gets his effects by playing off one delicately modulated—at first barely noticeable—detail against another. In the cast iron "Untitled," 1974-75, a 3¼-inch-high house is at the wall-end of a bar 29¼ inches long and 2¼ inches wide which, sitting on a wood shelf, projects out at the viewer at chest level. It looks like a house with a driveway that's too long for it. Shapiro slips his contradictions over so quietly that at first all you feel is "Something is wrong here, but what?" The projecting bar is bristling and rectangular and taut, but the house seems to have walked in from another sculpture—it bulges slightly on top and caves in from the front. (It takes a while to realize that you're seeing the house in reverse perspective; however, that's a label, not an explanation.) Shapiro pitches the two elements in the piece against each other, then he pitches the whole piece against the viewer: house and bar together stick out from the wall like a rifle. Then he undermines the tension by placing the dark, lethal-looking iron sculpture on a neutral, innocuous, simply-made wood shelf.

Some artists achieve a harmonious, complete balance, a new sense of unity, when opposites are pulled taut. Shapiro isn't after new unities. He feels the disunities. When he brings together

elements such as the slumpy house with the slender bar, or the whole piece with its pedestal, he can only show them holding each other off (even as he also shows how one would be incomplete without the other). In his art, he's like a man who's most alive when he can turn a scene into a confrontation. It can be obnoxious and ugly to expose every possible tension, yet Shapiro's effect isn't ugly. Possibly this happens because, in the confrontations he sets up, you feel he's sympathetic with both sides. He's able to position himself with what is threatened and with what is threatening, and this gives his work an unexpected emotional undertow. His ambivalence comes across more clearly in the representational sculpture and in the house pieces he did in 1974 and 1975 than it does in the very recent boxes, though it's there too. Sitting on the gallery floor, the 3-inch-high bronze chair, say, which he showed at Paula Cooper in 1974, radiates belligerence. It's so tiny, and it's such a bland, generalized image of a chair, that it mocks the space it's placed in, and you feel it's meant to do that. And somehow, the fact that it doesn't have to be a chair to get this effect, that it could be a table, makes it doubly offensive. But if space revolves around the object, space also threatens it. The size of the piece, and its position on the floor, make us both antagonistic and sympathetic toward it, and we can't separate our feelings. In the house and bar piece, the bar aggressively pushes the viewer off, yet that bar also emphasizes the vulnerability of the house it protects.

The house and bar piece, though, is significantly different from Shapiro's earlier sculpture. It doesn't need great space in order to make its point. All the tensions it generates are built into it. It has the same impact wherever it's shown, and this self-contained drama is what Shapiro is after right now, in the more simplified houses and in the boxes. Heftier in appearance, they can't seem beleaguered. One of the best is a half-box, a 7-by-7 1/8-by-7-inch near-cube, from which a small rectangular volume has been removed (it looks like Le Corbusier's Grand Confort club chair). Heavyset and physically imposing as it is, it's still uneasy at heart. It doesn't preside over the space it's set in, the way a Tony Smith black cube would. Working here and in similar

pieces with abstract shapes and chunkier proportions, Shapiro adds a darker, more solemn and rumbling overtone to his drama.

All Shapiro's sculpture implies human gesture, so it's not surprising that, in a series of etchings made in 1975, he's finally drawn the figure. Shapiro's figures are to human beings what his houses are to architecture—they're tiny, jack-in-the-box monsters. In one etching, a man thrusts out both arms (each of which is like the projecting arm of the house and bar piece) at the face of a woman who's standing next to him. Her arms fly up and her hair, horrified on its own accord, shoots straight off her head. Though he's poking her, there is so much character and personality in both of their puppet-like vaudeville gestures, and in her hair and massive skirt and klutzy high heels, that the brutality of the subject evaporates and we're left with black comedy. Though they seem to have been done casually, as an off-the-cuff experiment, Shapiro's prints are wonderful. The childlike crudeness— and delicacy—of the drawing recalls Chagall, though the feelings are more violent. They condense the edgy, witty, still growing vitality of his art.

1976

▶▶▶▶

Indignant Max Weber

HENRY McBRIDE WAS characteristically generous in his criticism, but when he came around to appreciating Max Weber in 1915 and again in the twenties, he laid it on extra thick. McBride wrote from the point of view that the painter was neglected and needed a boost, and he was right to salute Weber's talent and ask people to be more attentive. Few American artists have been as devoted to art and as energetic as Weber, and few have had to

face as hostile a press and public in their early years. McBride hoped that, if there were no private collectors ready for Weber, perhaps the museums would come through, and this did happen. Weber's first great patron was the Newark Museum, and he was eventually given retrospectives by the Museum of Modern Art in 1930 (the first retrospective given to a living American by the then one-year-old Modern) and the Whitney in 1949. Sales picked up, too, though slowly; it was only in the last decades of his life that he and his family were able to live comfortably off his work. But Weber never became a popular figure, and it's difficult to imagine his wanting popularity or being creatively encouraged by it. An Orthodox Jew and a man who prided himself on the ethical principles he lived by, he approached art as if it were both a sacred duty and a dignified, time-honored skilled trade, like masonry or carpentry. In his thinking, fame would have been a cheap, morally ugly reward.

In his forties, Weber deliberately broke with the New York art world and went into exile in the suburbs. He claimed to be indifferent to the values of progressive art, and he was pleased to act as a family-minded bourgeois householder; yet he wasn't a happy recluse. He always had one eye open to the world he had left; he never forgave his audience for its treatment of him. On the first page of *Max Weber*, the best parts of which are the details about the artist's character, Alfred Werner describes his subject as a man who couldn't forget a hurt. Finding the snubs easier to remember than the tributes, Weber was energized by believing that the world was against him, and what he imagined came true. Living in the Long Island town of Great Neck from the late twenties until his death in 1961, at eighty, Weber became less and less a presence, for the art world and the non-art public (though he participated in a few affairs, like art jurying, and was interviewed and given honorary degrees). He didn't have the satisfaction in his old age—would he have wanted it?—of having younger artists look at and talk about his work.

Fifteen years after his death, Weber is still hardly looked at. Next to contemporaries of his such as Hartley, Hopper, Davis and Dove, painters whose work people do want to see more of

today, Weber is a figure whose importance is sealed up inside art history. In Europe from 1905 to the end of 1908, he came back to New York and, in the teens, took up then current and risky styles with great seriousness. He was conscientious about everything he did, and as a young man he was an ardent believer in the Spirit of Modernism. Appearing, at different times, as a Rousseau-like primitive, a Fauve and a Futurist, Weber gradually developed the most full-fledged Cubist style (more accurately, it's a Futurist-Cubist style) of any American painter. By the early twenties, though, like other artists in Europe and America, including Derain and Hartley, he had soured on the experimental side of modern art. With the enthusiasm of someone who feels he has to re-educate himself, he turned, as Derain and Hartley had also done, to an Old Master-inspired representational manner. Typically, he became as devoted to the glory and wisdom of past art as he had earlier been to modern experimentation. In his later pronouncements, and in interviews, he distances himself from the hectic, buoyant days in Paris before the War, and yet Weber, from his contacts and the evidence of his paintings, sculpture and prints, ate up the atmosphere of that time and place. He always wanted to reminisce about his great friend Henri Rousseau, at whose soirées Weber would sing (he was a tenor), and who gave him his farewell-to-Paris party. But toward Picasso, Matisse, the Steins and the mood of change and newness that they represented, he was snappish.

Weber thought that his figurative style from the twenties on was the fulfillment of his career, yet it's far less alive than the semi-abstract work he did in the teens, and those paintings aren't so vibrant now, either. The problem with much of the early work, especially when it was large and ambitious, is that it's too studiously thought out; the pictures look more like illustrations of current art styles than paintings on their own, and the subject matter of many of them, the commotion of city life, is a deadweight, clichéd image to start with. But if pictures such as "Rush Hour, New York," 1915, affect us as slightly dated period creations, the august, grand-manner representational style which followed is prematurely aged. You can't imagine in what

era this painting, which has the appearance of runny, mottled Cézanne, would have seemed new. Trying to make art out of his veneration of the past, Weber got swamped in it: he doesn't rejuvenate the look of the Old Masters, that look devitalizes him. Although he is never calculating or insincere, too often his pictures make you question what, if anything, there is in them that fascinates him. The air of studio exercises, something unseen and unfelt, hangs over these idylls of reclining nudes and people conferring in bourgeois interiors. You never feel about this make-believe world, as you do about Walkowitz's Coney Island strollers or even Arthur B. Davies' prancing forest maidens, "This is what he wants life to look like." You feel "This is what he believes art looks like."

Alfred Werner knows that Weber is no longer fashionable and, although he doesn't have enough room for a full portrait—his essay is only forty-odd pages in what is essentially a picture book, a relatively clear-cut, unostentatious-looking one, with good color plates—he makes it seem in the beginning as if he is going to bring his subject out of mothballs. He spots a few flaws in his subject's character, and he fills in new factual information about Weber's rigidly scheduled working habits, his pious attitude toward art, his working-class background (and his pride in it) and his removed and severe public manner, all of which is revealing. You put down the essay feeling that you've come closer to understanding why Max Weber's art is limited, and how his strengths were diverted. But you do this on your own, without the help of the author. After presenting very alive biographical material, Werner doesn't see any ramifications to that material. He's reluctant to make connections between an artist's character and his work. There is something awful, even frightening, about Max Weber's arrogance and independence; he had real gifts, and enough drive for, say, three Charles Demuths, yet his values and attitudes outran his talent. His story, if treated sympathetically, is a tragedy: he was a man done in by his aspirations. Alfred Werner believes himself to be sympathetic, but the kind of sympathy he gives out—a make-nice variety of praise, with no jagged edges showing—hurts Weber more than it

helps. Dealing with Weber's art and stature, Werner's writing isn't much more penetrating than a gallery hand-out. How far can you go with a conclusion as polite and bland as this: "Weber's work should, then, be appreciated without any undue recourse to history or sociology. His pictures exist as sources of joy and pleasure, and as documents in man's struggle for a higher existence"?

Weber would have approved both this judgment and its language. He thought in exactly the same way, though his prose doesn't leave the gooey aftertaste Werner's does. In the essays he produced throughout his lifetime (none of which are reprinted in the Werner volume, although a number of them are available elsewhere), Weber doesn't merely write about art, he pontificates about the Higher Ineffables, and reading him for more than a page at a time is a trial. He deals with only the loftiest, most noble feelings, and his style, which might be called Institutional-Spiritual, is the creation of a man who yearns for a dignified, authoritative, philosophical tone and patches such a tone together from the speeches and sermons he's heard and the books and editorials he's read. The aphoristic remarks about harmony, beauty and purity are much too cloudy to remember, but there's an ungiving and belligerent layer underneath them, and that sticks in your mind. Weber writes from the attitude of someone who already knows the truth; he gives the reader the impression he's safe inside it. He tells you that real creativity is hard and rare, though he never makes it seem as if it had ever been hard or rare for him. Reading him makes real what Werner calls his "deplorable combativeness." Weber is as obsessed with vilifying the inauthentic stuff as he is in praising the authentic, and when he hands out a word of wisdom he has a way of making it sound like a threat. In his universe, there is true art expression and then there is its unfeeling, unspiritual imitation, which he is repulsed by—though he doesn't say what it is. (Weber mentions few names, which only adds to the airlessness of his writing. There are the Greeks, and Cézanne, the one modern artist he shows respect for; but for the most part, he must have felt he was "above" personality.) Harsh and judgmental as he sounds, how-

ever, Weber isn't totally offensive. The moralistic tone is impossible to identify with, yet you can see how much he needs it. He clutches at it. Although he has adopted the voice of a public speaker, he's talking to himself. He is convincing himself that being an artist is a calling, and that making art is ennobling work.

In an interview, Weber once said, "Cézanne taught me piety and reverence." But you feel that if it hadn't been Cézanne, it would have been someone else: Weber was keeping a sharp lookout for piety and reverence. (Naturally, he was blind to Cézanne's frustration.) Like many Jews in the visual arts in the beginning of the 20th century, he was a man in a world his background didn't prepare him for, and one way he justified being an artist was by giving art credit for more than art can do. He liked to say that his studio was his synagogue, and Werner describes how he "shaved and dressed carefully as a mark of respect to his work." There was no potchkeeing around for Weber. But that's not quite the same as saying he was all business. He never developed a professional ease about his work, and he was incapable of looking at other art in a professional manner. Art either had to be a book of wisdom one could never stop learning from, or else it was "modern" and therefore trash, and had to be dismissed. Aside from his own house, the only place Weber ever felt at home was the museum, and when he went to the Metropolitan (sometimes in the company of the sculptor William Zorach, the one artist he remained close to throughout his life), he never presumed to be among his peers. At the museum, he was an adoring schoolboy, looking up at his teachers. Perhaps his art is tired and impersonal because his most direct, spontaneous feelings went into his trust of other art. Not daring to call himself a professional, which would have meant acknowledging that he was as good as many of the people hanging at the Metropolitan, and which would have allowed him to be indifferent to much of what he saw, he used up his creative impulses in his "piety and reverence." Though he poured out great feeling in his studio, that feeling was already a leftover, not a fresh response.

This exaltation of art, and the humble, studious approach to it, was common among many transplanted East European Jews. Not only Weber (who was born in Bialystok, Russia, in 1881 and came to Brooklyn with his parents in 1891), but Berenson, Nadelman, Lipchitz and Jacob Epstein—all went to shul in the museum. There were others, though—Pascin, Soutine and Chagall especially—who were the opposite of highbrow, aesthetic and moralistic in their feelings. Less the scholar-artist and more the entertainer- or magician-artist, they had fewer preconceptions about their roles, and their art doesn't have the same built-in museum grandeur. Chagall was never in love with art for its own sake. Before he became conscious of his audience and his feelings petrified into a fuzzy, cottony sweetness, he snatched up radical styles in painting and poetry and made them his own with overnight, unthinking speed. The exact opposite of other, more analytically-minded young foreigners in Paris, Juan Gris and Nadelman in particular, Chagall never stopped long enough to think through what the new Parisian approaches to art meant. In his early, great years, the only thing he believed in was the romance of his own life, and the experimental techniques appeared on the horizon as ways to express his dislocation and his nostalgia. Cubism, with its image of simultaneously intersecting time periods, allowed him to make an art about his memories.

Like Nadelman and Lipchitz, Weber, in his work, ruled out personal memories. He was receptive to abstraction and, later, to Cézanne because he believed that art had no room for the self, and he was on the right track. By instinct, he was an abstract artist, though not a monumental, classical one, as Cézanne came to be; rather, a precious, fanciful, lightweight one. Weber's geometry is the geometry of the doily, the carpet and the teacup handle, not the cube or the cone. He is most alive as a painter when he lets go in the invention of tiny ornamental details, and these are most original in certain works from the teens, especially in smaller paintings, pastels and the lovely 1918 colored woodcuts, which are so muted and delicate that they can be confused with monotypes. In one of his finest pictures, "The Two Musicians," 1917, in the Museum of Modern Art, he starts

off with a typical Cubist shuffling of cards (as usual with him, it sags in the lower center), and then randomly sprays the open spaces with playful abstract signs, patchworks, dots, squiggles, stripes and lozenges. Details in unmixed red, yellow and purple float on a sour green background (a much duller green than in the Werner reproduction), creating the effect of faded embroidery. Chagall also used the canvas more as if it were a tapestry-space than a window-space, and recently Alan Shields, who literally strings beads and sews patches onto the canvas, has been continuing in that curtain tradition. The logical extension of Weber's feeling for floating clusters might have been sewing, too.

You can see why Weber responded to Rousseau's art: his interest in decoration is like a primitive's in painting the object before him. There's a folk-art quality to the fanciful colors and the ornamental shapes in "Two Musicians" and in his great pastel "Lecture at the Metropolitan Museum of Art," 1916, one of the finest of many strong works on paper from this time. As in folk art, while the individual details have an informal, homemade look, the overall tone is serious-minded and expectant. And the wonderfully silly caricatural musicians, with their dainty, thin beards and hairdos, elegant ties and shirt buttons, pointy shoes and fingers, come right up out of the naive geometry of the drawing. Weber couldn't make the traditional subject matter of Cubism or Futurism his own, but he could work around and through these styles, creating arabesque harmonies out of them. Unfortunately, that wasn't enough for him.

In one of the most ironically prophetic scenes in art history, Henri Rousseau, seeing Weber off at the station in Paris in 1908, ran after the train and, tears in his eyes, shouted to Weber never to forget "nature"—"*N'oubliez pas la Nature, Weber.*" Weber told this story and another, less dramatic and more poetic one, about how, watching Rousseau paint, he asked the Douanier why there was a sprig of leaves entwined around the thumb that held the palette and why, since there was no greenery at all in the picture being painted, Rousseau kept looking down at it. Rousseau replied that periodically it was always necessary to study nature. It's possible Rousseau might have been thinking only of

literal, outdoor nature, which Weber, then turning into an abstractionist, was ignoring. That's how Werner interprets the story. Yet Rousseau, as his painting shows, gave everything an enhanced, allegorical edge. Could he have meant nature in the widest sense? Did he believe that Weber was in danger of forgetting basic feelings?

As he withdrew into himself in his mid-thirties, Weber increasingly did forget his own nature. He wanted a reflective and sensuous art, a symbolic realism with the depth of Tintoretto, Cézanne and Rembrandt, though nothing could have been more out of his range or less suited to his character. Werner remarks that "From the Expressionist turbulence in his works, one might have expected clutter and confusion in his studio, but it was as neat as his person." Of course his studio was neat. Beginning in the early twenties and continuing until the end, neatness is crying to come out of the dishwater-thin "Expressionist" surfaces of his painting. You want him to drop the turbulence and the solemnity and be more himself—more tight, more artificial, more fastidious. Weber couldn't get anywhere with his Old Master style because, unlike Rembrandt or Tintoretto, he didn't allow his knowledge of the world to interfere with his art. He lived in an ivory tower of pure thought, and his self-righteousness turned the tower into a fortress. No new experience could dent it. His landscapes are unconvincing, except as stage sets, because he is insensitive to nature's light; he has only the vaguest interest in nature's forms. "Pleasures of Summer," 1934, looks as though it's taking place in a snowstorm, and this basic confusion, for the viewer, over what's happening is typical. He can't convey the physical sensation of being outdoors or indoors. More depressing is that, for the kind of painter he wanted to be, he had no interest in people. Presenting a distinct, psychologically compelling personality is beyond him, and the closest he can come to animating the figure is caricature. And while caricature suits the Cubist pictures, and is how he must have understood people best anyway, it is insufficient and awkward in the timeless settings of the later work. Not knowing what to make of his giggly, loose-limbed, dead-eyed figures, especially the gesticu-

lating Jews that he painted more and more often, Weber's audience could legitimately wonder whether his pictures were parodies.

Lloyd Goodrich says that when, in the late forties, Weber was asked if his Jews were comic caricatures, the painter "vehemently" denied the possibility, and you can feel how crushed and confused and angry he must have been to face such a question. All his life he had dreamt of a noble, distinguished style, and he was proud to make his own people his great subject. But Weber had never been conscious of how he or his worked affected other people. The combination of lofty idealism and innocence sealed him off. He would have been the last to see that his own work came close to parodying the art he worshipped.

1976

▶▶▶▶

When New York Went to New Mexico

LEO STEIN, ALWAYS READY to announce when he was in the presence of significant aesthetic connections, took in the mountainous terrain of northern New Mexico and felt it could only be compared to the deep, majestic landscape of Chinese art. He was out there in 1918, spending much time off by himself, hoping that perhaps, in the high altitudes, he could save what was left of his hearing. By then, Stein was already in his well-known anti-contemporary phase, which would last for the rest of his life. He had been intensely involved with modern art for a while, began to mistrust it, and finally pulled out completely, thinking his whole period was askew. Yet in his spontaneous admiration for New Mexico he was totally a part of his time.

Painters, novelists, poets and critics were all discovering the town of Taos, the small city of Santa Fe and the surrounding valleys and ranges in the years after the First World War. They were attracted to it the way advanced French artists were attracted to Brittany in the eighteen-eighties. On the surface, it was primitive and raw. In the mid-twenties, there were still no streetlights in Santa Fe and the roads were unpaved and in Taos, according to Ward Lockwood, there was no electric power, sewerage or water systems. And yet behind the rawness was a mixed Spanish and Indian culture that gave the place a settled, soaked-in, ancient quality. The music critic Paul Rosenfeld spent the summer of 1926 in Santa Fe and found it "charming" and "foolish," a perfect setting for comic opera—a tiny, unreal pink and tan hill city that looked and felt more as if it belonged in Spain or Italy. For Stein, Rosenfeld and many others, northern New Mexico, with its delicate, toy-like towns and romantically wild canyons, was a relief from the sporty, unhinged, car-oriented world of post-war America.

For painters especially it seemed, at first sight, to be too much. Nearly everyone who has left any record of his impressions was overwhelmed by the silent, wide-awake landscape, with its incredible range of saturated colors, by what Marsden Hartley, who was out there at the same time as Stein, called the "solid-ness" of its forms and the serene, steady "bigness" of its mood. In the 7,000 to 8,000 foot altitudes of the Sangre de Cristo Range, where Santa Fe and Taos are both situated (Taos being some sixty miles north of Santa Fe on the flat map), the air seemed to be magically clear. Van Wyck Brooks, in his biography of John Sloan, described the limpid spaciousness many painters felt: the "atmosphere in this high altitude was transparent and light so that one felt the reality of things in the distance." Paul Rosenfeld wrote back that traveling in the area made you feel as if you had gone through a fire without becoming hot. In the thick blue shadows of the adobe houses and inside them, Rosenfeld said, it was always cool, and the empty, bodiless air made you buoyed up for work and also intensely tired, though it took a while to coordinate the two.

From the mid-teens to the late twenties, when the Taos-Santa Fe belt was in its heyday, it was visited by artists of every camp, avant-garde and conservative, figures associated with Alfred Stieglitz—Hartley, Georgia O'Keeffe, John Marin, Paul and Rebecca Strand—and with Robert Henri, and independents, such as Paul Burlin. Henri, who went to Santa Fe in 1916 in search of unusual portrait types, was the first serious artist in the area. He encouraged George Bellows, Leon Kroll and John Sloan to follow, and Sloan, subsequently changing his summer address from Gloucester to Santa Fe, in turn invited out the twenty-nine-year-old Stuart Davis, a professional painter over a decade by then, who spent the summer of 1923 there. And Edward Hopper—who was, along with Davis, Henri's greatest pupil—drove out in the summer of 1925.

Of course, before New York started to make summer visits, northern New Mexico was already a budding art community. As Van Deren Coke, the area's leading art historian, has described it, the spot first attracted artists in the late 19th century, when Bert Phillips and Ernest Blumenschein "stopped there on a western sketching trip," and later returned to settle down. In their wake came the well-known Frederic Remington and the relatively unknown Oscar Berninghaus, Irving Couse, "Buck" Dunton, Frank Sauerwein, Victor Higgins and Walter Ufer. Many of these men were academically trained, in New York and/or Paris, had taught in schools themselves, and had done newspaper and magazine illustration.

Like much art that is based on a trained sense of design, their paintings are often striking in black and white reproduction and tend to fizzle out when seen in the flesh. Nearly all of them painted a solemn, studious Indianized landscape, and a few even had extra-artistic ties to the Indian community. To most outsiders, though, the strongest ties of these painters were to themselves as a group. They, and the succeeding generation of almost-illustrators, almost-serious painters who lived out there formed the quintessential, joked-about, to-be-avoided art colony. Everyone, New York artists especially, enjoyed making witty cracks about how lousy the local artists were. They gave

the area one part of its touristy picturesqueness; the other part came later, toward the end of the twenties, when the original natives of the region were inundated by the nouveaux natives. When Edmund Wilson, passing through northern New Mexico in 1930, gathering material for what would become *The American Jitters*, visited Taos and Santa Fe, he told Christian Gauss he encountered an "extraordinary population of rich people, writers and artists who pose as Indians, cowboys, prospectors, desperadoes, Mexicans and other nearly extinct species."

What Wilson was talking about was a tonier, faster, more sophisticated crowd than the one represented by the square Berninghaus-Blumenschein types, and this crowd was best personified by the wealthy, artistically and socially voracious Mabel Dodge (née Ganson). Whether it was the Steins, Stieglitz, John Reed, Thornton Wilder, Gide, D. H. Lawrence, A. A. Brill or Walter Lippmann, Mabel Dodge wanted to be in an intimate—or at least confidential—relationship with the top creative people of her time. Her autobiography comes in four large volumes. With Mabel Dodge, who arrived in 1917, the Taos community was transformed from an outpost for commercial artists into a busier, livelier, and, if possible, a more colorful, oasis. She brought out what Rosenfeld labeled the Greenwich Village possibilities of the place, and her Bohemian spirit spread out to cover Santa Fe, too. Mabel's going to New Mexico was a product of her emotionally and geographically demanding relationship with the artist Maurice Sterne. Sterne's physically big, dark, Russian-Jewish, Oriental-langorous presence magnetized Mabel, yet those same qualities became awkward and annoying when the two of them were in the company of Mabel's friends, which was most of the time. It became clear that she was more comfortable if Maurice was nearby rather than actually with her, and before they eventually married, an event which apparently took both of them by surprise, they played musical chairs all over Westchester, Provincetown, Monhegan Island and Ogunquit, Maine, with, during this same time, Maurice being sent out for miserable short work vacations in Pottsville, Pennsylvania and Cody, Wyoming, places from which he wrote Mabel telling

her that he loved her, and asking her exactly what was wrong, and, more importantly, what was he doing out here?

The way Mabel tells it, it came to her one day, with Maurice getting on her nerves again, to send him to the Southwest. "I've heard there are wonderful things to paint," she mused. "Indians. Maybe you can do something of the same kind as your Bali pictures. . . ." In his version, Maurice says he went to the Southwest at the recommendation of a personal friend, though the point is he went. At first, he hated it. He couldn't paint and he was "repelled" by the Indians. Mabel, however, had gone to see a medium in Brooklyn after Maurice had left, and was told that her future was with dark people, Indians specifically, who needed her for guidance and care, and that one Indian in particular would prove to be Mabel's muse. Shortly after this, Mabel joined Maurice in New Mexico.

After setting up house, she wired some of her New York friends to come see the land and the people she had taken to so instinctively. Within half a year, Andrew Dasburg, Leo Stein, the theater man Robert Edmond Jones and Marsden Hartley followed her out. Though they weren't all literally her guests, many significant and about-to-be-significant figures in the years to come would be. It was Mabel who, reading D. H. Lawrence, invited him, in 1921, to come to New Mexico and live there as her guest and, so she hoped, write about the place (which he did a number of times, in *St. Mawr, Mornings in Mexico* and elsewhere). Eventually she traded her son's ranch, the Flying Heart, to Frieda Lawrence for the manuscript of *Sons and Lovers*, and it was here, at what was rechristened the Lobo, and then the Kiowa, Ranch, that the Lawrences lived on and off until 1925.

Meanwhile, back at the hacienda, Maurice's days with both Mabel and New Mexico were numbered. The Indian inspiration forecast by the Brooklyn medium turned out to be Tony Luhan, a famously silent, well-built Indian of uncertain tribal origin. According to Sterne, Mabel set up a tepee on the lawn of her Taos house, and every night someone on a horse would arrive. Sterne finally had enough and left for New York. In the twenties, he became one of the most highly regarded—and one of the

highest priced—of American artists. For Mabel Dodge, New Mexico became home, and Tony Luhan her fourth, and final, husband.

Yet, with or without Mabel Dodge and the festive atmosphere she created, northern New Mexico was quite a different summer community from Provincetown, Ogunquit or Gloucester, seaside places New York artists were going to at the same time. The Taos-Santa Fe landscape could never be a neutral backdrop for work. It was more a theatrical setting, and so demandingly beautiful that it became an obstacle for many serious painters. Paul Rosenfeld told Stieglitz that the air was so clear that the great distances never really seemed far away. Everything was close-up, and that, somehow, made the land unfluid and unmysterious. For Stuart Davis, it was hard to work there because, as he told James Johnson Sweeney, "the place itself was so interesting. I don't think you could do much work there except in a literal way, because the place is always there in such a dominating way. You always have to look at it. . . . Forms made to order, to imitate. Colors—but I never went there again." His remarks notwithstanding, Davis's few New Mexico paintings made the three or four months he spent out there worthwhile. The richness of the material, combined with his feeling that none of it mattered a great deal to him—that he wasn't face to face with a Stuart Davis landscape but, rather, peeking in on somebody else's—resulted in the most relaxed pictures of his career. Relaxed without being limp. The pressure in them comes from the way the "literal" landscape pushes up against everything Davis knows about how to artificialize the motif. If, in his effort, he came close to making cartoons, they're taut, witty, muscular ones.

Marin had less trouble than Davis, and liked the place enough to spend two summers there, in 1929 and 1930. When he wrote Paul Strand, in the beginning of his stay, that he stumbled one day into an Indian rabbit hunt and was "almost taken for a rabbit," he might have been poeticizing the awkwardness of a foreign place. He was a quick adapter, however, even at fifty-nine. Mabel Dodge, who had invited him out at O'Keeffe's

suggestion, lent him a Ford and he put in many miles. He told Stieglitz that on some mountain tops "you can see six or seven thunderstorms going on at the same time," and this, along with the dance of the San Domingo Indians, which he was over-whelmed by, was the kind of confusion Marin's eye was ripe for. Of all the artists who recorded this place, he is the only one who saw its storms, and his storms are the best of his New Mexico pictures.

The most extraordinary experiences in New Mexico, though, were Georgia O'Keeffe's and Marsden Hartley's, O'Keeffe's as a meeting of minds, Hartley's as a near-meeting. When O'Keeffe went out to Taos in 1929, the guest of Mabel Dodge, it was with a memory of the land from a 1917 stopover in Santa Fe; she loved it then, mentally vowed to return, and liked it as much twelve years later. She has been living there permanently since 1949.

Marin in New Mexico made the Marins he always made, except that the details were subtly different. O'Keeffe in New Mexico, forty-one in 1929, found a whole new vocabulary. The desert stones and flowers, the 18th-century Ranchos Church, Taos, the skulls and bones, the dry waterfalls and crosses gave her a series of emblems and a mythical tone she didn't have before. She missed this tone both at Lake George and in New York, where she spent the twenties; these places were either too dark, too soft, too vague or too detailed for her. In New Mexico, where, as Calvin Tomkins, in *The New Yorker*, reports her saying, "half your work is done for you," the brightness of light and simplicity and clarity of shape prodded her on. At her first show of New Mexico work, in 1930, the most sensational pictures were of crosses stuck in the canyon floors, and it was about these that Henry McBride said that they were "something less and something more than painting." Like Gauguin in Brittany, O'Keeffe brought back images from New Mexico—and not only the crosses—that could be taken either way: they were naturalis-tic and visionary, secular and pious, severe and luxurious, primitively stiff and canny. If they were memorials, as the crosses implied, were they for New Mexico?

O'Keeffe's painting expressed, as no one else before her had, the living deadness that many people felt in the Southwest. Edmund Wilson told Gauss that the place, though fantastically beautiful, was essentially a "museum." Its culture, though still "living," wasn't going anywhere or producing anything. It was just being repeated. Stuart Davis, listing the rough spots in his experience, remarked "Then there's the great dead population. You don't see them but you stumble over them. A piece of pottery here and there and everywhere. It's a place for an ethnologist not an artist. Not sufficient intellectual stimulus." O'Keeffe immediately recognized this leftover, near-derelict quality of New Mexican life. She was able to get inside it (something that wouldn't have occurred to Davis to do) and then work out.

O'Keeffe seems not to have had to try to feel at home in the Southwest. Hartley had to work at it every inch of the way. When he set out for New Mexico in the late spring of 1918, he was, as usual, on the edge of salvation. Life in the East had become unbearable: his shortage of funds was getting him to the breaking point, he found the cities unspeakable, and the land-scape, especially the New England one he was familiar with, grim and dark and small. He expected that a fresh—and bright—landscape would give him the vitality he needed. Taos, his first location, was cheap, though, for him, not cheap enough: his three-room adobe house cost $10 a month, with food roughly $8 a week, which hardly left him with enough to pay for transportation to the canyons west of Taos, where the best views were. Nevertheless, Hartley was enchanted when he first arrived. He told Stieglitz twice that Taos meant "richness," and his nose was busy sniffing great scents in every direction—the unexplored mountain legends, the possibilities of color and form. The shapes, he said, were massive enough for Courbet, and the colors complicated and rich enough for Renoir. Which was to say, he wasn't going to expend himself on small stuff.

In different ways, Hartley and Mabel Dodge (and Lawrence) were alike in that they craved being explorers—they always wanted to bring back news of a new world. In the beginning,

Hartley concentrated on his art and ignored the Indian population. If he thought about them at all, he was suspicious or bored with them. But by the end of his stay, in the fall of 1919, he had transformed himself into an authority: he not only felt himself the most important pictorial interpreter of the Western landscape (which, in 1920, he was), but the first poet-anthropologist of the "Redman," with a number of essays on the subject to his credit. From time to time during his prolonged visit, he bolstered himself up with thoughts of a double triumph in New York.

But Hartley had only the shell of self-confidence in the late teens and early twenties, and his love for New Mexico was touch-and-go. He confessed that his enthusiasms were slightly manufactured, and the manufacturing of them took more energy than he had to give. After Leo Stein left, he had no one to talk with for sustained periods. He couldn't seriously believe in Mabel's new Indian identity, and that separated them. His lordly disgust with the local cowboy and Indian artists was transparent and unendearing. Marin, with his gentlemanly indifference, could deal with the art colonists; he held court on Sunday mornings, when he showed them his week's batch of work. Hartley, craving Marin's impersonal style and unable to manage it, stepped all over everyone's feet, going so far as to describe the backwardness of these painters in an article that appeared in a local journal. Finally, the rough weather (he was assured that the snows of the 1919 winter were the worst in memory, and he passed this information on to Stieglitz as yet another aspect of his personal bad fate), his uncertainties about future gallery representation, and his incessant stomach condition and bad flu pulled him down. In the end, he was glad to leave, his hopes now set on his European career.

He kept working the New Mexico scenery over and over in the years to come, however, first in New York and then in Germany. In 1920, he told O'Keeffe he was associating himself with the "West," but this role didn't last long. The place he saw so calmly and realistically in the 1918 pastels and so heroically in the 1919-20 oils, became by 1923 monstrously bleary and de-

formed. In his mind, its bright, sprawling bigness blended into the darker, nearer New England mountains of his youth, and the combination was cold and ugly. He wanted New Mexico to be a great theme, he saw that it could be, and he nearly got hold of it. But he couldn't fasten onto anything for long in his middle years, and so he came to begrudge it. Until he became the center of his world later in his life, and then could forget about the Southwest, he was sure to say that, as far as he was concerned, Taos was spelled "chaos."

1976

▶▶▶▶

King's Woods

WILLIAM KING'S MONOGRAM is a W and a K interlocked and set in a circle. It has always reminded me of an abstract version of Whistler's monogram, a languidly flattened-out butterfly shape, which is also circular in form. That the connection has stuck with me in spite of the fact that the two artists have virtually nothing in common, and the monograms are only vaguely alike, is probably because Whistler and King are both masters of the slight effect. Whistler said "less is more" because he was canny, innately stylish, and realized that Victorian art and life could afford to lose some of their details. King has an innate sense of style too, but when he drastically abbreviates forms you feel that he does it more out of personal modesty than a desire to be flamboyant. King doubles back on himself: he's a technical virtuoso, a brilliant carver, designer and modeler, and an artist who dreads to seem fussy. You experience his energy not as a force flowing out and spreading but as a coil being wound tighter and smaller. He wants to get by with as few details and as little

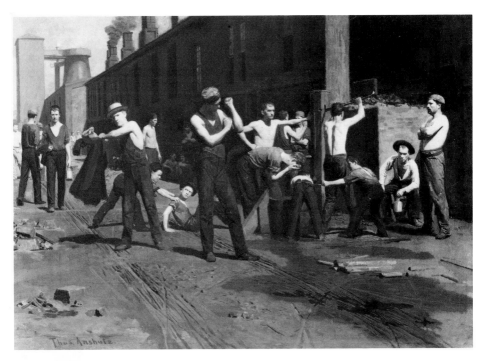

1. Thomas Anshutz: *Ironworkers—Noontime*. 1880-81. Oil, 17 × 24″. The Fine Arts Museums of San Francisco, Gift of Mr. and Mrs. John D. Rockefeller 3rd

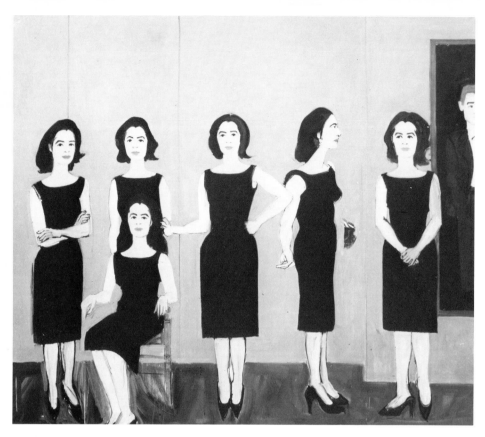

2. Alex Katz: *The Black Dress*. 1960. Oil, 6 × 7'. Private collection, New York, courtesy Marlborough Gallery

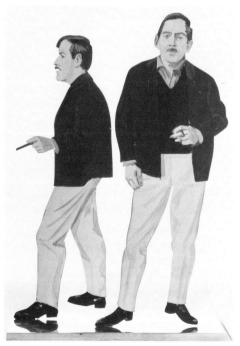

3. Katz: *Howie*. 1966. Cutout, oil, 13" high. Abrams Family Collection, New York

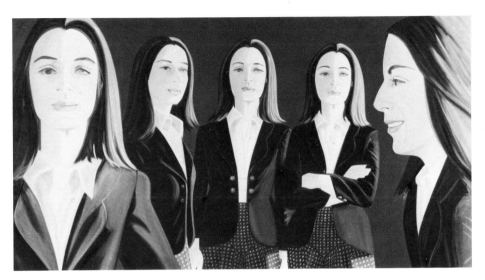

4. Katz: *The Black Jacket*. 1972. Oil, 6′ 6″ × 12′. Collection Paul Jacques Schupf, New York, courtesy Marlborough Gallery

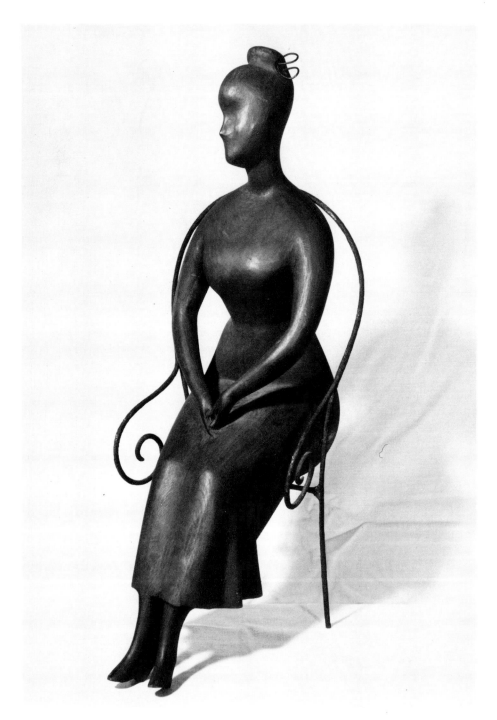

5. Elie Nadelman: *Seated Woman*. c. 1918–19. Cherry wood and wrought iron, 33″ high. The Portland Art Museum, Portland, Oregon. The Evan H. Roberts Memorial Sculpture Collection

6. Nadelman: *Head of Man in the Open Air* (or *Profile of Man in Bowler Hat*). c. 1913-14. Ink and wash, 7 × 5³/₄″. Private collection, New York

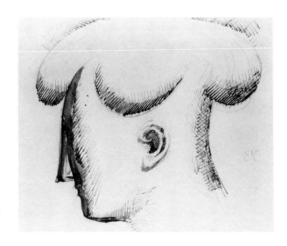

7. Nadelman: *Head.* c. 1917. Graphite, ink and wash, 7³/₄ × 9¹/₂″. Private collection, New York

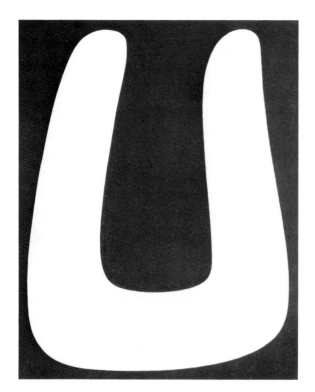

8. Myron Stout: *Untitled* (Number 3, 1954). Oil, 20⅛ ×
16″. The Museum of Modern Art, New York. Philip
Johnson Fund

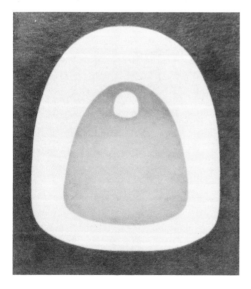

9. Stout: *Delphi II*. 1970-73. Graphite, 5½ ×
5″. New York University Art Collection. Grey
Art Gallery and Study Center

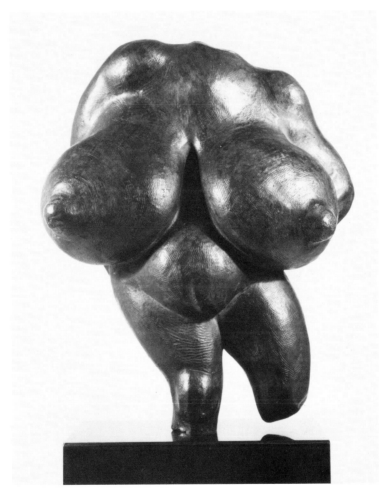

10. Gaston Lachaise: *Torso*. 1928. Bronze, 9½″ high. The Lachaise Foundation, courtesy Robert Schoelkopf Gallery

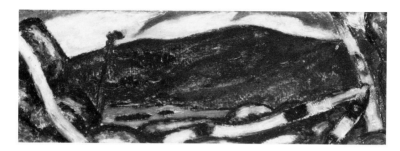

11. Marsden Hartley: *Mountains*. 1909. Oil, 5 × 14″. Private collection, New York

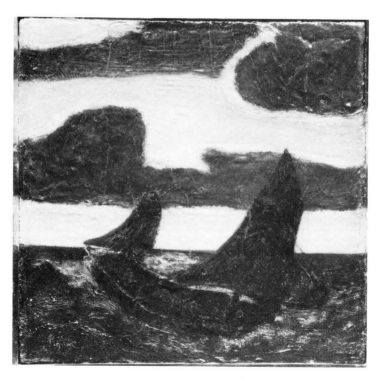

12. Albert Pinkham Ryder: *Moonlight—Marine*. Oil, 11³/₈ × 12″. The Metropolitan Museum of Art, Samuel D. Lee Fund, 1934

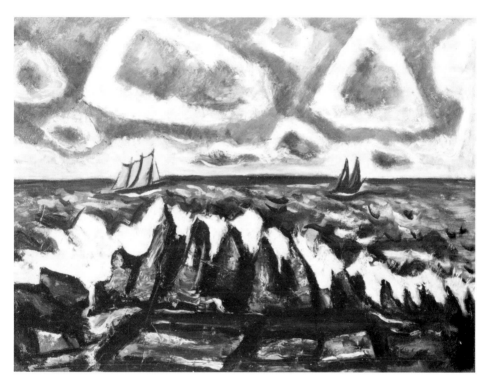

13. Hartley: *Northern Seascape, Off the Banks*. 1936-37. Oil, 18³/₁₆ × 24″. Milwaukee Art Museum Collection, Bequest of Max E. Friedmann

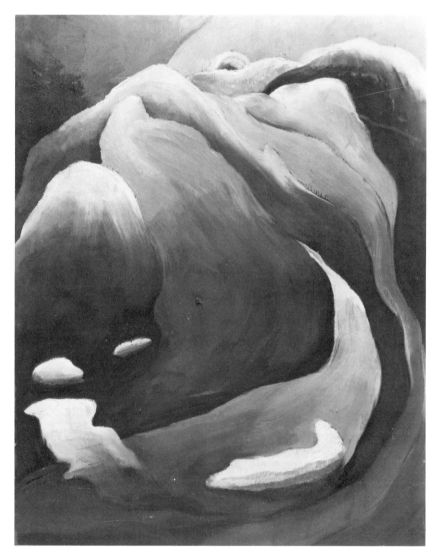

14. Arthur G. Dove: *Waterfall*. 1925. Oil, 10 × 8″. The Phillips Collection, Washington, D.C.

15. Joel Shapiro: *Untitled*. 1973-74. Cast iron, 3″ high. Collection Panza di Biumo, Varese, courtesy Paula Cooper Gallery

16. Shapiro: *Untitled*. 1975. Cast iron, 7″ high. Collection Mr. and Mrs. Albert List, courtesy Paula Cooper Gallery

17. Helen Frankenthaler: *Provincetown Bay*. 1950. Oil, 16¼ × 20¼″.
Collection Janice and Clement Greenberg, courtesy André Emmerich
Gallery

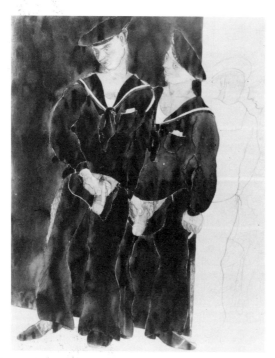

18. Charles Demuth: *Two Sailors*. c. 1930. Water-
color, 11 × 8½″. Courtesy Sotheby Parke Bernet
Inc., New York

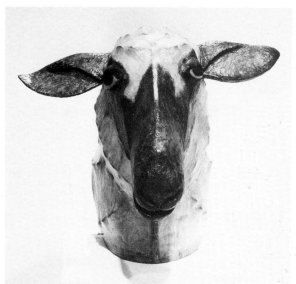

19. Anne Arnold: *Heidi (Ewe)*. 1973. Polyester resin, dynel and plywood, 22″ high. Citibank, N.A., courtesy Fischbach Gallery

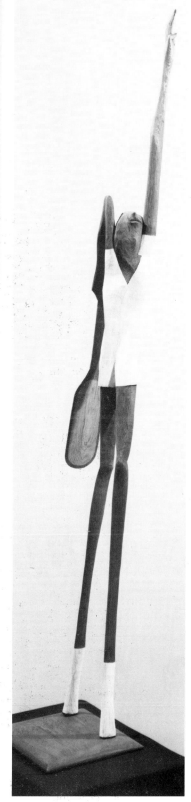

20. William King: *Ad Here*. 1975. Redwood, 56″ high. Courtesy Terry Dintenfass Gallery

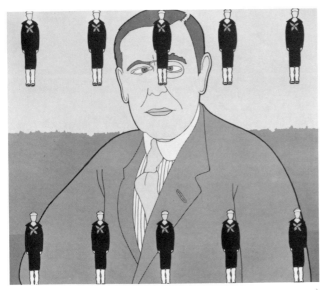

21. John Wesley: *Woodrow Wilson Crossing the Delaware with Sea Scouts*. 1976. Acrylic, 42 × 50″. Collection the artist, courtesy Robert Elkon Gallery

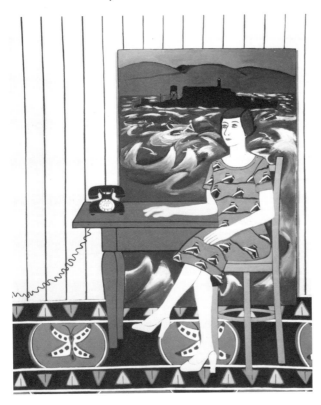

22. Joan Brown: *After the Alcatraz Swim No. 3*. 1976. Enamel, 8′ × 6′6″. Private collection, New Jersey, courtesy Allan Frumkin Gallery

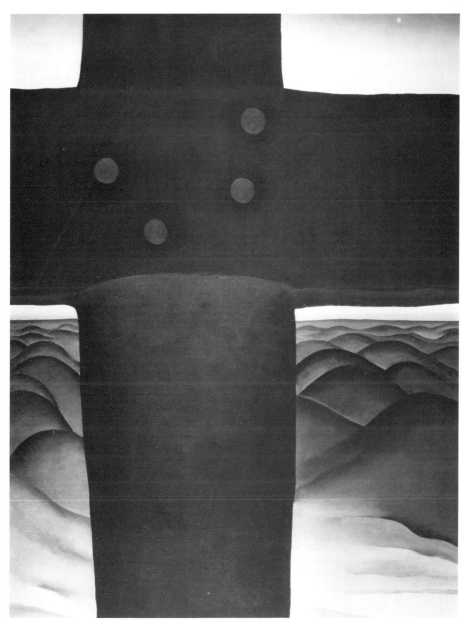

23. Georgia O'Keeffe: *Black Cross, New Mexico*. 1929. Oil, 39 × 30¹/₁₆″. The Art Institute of Chicago

24. Lucas Samaras: *Untitled* (Nov. 18, 1961). Pastel, 12 × 9″.
Private collection, New York

physical substance as possible. Seen head on, the volumes in his pieces look as if they've been turned into silhouettes of themselves, and, at certain angles, he makes sculptural mass almost disappear into thin lines. Even when he talks, or in the statements he's made (or in Patricia Tate's interview with him in the May-June-July *Currant* magazine, one of the few documents so far on how he works), King takes out the links. He makes cuts in the language that spare him from having to go to the corners of things—he telegraphs his thoughts.

Carving wood has always made him slow down, be more descriptive and also more layered in his feelings. For the first time in his now over twenty-year career, King limited himself, in his April show at the Terry Dintenfass Gallery, only to wood pieces, and the show was the strongest he's had in many seasons. Among the thirteen redwood, cedar and pine works, all done in 1975 and 1976, at least five—"Boating," "George Washington," "High and Hard," "Ad Here" and "Kiss Me"—must be in the circle of the best work he's done. All along, King's woods have been his finest pieces—the most beautiful physically and the most complicated emotionally. He gets a poetic resonance out of this material. When he works in burlap, aluminum or tin, his thin, delicate line can be waspish or wonderfully silly, coolly elegant or charming. In wood, the thinness is also fragile and vulnerable, and his expression of that vulnerability is the deepest, loveliest note in his art.

The finest of the new pieces is the 55-inch-high "Boating," a boyish-looking man, striding forth, carrying a paddle. "Boating" is broad and unsymbolic, as King's best woods are, yet it has the dimension of a symbolic piece: the chipper, starchy legs give the figure a silhouette two-dimensionality, but the meltingly rounded face, its features barely defined by a series of generous looping curves, tones down the briskness and adds something more reflective. An air of self-pity hangs over this character, though not enough to make it maudlin. Buoyant, hopeful and wary in expression, "Boating" seems as if it speaks for King the man; it might be him, looking out on a world populated by the other types he makes again and again: the bleary, punchy face-

makers, the wizened ghouls. "Ad Here" and "High and Hard," each of a single tennis player seen in action, are leaner and less textured in feeling than "Boating," though the spatial conception of both is more inventive. They're awesomely refined feats of design and carving. "Kiss Me" plunks down with a robust physical presence and a pose that's quite realistic, for all that it seems artificial at first. I only wish the words "Kiss Me" weren't carved onto the shirt of the figure; no matter how much you admire the piece, the pop cuteness gets in the way.

King's relation to popular culture is frequently less guarded than it might be. He uses details like "Kiss Me!" T-shirts only superficially, sticking them on as if they were decals. But these details are never fully absorbed into the sculptural presence, and they never lose their coarse cuteness. Certainly it's this edge of unadulterated pop in his work that has contributed to King's not being taken seriously by enough people and that has even kept him, the only first-rate comic sculptor since Daumier's time, from having had a museum retrospective, which is shocking. It's characteristic of him that, when he should be running away from the idea, he's done a George Washington this year. What he has done with it, though, is so funny and frightening that it exists independently of any Bicentennial festivity. Alex Katz (who also hangs loose) attempted a Washington too, for a Bicentennial print series; Katz researched his subject's phrenology and came up with a trimmer, handsomer, less solemn and more passive portrait. Katz takes the marbles out of the General's mouth, while King, whose "Washington" is based on the idea that no one ever remembers what the Father of Our Country looks like, puts them back in. This Washington is the garbled non-personality of everyone's imagination, except more hideous: the face, all chin and no teeth, looks like a rotten peanut shell. With his arms thrust up, and his fingers carved as if they they were feathers, the image is a mad mixture of Nixon transforming himself into a V and those squatting NRA-era eagles—or that bird on the Whitney's old 54th Street facade.

King must have enjoyed turning Washington into a monster, because the piece itself, made from slotted boards, is a beauty.

Painted in unmixed blue, white and black, with Washington standing on a green base, King reduces what feels like all the details of 18th-century military dress into a few geometric patterns. The surface is especially fine, soft and handled-looking rather than weathered. King's monsters of contemporary life are usually dank in spirit and confusingly unfunny. With Washington he's nasty and funny, in control all the way. So this is not only the most audacious work of art to come out of the Bicentennial so far, it's one of the best pieces to have come out of the black side of his comedy.

1976

▶▶▶▶

Anne Arnold

ANNE ARNOLD HAS modeled and carved the human figure, but she is best known for, and in recent years has exhibited only, sculptures of animals—dogs, rabbits, racoons, cats, pigs. Though the best ones have a lively individual presence, Arnold stops short of turning them into "characters," which could be ruinous. She isn't ironic or sentimental, and though she shows how animals can appear silly, she doesn't make them dumb or cute. While her work has the look of folk art, it is less coy and whimsical, more lifelike and sturdy. There is rarely anything attenuated or inflated about her forms; they are neither especially graceful nor awkward, and in memory they always seem naturally proportioned and lifesize, even when they're not really so. Arnold bypasses all sculptural styles and comes out on the side of an impersonal, dignified, unponderous realism, a transparent style on the order of Despiau's. That she gets this classical realism as a sculptor of animals is at first witty and surprising,

though what her art leaves us with is more temperate and bemused than witty.

The only other serious American sculptor of animals, John B. Flannagan, is her opposite—a mystic Expressionist. Always wanting to reproduce a swelling contour in stone or wood, Flannagan believed in the purity of animal life, and his best pieces are frequently of animals in their infant stage. That beautiful long yearning line doesn't appear too often in Arnold's work; her contour is chunkier, almost Cubist in its variety of clipped planes, and she leaves out the purity of animal life, too. Flannagan was literally and spiritually a carver: he was after a spiritual unity with his materials. Arnold by nature is an assembler of parts. In the work she has been doing since the late sixties, she starts off by carving and assembling wood or wire armatures, then stretching a surface over the frame, and, finally, painting the surface. The sum of this is a complicatedly conceived and painstakingly built object that is uncomplicated, direct and immediately accessible in feeling.

Of the seven pieces in her new exhibition at Fischbach Gallery, the earliest two, a ewe's head, "Heidi," and a ram's head, "Nimble," are from 1973; the other five were done in 1975 and 1976. (There was also a large selection of drawings, done over many years: some descriptive, snapshot-like ones, others that showed her abstracting sculptural shapes out of actual animals, and a third kind, drawings for sculpture.) As a group, the show isn't Arnold at her peak. The five most recent pieces, "Gertrude" (cow), "Lassie" (a Puli), "Holly" (racoon), "Ohno" (skunk) and "Bill" (horse) are still in third gear, about to go into fourth, and "Bill" may be in second. Since her show of painted canvas cats in 1969, Arnold has been attempting to get more substantial, life-like surfaces; the "skin" now is dynel, covered with a wettish, sticky-looking polyester resin (she still uses wood armatures mostly, though the racoon is carved styrofoam). Without being too literal about it, she wants to come closer to actual animal fur than she did with the earlier acrylic-on-canvas surfaces, which had a light, airy, artificial appearance—which was perfect, though not an idea she wanted to repeat forever. The problem

now, with the coated resin, is that frequently the painting is at odds with the surface. The black markings placed on top of the cow's milky white body are too brushy; they don't seem part of the skin, as the markings on the canvas cats do. The facial expressions on the skunk and racoon are indistinct, and while real animals might look like this, Arnold needs a little more abstract clarity. Her scale is always broad and her forms clear-cut, and the viewer expects the details to be clear-cut too.

Anne Arnold shows so rarely and is such a special, separate figure in American art that it is difficult to have to say when pieces aren't exactly right. The new pieces aren't a falling off, though; they just don't match the level Arnold has set for herself. Compared with the ewe and ram heads, which are completely successful, and may be the best sculptural portraits being done by anybody now, the newer works just miss because of a fraction too much detailing or—in the case of "Bill"—a fraction too little.

1976

▶▶▶▶

Glimpsing the
"Hidden" Demuth

CHARLES DEMUTH WAS ABLE to invest the slightest subject with a sense of erotic mystery, and it has always seemed poetically right, if also annoying, that a bit of the mysterious and hidden has surrounded his career. When Henry McBride reviewed the large Demuth retrospective at the Museum of Modern Art in 1950, he emphasized the fact that much of the work was new to him, especially the illustrations Demuth had done for Zola and Wedekind, and McBride was the perfect person to be surprised

since it was widely known that he had been a close friend of Demuth's. Of course McBride had known that there were Demuths that the artist didn't want put on formal exhibition; he would occasionally see some in the "back room" of galleries, and he tried to buy them when he could. But he had no idea of their number or importance before the 1950 show, and before he saw, in Andrew Carnduff Ritchie's catalogue, the reproduction of some of the Demuths in the Barnes Collection. During the artist's lifetime, over thirty figurative works went straight to Dr. Barnes from Demuth's home in Lancaster, Pennsylvania, by-passing public exposure completely, since for many years the Barnes was a place one imagined rather than saw. (That these Demuths are impossible to see in any detail without a flashlight and binoculars, now that the Barnes is semi-public, is another problem.) In addition, Demuth, reluctant to talk about his work or career with friends, kept a good number of pictures in the studio, apparently uninterested in letting them be shown publicly (though he always sold well, he had an independent income and never had to show).

The bulk of Demuth's work is now known and has been photographed. Yet among Demuth scholars, dealers and fans it has long been surmised that there are unseen pictures still sequestered away, and that there were also "pornographic" works, probably destroyed by people wishing to preserve his reputation. Demuth people will jump when they learn that over thirty watercolors, drawings and sketches, plus a sketchbook containing over forty drawings, have come to light, and will be exhibited at Sotheby Parke Bernet in October prior to auction there. These are works from one member of the Weyand family. Behind which fact there is a history of inheritance.

According to his biographer, Emily Farnum, Demuth willed his watercolors, colored drawings and pencil drawings to his lifelong friend, Robert Locher (the relatively fewer oils were left to Georgia O'Keeffe). At the death of Augusta Demuth, Charles's mother, in 1943, Locher also inherited the famously beautiful 18th-century Demuth family home, in Lancaster, where Charles Demuth had produced most of his art. Locher and a friend, Richard Weyand, who had also known Demuth,

turned part of the house into an antique store and gallery, and Weyand took over the job of cataloguing Demuth's work. Over many years, Weyand also compiled a good-sized scrapbook, including letters and notices, which, it was thought, would eventually go to the Beinecke Library, Yale. When Locher died in 1956, the remaining Demuths, as well as the Lancaster house, were inherited by Weyand. Five months later, Weyand too was dead. Unfortunately, he left no will.

The Fulton National Bank of Lancaster became the administrator of his property, for his four brothers and sisters, and among its first acts was to auction off the property on East King Street in March, 1957. Then, that October, the first of two large Demuth sales took place at Parke Bernet. The 1957 sale catalogue listed eighty-three items, mostly watercolors, and the February, 1958 catalogue, eighty-six. These catalogues are an indispensable part of the small Demuth literature; many of the pictures are reproduced and all one hundred and sixty-odd, representing perhaps an eighth of his output, are described.

However, not all of Weyand's Demuths were sent to Parke Bernet. As those interested in Demuth's career have exasperatedly learned, Richard Weyand's four siblings, who themselves did not know Demuth, were given works as part of the settlement, and none has been especially receptive to the wider art public. The scrapbook was also divided among them; if it still exists in its entirety, it is a four-volume work.

The cache that surfaced at Sotheby Parke Bernet over the summer, to be auctioned off in a separate, all-Demuth sale in October, is the first of those Weyand holdings to emerge. It comes from the late Robert Weyand. While there are few first-rank Demuths in the bunch, the majority of them, fragile and small as some are, have the distinct aroma of his personality. If these sketches and half-completed watercolors prove anything, it's that Demuth can afford to be seen in his slight moments; they're different only in degree from his full ones. And as a group, these Weyand sheets neatly span Demuth's entire working lifetime—when the nearly eighty works go up at the auction house, it should look like an impromptu, low-key retrospective.

The sketchbook is amazingly diverse. There are studies in it

for the Paris street scenes of the early twenties; male nudes that are conceivable at any phase; the ambitious, carefully planned industrial oils of the early thirties; heads of people in cafes and at a concert, and tree and rooftop notes that fit into the late teens; and the poster portraits he was making in the mid-twenties (including one for Wallace Stevens that apparently was never executed). The loose drawings and watercolors are even more comprehensive. Opening with people-in-the-street scenes that are reminiscent of Marquet or Prendergast, and might be child-hood work, there are individual examples of every phase of the career, ending with 8½-by-11-inch sheets undoubtedly made in Provincetown in 1934, and therefore among the last things he did (he died the next year).

Are there any revelations in these new pictures? Not revela-tions, exactly. More like confirmations. The works in the S.P.B. collection that will make the biggest splash are of men in various states of undress, and what they make clear is what many have suspected: that Demuth wanted to show a wide range of homo-sexual experience in his work, that he wasn't content only to symbolize his feelings, and that the problem was greater than his capacity to deal with it more than intermittently. It isn't real news that he tried to bring male homosexual themes into his art; already in the 1971 Santa Barbara show, a 1918 "Turkish Bath" watercolor proved that he could be explicit, even deadpan, about the facts of homosexual life.

The homosexual scenes in the October sale show him hitting the problem from slightly different angles. In the outline draw-ings, he turns out to look like Roger de la Fresnaye or Cocteau. What he's drawing with, essentially, is the Neoclassical line of the early twenties, which adapted perfectly, at least on a certain level of feeling, to an aspect of homoerotic taste—the pretty, semi-chaste, Greek shepherd boy part. In the watercolors, he goes deeper. He risks more. In "Two Sailors," the figures are urinating (or possibly masturbating—Demuth typically leaves it unclear), while in a back room we see three more men, and in "Four Male Figures," another finished watercolor, anonymous-looking men, in what might be a city park, have begun taking off

their clothes. "Two Sailors" is funnier and coarser, and the conception is more sculptural and monumental, than Demuth is thought to be, and "Four Male Figures" has a lumpen, unshaded, illustrational quality that is also rare for him.

Without seeming dated, Demuth always looked like a period artist. Part of his attractiveness in his own time was that he preserved the fin de siècle: he unexpectedly made it seem right as a way to look at the teens and twenties. Chronicling his life as a homosexual (which, from stylistic analysis, he began to do more and more as he aged), he pushed himself into an area where his style, a genius-like blend of the emotionally murky and the technically precise, would have diluted the effect of his experience. There are vestiges of the known Demuth in these S.P.B. watercolors, which are ca. 1930; but the chief impression is made by a new, raw, as yet textureless personality—an artist without any period flavor, a man who steps out of nowhere. When you see works like "Two Sailors," you know that they aren't the most complexly alive Demuths, and that they really don't do more than label the fantasies and dreams that are implicit in whatever he does. Yet you are stirred to see him groping, trying to leave behind his perfect taste. In his last years, he was moving on toward new themes, a different, slightly larger scale, and a new emotional directness. From the known evidence, he died before he got all the parts in place.

1976

►►►►

Joan Brown

WHEN JOAN BROWN HAD HER first solo show in New York at the Staempfli Gallery in 1960, she was already known as something of a girl wonder. She was then twenty-two, individual works of hers had been shown and sold by Staempfli for a number of years, and she was gaining a reputation as the gifted junior member of a group of West Coast figurative artists that included Elmer Bishoff and David Park. In 1957, at nineteen, she had been included in the Annual Painting and Sculpture Exhibition of the San Francisco Art Association; three years later, she was one of the youngest in the Whitney's "Young America 1960" exhibition. Brown eventually stopped showing in New York and in Los Angeles—perhaps because the fame was piling up too fast, and in too many different places. She was being written about not only in the art magazines but in *Glamour, Cosmopolitan,* and *Look,* and *Mademoiselle* gave her an award for her art in 1962. She withdrew totally. The result is that, as Brenda Richardson describes it in her catalogue for the 1974 Brown retrospective at the University Art Museum, Berkeley, Brown's work is less well known "now than it was in the fifties and sixties, her artistic reputation is basically a quiet underground one, and her primary influence is restricted to the Bay Area where she lives and teaches."

Recently, she has returned to New York, with shows in 1974 and 1976 at the Allan Frumkin Gallery. Based on these shows, especially on this last one, and on the isolated Brown painting that appears now and then in a Frumkin group, it is to be hoped—and it seems likely—that she won't retreat again. Now in her late thirties, Joan Brown is still a wonder. And while this time it has nothing to do with her age, you can see how she was a precocious talent. The pictures she exhibited in December, all of which were done in 1975 and 1976, are the work of a virtuoso—an artist who is equally in love with her intuitions and the

history of painting. Brown is a fancy painter, but in the good sense: you can imagine her being surprised by her own inventions. Besides, the nine pictures she showed aren't fussy; there is something dogged and clunky to them. They're large—all 7 and 8 feet high. Painted with commercial outdoor enamel, on canvas primed with two coats of rabbit glue, their surfaces are shiny, thick, and dense, and that has the effect of adding to their literal size—they seem massively, industrially big. The pictures lead a double life: you want to get very close, to look at the parts as if they were miniatures, yet you can get quite far away, and they hold up.

Each painting is of one woman, often accompanied by a dog. Usually the scene is a sparsely furnished living room; there might be a window with a view, or a painting on the wall, and perhaps a fireplace, table or telephone. In other paintings, the woman is in a shower or a restaurant. (Most of the women are self-portraits, but that isn't something you absorb when you're looking at the paintings; the women don't seem like specific people, and they're all vaguely alike.) Every form is defined by a clean narrow line, which gives the pictures a cartoon-like neatness and shallowness. Yet these pictures aren't stylistically consistent the way the cartoons are. Brown paints as if she were a born mimic of different styles, and that might explain why she isn't after the unity of any one style. She wants to mix together as many ways of painting as possible, and see if some new clarity comes out of that impurity. With most of these pictures, especially *"The Dinner Date # 2"* and the three paintings in the series *"After the Alcatraz Swim,"* she's successful. While some details, such as hands, legs, and shoes, can be cardboard flat, others—like human and dog hair—are naturalistically shaded. Still other objects—a bottle on the floor, a painting propped up against the wall—cast shadows. The patterns on the carpets and the clothes have a life of their own, too—they're the busiest, and among the best, clothes worn in paintings since Vuillard. But where Vuillard makes clothing patterns merge with wallpaper and furniture, Brown keeps every unit separate. Whether it's a dress, a dog, a wine bottle, the bricks in a fireplace or the tiles in a shower, each detail has been isolated, given its own texture, and

brought to the brim of its own kind of intensity. Each is such a contained force one feels as if it could take off and become its own painting.

It's not surprising that she actually has included paintings-within-paintings. They're mostly seascapes, which include swimmers, of San Francisco Bay—Alcatraz, the Bay Bridge and the city's skyline, with simple silhouetted portraits of actual buildings, are seen in the background. These are loving, beautifully crafted primitive pictures; with their chalky white, fang-like waves rising up from a dark green ground, they could be compared with seascapes by Marsden Hartley or the English primitive Alfred Wallis. They have an old-fashioned depth of space and feeling, which makes them seem like cameo performances in another key from the rest of the cast. You're pulled into their dark, tonal, craggy space, while most of the other details in the paintings are glaringly bright, and keep you at arm's length.

That some of the titles refer to the "Alcatraz Swim," and that many of the paintings-within-paintings are of swimmers in San Francisco Bay, have an autobiographical explanation. As an intelligently sympathetic (and unsigned) piece in the *Allan Frumkin Gallery Newsletter* for Fall, 1976, describes her, Brown, in the past few years, has pursued non-professional competitive swimming with the same ardor she is known to bring to painting. The Alcatraz Swim is not only for real, it's a race she has participated in. Since she has become such a devoted amateur, she has painted her swim coach, herself in an indoor pool, people swimming, things seen from the swimmer's point of view. In these new paintings, her life as an artist and swimmer and native San Franciscan hovers over her in the form of paintings on the wall. Yet if there is a central character to these pictures, she is someone who has little to do with either activity, and isn't simply a native daughter. She is a slightly anonymous, independent, contemporary woman who relaxes at home, has a date, takes a shower, gets dolled up and goes to a restaurant.

Brown must like the idea of having contemporary-looking people in her paintings, but, as an artist, she is too operatic a personality to be consistently realistic about contemporary life. Something comic and grotesque keeps breaking in; occasionally

it more than breaks in—it swamps the painting. The woman in "Woman and Dog with Chinese Rug" is scary, a dark-faced ghoul whose mouth is open and has what looks like a set of wind-up clattering toy teeth in it. The dogs Brown paints can be nasty and glinty-eyed, too. And yet, while the weird little dog that stands on its hind legs and holds a washcloth in its mouth in "Woman Waiting for Shower" doesn't enhance the painting, it doesn't ruin it, either. The dog is only a shade more peculiar than the awkward way the woman is standing in the shower, and her bodily position isn't any stranger than the fact that, while she is supposed to be waiting for her shower, she's still wearing her bathrobe. If they were taken seriously on their own, such arch and whimsical details would be creaky and unbelievable (like the allegorical gestures in Max Beckmann, which they resemble). But you don't take them on their own, as you don't take Beckmann's. You read them as private mannerisms which are part of the overall public flavor.

"The Night Before the Alcatraz Swim," however, doesn't jell as a painting. The figure in it, with her slumped body and dreamy face, is too naturalistically conceived, and the naturalism gives the picture a soggy weight in its center. The figures in the other paintings are more vacant and tense, bodily and facially. They have a frozen, immobile expression that works in their favor; it operates as a center of calm, rooted strength in pictures that are almost too busily full. Take away that presiding, abstractly large figure, as in "The Night Before," and Brown's manner becomes overbearing and showy. Yet if "The Night Before" is a failure, it is one you can be sympathetic towards. It shows that Brown is trying to add a layer of descriptive realism to her art, and that so far she hasn't found a way to make it convincing. Her art would only get deeper if she could do it, and considering how much she aims for and how much she achieves, that doesn't seem like too much to expect. For many artists, these paintings would cap a career. For Brown, with her tigerish energy, they are overcrowded with possibilities for future work.

1977

▶▶▶▶

John Wesley

THE SIX CANVASES and more numerous smaller studies John Wesley showed this year at the Robert Elkon Gallery are collectively titled "Patriotic Tableaux." Taken from past American history, these "tableaux" are concocted moments, odd angles on names we're familiar with ("Woodrow Wilson Crossing the Delaware"), remember vaguely ("Wiley Post Crossing the Red River of the North"), or have to take a pass on ("Flood: Johnstown: Pennsylvania: 1889.") "Woodrow Wilson," the best painting in the exhibition, gives us a slightly cross-eyed, complacent-looking Wilson, seen from mid-chest up, with five faceless "sea scouts" (who look like naval cadets) standing frontally along the top of the picture, and five on the bottom. The row of scouts on the top is laid over Wilson's face, somehow accentuating the fatuous benignity of the expression. "Wiley Post," a study on paper, is less political or literary; elegant and simple, it is a more purely abstract image. Our view is straight down on a one-prop plane, which is white, rendered so that it is totally flat, while underneath it, also very flat, is a curving blue line (the river) surrounded by green (fields). "Washington Crossing the Delaware," a third strong picture, dreamy and blissful in feeling, shows a character-less, boyish-looking Revolutionary War-type about to fall out of a small boat, with a similar-looking figure holding him back by his coat tail.

Wesley doesn't seem to be revisiting American history in these pictures, all done in 1976, so much as reinventing it, detexturizing it, bringing it closer to the illustrations in children's books. He delineates the figures, facial features, airplane wings, clouds, boats, rudders and all his other details with a narrow, pliant, cartoon-like black outline, and fills in the drawn parts—clothes, water, sky, land—with untextured flat colors, mostly blues, greens and grays. There are also frequent appearances of an

108

undiluted, billboard-power flesh pink. Cleanliness, neatness, a sly, laconic perversity, a feeling for the out of the way, a sense of something mild but immovably itself—these are one's immediate impressions of "Patriotic Tableaux." The faces on these un-shaded picture-book people are blissfully removed, vacuous—or else, by small lifts in the line around the eyes, they're made to seem deranged. The figures in "9 Female Inmates of the Cincinnati Workhouse Participating in a Patriotic Tableau" (a diptych, and the largest, most imposing picture in the show), could be the children of Thurber's wary couples. And yet the all-pervasive milky white (in the borders that enframe these images), the soft greens and blues, the dampening gray, plus the baby-skin thinness and newness of the surfaces of the paintings, add a milder, more pastoral note—though not one you want to give your heart to.

In "Woodrow Wilson Crossing the Delaware with Sea Scouts," the confusion of the historical events and eras isn't much weightier than a literary-visual pun—unlike Washington, Wilson isn't crossing the river, he's crossing his eyes. What is complex is the way Wesley blurs together our nostalgia for and repulsion from this face, which we read not only as an image of a specific historical personality, but of the past in general. Wesley makes the past paper thin; he toys with it, degrades it slightly, pulls it up into the present by posterizing it, then throws it back into a quaint, antiquarian mustiness. But, especially with the rows of repeated images (like the sea scouts), he also gives it a remote, iconic solemnity. In *Ragtime*, E. L. Doctorow artificial-izes history too, and presents details in the same flat way Wesley does. Except that, with Doctorow, the neutral, anonymous tone is only skin deep. Running along beneath it, there is a rhapsodic and analytical force which gives off a romantic heat and unifies the history's disparate strands. With Wesley, there is only the neutral, anonymous tone; his vision is cool and impassive through and through.

The many references and details packed into these 1976 paintings—the floods, rivers, dates, names, places, "crossings"—seem slightly arch and peripheral, though you hardly know what

they are peripheral to, and that almost seems to be the point. The viewer never fully knows how much of this farfetched, esoteric, often "dumb" subject matter Wesley believes in, and the viewer comes not to care, either. It is Wesley's ironic distance from his material, felt like a magnetized field, that becomes the true content, the emotionally most real part, of the work. In this show, the field isn't always magnetized. Wesley's taste for the bizarre and the frigid can take him down to a dead-end where he doesn't seem to be doing much more than magnifying weird cartoons. "Flood," with, as its only figure, a squawking eagle wearing shoes, and "New Army Recruiting Poster," with its Donald Duckish ducks, are crass and off-putting. But in "Wilson," in the less ambitious "Wiley Post," on a subdued level in "Washington," and possibly in "9 Female Inmates," the irony spreads in so many directions you can't follow them all. In these pictures, like the modern primitives from Rousseau to Morris Hirshfield whom he so much resembles, Wesley really is making "tableaux"—open-ended, poetically resonant dramas of simplicity and ambiguity.

1977

▶▶▶▶

Nicholas Vasilieff

NICHOLAS VASILIEFF (1887-1970) was a too little known painter during his lifetime and to give him his first (and no doubt last) New York retrospective in July isn't geared to making him better known. Vasilieff's name crops up again and again in the art magazines during the forties, fifties and early sixties, but he has long been a figure of uncertain stature. He's totally excluded from the histories of the period—he's even missing from Jerome

Mellquist's *The Emergence of An American Art*, that big-hearted history which goes out of its way to pay tribute to every underdog. His retrospective, organized by Stephanie Terenzio for the William Benton Museum of Art (of the University of Connecticut, Storrs), where she is assistant director, and where the Kennedy Gallery show was originally installed, didn't reveal a great artist unjustly neglected. It revealed a good and likable artist who, in the last analysis, disappoints you. Vasilieff had real gifts; he knew what he wanted and he had the technique for it. Like many another Russian in the arts—Rachmaninoff, Stravinsky, Tchelitchew, say—he had the inborn techniques for any number of different styles. He was such a natural he could have turned into a smoothie, but he reined himself in (unlike Tchelitchew), and you congratulate him for that. Yet he won a pyrrhic victory. Perfect as many are within their own limits, his pictures leave you with the impression of a lavish talent that allowed only part of itself to emerge.

Leaving a wife and children behind him in Russia, where he had been trained in the academies, and had later associated with Goncharova and Larionov, Vasilieff came to New York in 1923. By the thirties, he had taken his place in the city's growing corps of talented unknown artists. He lived next to Gorky on Union Square, John Graham was close to him, and he saw much of Milton Avery and David Burliuk, among others. What these artists shared was a heightened respect for the art of painting, a love of the museums, and a working, partisan knowledge of what was going on in Paris. Many were foreigners. A high percentage were Russians, Jews, or Russian Jews. Few had money, the majority were almost never able to support themselves by their painting, and their work, especially in the thirties, was too experimental—too self-consciously coarse and tentative—for New York's essentially conservative galleries to take them on. Many did achieve big reputations, frequently only at the end of their lives, or posthumously; but Vasilieff's reputation remained an underground one. Like Leon Hartl or Arnold Friedman, he was known in his maturity, in the forties and fifties, as he had been known from the beginning, as a painter's painter, a minor-

ity taste. His chief support came from Fairfield Porter, our leading connoisseur of minority tastes (the Vasilieff catalogue is dedicated to the painter's widow and to Porter's memory).

Terenzio tells us that Vasilieff kept up a "close and mutually respectful relationship" with Pollock and de Kooning, and you can see how they, as much as Graham, Avery, and Burliuk, could have admired him. He was a painter down to his fingertips; he loved the culture of oil painting, its tricks, shortcuts, problems. Taken individually, the Vasilieffs—close to Avery in their child-like drawing, similar to Soutine in their scumbled hot surfaces—are sturdily built, knowing and charming. Yet after you have seen ten or more, you have to work hard to keep individual ones in mind. Always the purest, least commercial, of painters, he nevertheless arrived at a formula, and it's only in the still lifes, by far his best pictures, that he left himself room to keep on inventing within that formula. All the artists around Vasilieff in the thirties were provincials of one variety or another. They knew that they had to lose that provinciality, either by absorbing a complex new style (which usually meant going through Picasso or Miró) or by finding ways to enrich a primitive figurative style they wanted to keep (which led through Matisse). Taking the latter route, Vasilieff broadened and enlarged his forms and keyed up his color, yet something coy and rustic remains. His manners are too folksy to allow us to fully trust him, and he's too cunning to be a convincing folk artist. The figure paintings, by which he set much store, represent him at his most trapped; you can look at the still lifes more easily as pure paintings, admiring his virtuosity.

Vasilieff's retrospective is accompanied by one of the most appealing exhibition catalogues to appear in recent years, not only because it's a readable and impeccable piece of scholarly art history, but because the book itself is such an unusually spruce production. John E. Bowlt has supplied a short piece on the painter's Russian background, and Terenzio's long essay covers his life and work. She likes the challenge of writing about a neglected figure—something in her, you feel, warms up to the idea that her subject has never quite made it out of the gloom of

obscurity. Everything about her piece and the catalogue she has engineered says that working on Nicholas Vasilieff has been a labor of love.

1977

▶▶▶▶

Michael de Lisio

MICHAEL DE LISIO MAKES SMALL, table-size sculptures, most about a foot high, of personalities from the world of the arts. The majority of his subjects are people of considerable fame, known to us from photographs and paintings, which de Lisio works from. Picasso, Pound, F. Scott Fitzgerald, Robert Louis Stevenson, Baudelaire, Hemingway, Joyce, Henry James and André Gide are some of the men he has done, Martha Graham, Sarah Caldwell, Gertrude Stein and Janet Flanner some of the women. Sculptures of well-known personalities have a way of rarely being good sculpture, and small-size sculpture of famous people sounds hopeless. One expects an excess of the coy, the self-conscious, the whimsical; one imagines figurines for a paneled library, Baudelaire as a book end.

The first thing one notices about de Lisio's sculpture—and draws one to it—is its freedom from anecdotal literary and biographical references. Looking at his work, one thinks he must admire Daumier's small bronze busts, the portrait drawings of Max Beerbohm and, perhaps too, David Levine's drawings. There are affinities in the work of all four, but they aren't more than surface affinities. While Daumier, Beerbohm and Levine are all caricaturists, on respectively different levels of intensity, de Lisio has almost nothing of the caricaturist in him. He has no urge to get an angle on the historical figures he picks for his

subjects. Like 19th-century multi-volume Life-and-Letters biographies (and unlike modern psychological ones), his portraits are broad and big in feeling and also, in the end, a bit removed. In his "Fitzgerald" or "Pablo Picasso ca. 1905," for example, he sums up everybody's highest and widest feelings about these personalities, and then leaves us with the sense that there is still more to know—that there is something about them that we may never know. Perhaps because of this open-ended, generalized mood, his pieces, especially the standing figures, have a public presence, an unstuffy, pleasing dignity. Enlarged, they would look wonderful in parks, set among trees. They might be even more at home in residential city squares.

De Lisio often works first in terra cotta, which he paints. Then he casts the same pieces in bronze, to which he applies a variety of patinas. It's to his credit that, as he moves to the more imposing, physically substantial medium, his conceptions look even stronger. His art becomes fuller and more original in bronze, where somehow it's easier to see his understated, and always purely sculptural, qualities: his witty dimensional play, very evident in the "Eliot" and the "Fitzgerald," on frontal broadness and profile narrowness in the same figure; his attentiveness to the smallest, most plain details, such as buttons, collars and ties, which he doesn't make stand out, but which, considering the delicacy of their execution, he obviously enjoys fashioning; his unexpectedly audacious drive to have large areas in a single piece devoted to one element: Martha Graham's dress, Baudelaire's coat, the table on which Gide rests his thoughtful arms—elements which, for the viewer, have an absorbing life of their own.

Michael de Lisio's work might be called cosmopolitan folk art. It's a sculpture that takes as its subjects people we know to be complex, and presents them to us with a sense of form that, while not simple, seems invented, innocent. Florine Stettheimer brought together these opposites too, in her portraits of New York art world and cafe society personalities in the teens, twenties and thirties. Stettheimer's spirit, of course, is quite different from de Lisio's. She was an academically trained

painter who developed a naive drawing style because it gave her a way to be candid about her milieu—to make art out of gossip, to name names. De Lisio isn't trained in the academic sense, and his work doesn't have anything of Stettheimer's facetious, bubbly, waspish tone. But when it comes time for him to take a seat in the history of American art, he might wind up in her row. Both appear to be literary minds who have made a detour and are now expressing themselves visually, and neither does work that can be said to have much relation to the painting or sculpture of their contemporaries. Yet both make art that lives because, in an oblique way, it's about the problems of painting and sculpture. Both evolve an original sense of form, not because they deliberately want to contribute to the history of form, but because their private needs demand it.

In comparing them it should be added that Stettheimer's work has a period vividness that de Lisio's lacks. She pinned down, like a butterfly under glass, the doll's house aspect of a phase of New York social and artistic life. De Lisio's portraits, ranging from Baudelaire to Auden and Sarah Caldwell, don't have the stamp of any particular period. On the other hand, Stettheimer's comedy is no longer very resonant—it may be too much a product of its era. Whereas de Lisio's art, for all that it is a bit of a guest in its own time, has at its core something tender and deeply anchored, a simpler something that will probably always be accessible to people in the same way.

Michael de Lisio began making sculpture in 1965, at the age of fifty-four. He had written poetry for many years (and supported himself by working as a press agent for movie companies). He harbored no lifelong desire to sculpt; he happened to begin when, visiting his friend the sculptor Daniel Maloney one day, he randomly picked up some wax in the studio and decided to see what he could do with it.

His earliest pieces have an understandably borrowed air: there is a Picassoesque head entitled "Anon.," a Gonzalez-like "Marcel Proust" relief. Within a year or two, however, he found a plainer, more naturalistically detailed, less "artistic" vein, which gave him a lot of room to move around in. Works such as the

torso "Marianne Moore," the bust "Edgar Allan Poe," and the full figure "Robert Louis Stevenson (after John Singer Sargent, 1885)," all from 1967, show him finding most of the ingredients of his style. The "Gertrude Stein" torso of the following year, a piece that exaggerates Stein's roundedness (and resembles an inkhorn), added the final and most distinctive ingredient: a feeling for massive weight neatly contained. In the ten years since, he has been able to fit the bulging monumentality of the "Stein," which is a bit too abstractly conceived to be a bona fide de Lisio, into the more straightforward appearance of, say, the "Stevenson." The result of the blend, seen in such pieces as "Henry James," "Baudelaire," "Gide," "Fitzgerald" and a number of others, is the complete expression of what could be called de Lisio's first phase.

The 1978 show catches him at the beginning of a new, less naturalistic, less refined phase. The change is best seen in his handling of faces. In the "James," for example, the face isn't weak, yet what one lingers on, what one remembers, is everything but the face. A similar thing happens with the "Baudelaire," where the body has the strangeness of a personal invention, while the face seems a sculpted rendition of the face we know from photographs. But in the past two years, with such pieces as the two different versions of the standing Picasso, and "Letter to the World," a work based on Martha Graham's 1940-41 dance about Emily Dickinson, de Lisio has begun to make facial features that come from the same world of forms as the slightly too-large heads and slightly disproportionate bodies. The bluntness of these faces of Picasso, Dickinson and Graham verges on the coarse and toy-like. There is a combination of placidity and mask-like tension in them which takes a while to get used to, then begins to feel right. It reveals how much tension lies buried within the bodies.

The primitive staring eyes and benign but also ominous cast in the faces of the new pieces hint that de Lisio may be willing now to open up his art to different forces. There has always been an expressive deformity in his work, it's there even in his first piece, the "Anon." head, but it has always been held in the back-

ground. Now perhaps its time has arrived. This isn't to say that the newer work is finer or more personal. It simply goes in another direction. Part of the beauty of the earlier sculpture (the "Fitzgerald," for instance) derives, for the viewer, from seeing an artist filter his instincts through an idea—in this case, a true-to-life, classically representational idea—which may not be his own entirely, but which he knows he has to master, and which he suffuses with his own light. The recent sculpture comes from a man who is confident that he has brought certain of his resources to perfection, and wants now to fish inside himself for more.

1978

▶▶▶▶

Helen Frankenthaler

BEFORE BEING SENT on to the Far East, Australia and Latin America, a substantial sampling of what are called Helen Frankenthaler's "Small Scale Paintings" (more accurately they're her "Small Size Paintings") was shown at André Emmerich. The heart of the exhibition, the unexpectedly absorbing part, was the group of eighteen paintings, done between 1949, when she was twenty-one, and 1960, in the gallery's first bay. Almost each of these pictures, the majority of which are pre-1954, is different from its neighbor, and is its own experiment in color, drawing, and touch. Many of the works, especially among the very earliest, are worth looking at on their own, but it is as a collection—a young painter's view of many of the themes and possibilities in 20th-century European and American art—that they hold you.

From painting to painting, here is Cubism's fractured vertical space, Braque's dished form, the sandy surface of Masson and

Picasso, the improvisatory drawing of Kandinsky, Miró, Motherwell, Gorky, Pollock. In trying to place her, Hilton Kramer has repeatedly compared Frankenthaler's abstraction, tied so often to landscape, with Dove's and O'Keeffe's. O'Keeffe isn't in these early works, but Dove is. "Provincetown Bay," 1950, one of the most satisfyingly complete and densely painted works in the show—an abstraction based on a view of high foreground rocks and a distant, even higher harbor line—looks as if it were a Dove, though she may have been thinking of Gorky if anyone. In it, the color and light of rocks, water and clouds are turned into an animated tapestry whose shapes seem to hang in place and wave, like laundry on a line. An even greater presence is Marin, whose more purely formal way of thinking probably would have been closer to her concerns. An untitled horizontal painting of 1950-51 comes with a Marinated painted-and-scored frame, and many pictures have his blistered, ancient-looking surface and flickered drawing. Other paintings, especially a few near-monochromatic ones, built around boggy, mildewy browns, are reminiscent of Rothko and early Stamos; an untitled 1952 gray and tan landscape recalls Edwin Dickinson.

Not one of the pictures has the all-out power of the great student works, pictures such as Gorky's Picassos or Hartley's Ryders, where the student isn't afraid to be totally derivative, jumps right into the mind of the teacher, and comes out with an imitation that is more passionately painted than the inspiration for it. The young Frankenthaler flirted with many artists without giving herself to any. Her paintings of the early fifties, at least those shown here, have an anonymous intelligence. The personality behind them is blurry and undefined. Yet they aren't timorous or studious in spirit, and the muffled mood may have been what she was after. Many of the pictures, even those that are clearly abstractions, seem to be of marshlands or thickets, or bays or coves seen through rain. When she was in her early twenties, Frankenthaler was confident that she could engage any of her older contemporaries, both those widely known and those still obscure, in a kind of brisk, spontaneous shop talk. From the vantage point of twenty-five years later, her youthful confidence is attractive, even moving.

Beyond this bay, Frankenthaler looked progressively less exploratory, and the show dwindled in interest. Her ideas are geared for large-size canvases, and perhaps shouldn't be judged in a small format; but her effect in these small paintings is almost the same as in her large ones. Regardless of size, her paintings have the weight of knowing, perfect things—spills of paint which, by the addition of a line or a blotch, or by a deft crop, are transformed into well-tailored, well-balanced pictures. Spending time with any one of them, you invariably know why, whether she's painting or editing the canvas, she had to stop just there, and go no further. That clarity makes her pictures forthright and readable—each comes complete with its own libretto. Few women artists have spoken the language of their chosen medium as purely as Frankenthaler does painting. She doesn't ride roughshod over her medium, flattening it unconsciously, in an effort to make an art that will be a shrine to her personality. For her, making art isn't a way to assert herself in the world. She makes art because she's after the laurel of her profession. She is all business. Among American women artists before her, only Mary Cassatt, by the evidence of her work, was as much at home in the studio.

But Frankenthaler sacrificed a part of herself to be so businesslike. It's as if she felt she had to give up her bite in order to paint like a man. Considering her industry and dedication, as a painter and printmaker, she is a person of some bite—but it isn't in her work. There are times when her paintings have a resplendent beauty that stops us short. None of her contemporaries work from as seemingly wide a range of subtly interconnecting and also headstrong, difficult-to-manage colors. She's comfortable with lavender, tropical greens, Tintoretto maroons, a flotilla of reds, soft sherbet oranges and an array of the richest earth tones, to name but a few. Her color hovers on the edge of prettiness. That her art doesn't go over the edge is a feat; her pictures are luscious and reserved at the same moment. But this feat often seems to be the most substantial thing you are left with. Some personal reason for her color to be the way it is is lacking. She is too proficient about beauty. She reduces painting to a few alternatives, and resolves all of them—mass vs. line; stain vs.

brush; center vs. edge; balance vs. imbalance—with a bravura, and frequently monotonous, simplicity. There is a premonition of this in her early work, where she synthesizes the lessons of perhaps too many artists, and does it perhaps too fluently. But that attempt has grit in it, and something which the later work misses: the air of a challenge—Frankenthaler competing with, and being tested by, others.

1978, '81

▶▶▶▶

Georgia O'Keeffe Writes a Book

GEORGIA O'KEEFFE WRITES in an informal, conversational manner, yet her tone is distant, and she makes everything—stories, anecdotes, even one-sentence descriptions of paintings—sound preordained. She is casual and regal simultaneously. At the beginning of *Georgia O'Keeffe*, she announces, "Where I was born and where and how I have lived is unimportant. It is what I have done with where I have been that should be of interest," and she follows through on this program of Olympian simplicity. Reading this memoir—a short text that weaves its way through a large, portfolio-size book of color reproductions of her oil paintings, pastels, and watercolors—you're held at first by how much O'Keeffe has left out rather than by what she has put in. Members of her family are unidentified and barely characterized; even Alfred Stieglitz, her husband from 1924 until his death in 1946, her first great supporter, and her dealer, isn't much more than a name that drifts by. (They marry in the Chronology, not in the text.) She seems to have no contemporaries, close friends, or critics, nor does she mention artists or writers of the past who might have influenced her or whose work she might love. What

we're given are memories of childhood and art-school days, often cryptic explanations of how paintings came about and what they mean to her, descriptions of objects she has admired and painted—shells, shingles, animal bones. It's the tiny, almost always physical and visual details that she wants to retrieve from the past. And while they aren't such odd details, they stand out with a surreal largeness and spookiness, since the surrounding landscape is so bare and unpopulated. Recalling a camping trip in the desert hills, she writes, "Breakfast was very funny. The wind blew so hard we could only fill our cups half full of coffee. It would just blow away right out of the cups. So we packed up and went home—most of the hundred miles sliding all over the road in the mud." Of a day she visited Stieglitz's gallery at 291 Fifth Avenue: "It was a day with snow on everything. I remember brushing snow off a little tree by the railing as we walked up the steps of the brownstone."

O'Keeffe began what was to become *Georgia O'Keeffe* (it could stand a better title) in the early thirties, when the painter William Einstein urged her to write about her art. In her typically blithe way, she tells us that, after she had begun, Einstein "went away and I forgot about it until Virginia Robertson found the writing a few years ago and encouraged me to continue." With the aid of Juan Hamilton, who helped principally with the technical aspects of assembling the pictures and the layout, she then worked on this book for three years. Parts of the text are reprints from catalogue statements that she wrote for exhibitions she had in 1923, 1939, and 1944. There are also sections taken from her *Some Memories of Drawings*, a handsome, trim volume that appeared, in 1974, in so limited an edition that it is virtually unknown. But if *Georgia O'Keeffe* has been worked on over a long period of time, with many interruptions, and with transplants from other texts, you aren't aware of this jumbled history when you read it. In mood, it's seamless, completely of a piece. O'Keeffe must think of it primarily as the ideal picture book of her art, and the text certainly is geared to the demands of the pictures. In the original, 1976 edition, now out of print, the book's size was enormous—16 by 12-inches (which means 24

inches when you open it)—and a typeface had to be chosen that was big enough so that the words wouldn't look like army ants marching across the pages. Even so, when you go from the text, which for the most part is placed on the bottom half of the left-hand page, and look up at the reproductions bearing down on you on the right, the sensation is like riding through a canyon. The canyon effect was a bit lost in a slightly smaller-sized edition that was published in 1977 and will be reissued this fall.

Yet O'Keeffe came up with more than an extra-large picture book with autobiographical remarks floating off to the side. In her late eighties, she produced a work that, far from being a rehash, reintroduces and perpetuates the qualities that make her original. The memoir is not just a feather in her cap; it's the whole cap, which completes her outfit. O'Keeffe has been one of the best-known figures in the world of the arts for over fifty years—in part as one of the few women who, at a time when it was difficult for any American to keep going as an artist for more than a decade, made full-fledged, lifelong careers for themselves. The only other woman painter of that period nearly as distinctive was Florine Stettheimer, but she self-consciously thought of herself as an amateur, and she was always a purely New York, and somewhat coddled, personality. Stettheimer had a cult following, whereas O'Keeffe was a figure with a national renown that cut through art circles and reached the widest public—a public that often had little or no interest in the art world. O'Keeffe's fame was special in that it was based equally on what people knew of her work and of her life. As the most famous couple in American art, she and Alfred Stieglitz each glamorized the other's career in his photographs of her—a legendary series of pictures, roughly five hundred in number, made during the years 1917 to 1937. The photographs (which to date have not been exhibited in their entirety) gave O'Keeffe an almost movie-star aura that, before Jackson Pollock, no other American artist had ever had. Whether she appeared, as she did in *Vanity Fair*, standing in front of one of her paintings, wearing a man's hat, or whether the photograph was simply of her hands touching her overcoat, Stieglitz's images dramatized a vein of bluntness in

her—a conviction that had already been felt in her art. People responded to O'Keeffe because she conveyed an almost story-book sense of the responsibility one can have toward one's art. Her painting, with its images of romantic, isolated purity, became an embodiment of an individual who was strong enough to live out her life exactly as she wanted to. For O'Keeffe's public, the pictures were almost as much about the attainment of privacy as they were about the flowers and bones, the Lake George and New Mexico landscapes she painted. And this privacy didn't have a snobbish or secretive overtone, perhaps because the themes in her art were so broad and accessible. For many Americans, especially in the twenties, thirties, and forties, O'Keeffe was a living symbol of self-assertion—not belligerently or anxiously, or with Pollock's tragic excessiveness, but with a mild, unflappable, resolute integrity. Her memoir has that same integrity.

There are artists' writings that can be called great literature— van Gogh's letters certainly; Delacroix's *Journal* probably. There are also writings—Noguchi's *A Sculptor's World*, say—that don't quite get off the ground: they give you a faint sense of the artist's mind, but the expression is too public; the artist sounds like his or her own press secretary. O'Keeffe's memoir, like Gauguin's fragmentary *Noa Noa*, lies somewhere in between. It doesn't have a robust or expansive spirit; there isn't much variety in the things it tells. Yet it is never monotonous, and though you may not want to embrace it, you can respect it. There are no loose, florid, or fancy touches, and her carefulness with language is charming and, ultimately, affecting. Every sentence seems to have been held up to the light, and tapped for soundness. Perhaps even more consistently than Gauguin, who dashed off *Noa Noa*, O'Keeffe has a real presence as a writer. Her voice is hauntingly off-key: it is always a shade too remote, too head-strong, or too naive. The way she presents herself, she could be a character in a short story (in length, her memoir is a long short story). She is the too isolated, eccentrically different adolescent who assumes she is not going to learn much from anybody, accepts her uniqueness, and grows to take some pride in it.

Highly opinionated, she sticks to her opinions even when, as she says, she doesn't know where they come from. But while she is entrenched in her isolation, she still wants to make contact with the world; she continually wants to rehearse the scene where she asserts her differentness. She might remind you of Frankie in *The Member of the Wedding*, except that she is never as vulnerable as Frankie. O'Keeffe is tougher; she has a mulish, Dreiser-like hide.

O'Keeffe surprises you most—she has an unexpected peppiness—when she recounts her dealings with people. "From my teens on," she says, "I had been told that I had crazy notions so I was accustomed to disagreement." But even earlier than that she had found that people questioned her, and she had to be adamant:

My first memory is of the brightness of light—light all around. I was sitting among pillows on a quilt on the ground—very large white pillows. The quilt was a cotton patchwork of two different kinds of material—white with very small red stars spotted over it quite close together, and black with a red and white flower on it. I was probably eight or nine months old. The quilt is partially a later memory, but I know it is the quilt I sat on that day. . . . Years later I told my mother that I could remember something that I saw before I could walk. She laughed and said it was impossible. So I described that scene—even to the details of the material of Aunt Winnie's dress. She was much surprised and finally—a bit unwillingly—acknowledged that I must be right, particularly because she, too, remembered Winnie's dress.

At the American Watercolor Society exhibition, in 1914, she looks skeptically at her earliest competitors, and trots through the show with the flip determination of the adolescent who can afford to brag because competition is still something being played out more in the mind than in reality:

Everyone was just about as they had been six years before. I hadn't been looking at pictures during the time away from New York, but I was really very bored with all of it as I walked around and I thought, "Making a painting as good as these is no problem. I'll go home and make one this afternoon for their next show."

She never loses that adolescent confidence. In the early twenties, when she becomes a significant figure in New York (she was to be the subject of an early *New Yorker* Profile by Robert M. Coates), O'Keeffe eyes her competitors with the cocky assurance of someone who enjoys playing the outsider:

It was in the time when the men didn't think much of what I was doing. They were all discussing Cézanne with long involved remarks about the "plastic quality" of his form and color. I was an outsider. . . . I never did understand what they meant by "plastic." Years later when I finally got to Cézanne's Mont Sainte-Victoire in the south of France, I remember sitting there thinking, "How could they attach all those analytical remarks to anything he did with that mountain?" All those words piled on top of that poor little mountain seemed too much.

But she humors them, these unnamed "men"—or "city men," as she refers to them elsewhere, or "boys," when she is talking about student days. In 1922, she is up at Lake George (where she and Stieglitz went in the summer), using "the Shanty," a large one-room shed beyond the farmhouse, as her studio. The Shanty

looked very shabby. It had never been painted and the outside boards were scorched by the sun. The clean, clear colors were in my head, but one day as I looked at the brown burned wood of the Shanty I thought, "I can paint one of those dismal-colored paintings like the men. I think just for fun I will try—all low-toned and dreary with the tree beside the door."

In my next show "The Shanty" went up. The men seemed to approve of it. They seemed to think that maybe I was beginning to paint. I don't remember what the critics said about it, but when Duncan Phillips saw it he bought it for the Phillips Collection. That was my only low-toned dismal-colored painting.

The world of "the men" is a comedy for O'Keeffe, but that isn't how she sees her own life. *Georgia O'Keeffe* has the ornamental delicacy of observation of *Noa Noa*, and also shares its vision. Gauguin's novelistic memoir about his Tahitian voyage is a dream of uncivilized strength and beauty told by a man who

wants to live in such a dream and imagines he is coming closer and closer to it. O'Keeffe's is a more summery, self-assured version of that dream—*Noa Noa* without Gauguin's victimized, high-strung, all-or-nothing edge. Gauguin had to struggle to stay in his paradise, but O'Keeffe seems to have been born in hers. About one of her desert camping trips, made near her home in northern New Mexico, she says, "We went on a warm still night. We were very comfortable in a new tent. I was up before the sun and out early to work. Such a beautiful, untouched lonely-feeling place—part of what I call the Far Away." O'Keeffe sees every facet of her life as imbued with the spirit of "the Far Away." She isn't mystical in the religious sense, but she has a mystic faith in perfectionism. She tells about sitting in on Alon Bement's course at the University of Virginia in the summer of 1912. Bement, she says, "had an idea that interested me. An idea that seemed to me to be of use to everyone— whether you think about it consciously or not—the idea of filling a space in a beautiful way. Where you have the windows and door in a house. How you address a letter and put on the stamp. What shoes you choose and how you comb your hair." She could have added "how you make a book," since the few books, catalogues, and portfolios that there are on O'Keeffe, including this one, have been done under her supervision, or with her participation, and are quietly ritzy productions, simpler and clearer in format than most art books, made with a greater feeling for the best possible quality of reproduction, the finest paper, the least obtrusive layout.

O'Keeffe's paintings mirror this belief in the beautiful, organically whole gesture. They are souvenirs of a way of life that is based on the idea that all experience can be seen aesthetically. Yet these souvenirs don't travel very well. Like Shaker furniture, they demand their own setting. In the open competition of the museum, her pictures can seem awkward, raw, precious; you can see that she is serious, but the paintings leave a residue of something garish and untextured. They're sparklingly bright in the wrong way, like Old Master paintings that have been cleaned excessively and turn out to look naked. O'Keeffe, of course,

would be the first to say that she isn't speaking the language of "the men"—Mont Sainte-Victoire, in her mind, will always be an actual physical object, "that poor little mountain," and never a motif. She is one of the most ambitious artists of her generation, but she has never been fazed by the great desire of her contemporaries, and of subsequent generations: the desire for one's painting to hold its own next to Cézanne, Manet, or any of the modern heroes of the museum. Her art does something else. If O'Keeffe's are often the paintings that we are attracted to when we begin our careers as museumgoers, it may be because, especially when we come to them in our adolescence, they are among the first paintings that give us an inkling of what style is—of the way every nuance in a work of art can come back to one conception, and the way you can hold that conception in your head, as if it were a real thing. Hemingway does something similar when we first read him. He takes the anonymity out of language, and shows how personal and three-dimensional the use of words can be, how a sentence can have a profile and be as contoured as a carving. O'Keeffe enlarges and animates the formal elements in art and keeps each one distinct: the sharp, clean line and the gauzy lack of line; the heightened bright colors and the glistening blacks; the voluptuous never-ending curves and the abrupt, pinpoint conclusions; the creamy surface and the dry, brushy surface. Feeling our way through the parts of a painting of hers is for many of us one of our earliest experiences of the physical act of painting. In retrospect, the experience can seem too simplified; you may want art that gives you all these elements without any of the distinctions among them. Yet, at the time, seeing the elements so distinctly is what is so powerful.

If O'Keeffe expresses the glamour of style for many Americans, it may be because her audience (rightly) intuits in her a disinterest in the sociable, urbane side of style. She represents style without the overtone of stylishness, fashionableness, artificiality. O'Keeffe's aesthetic is closest to Art Nouveau, but she doesn't have the conscious sense of style or the witty-and-romantic double awareness that we expect from figures of the fin de siècle. (Born in 1887, she just missed being part of that era,

though she did grow up in its shadow.) Beneath the Art Nou-
veau surface of her art there is a more deliberative, even obdu-
rate layer, and it expresses itself in a way that almost makes her
seem like a primitive—though not in the untaught sense. She
resembles a primitive in that she is devoted to reproducing the
real world as it appears before her and carries in her mind a very
firm idea of how things should look—and the two don't quite
match. There is a distorted overlap, and, as is often the case with
primitive artists, you don't know how much of this distortion
she is aware of. Very little of it, you suspect. The paintings hint
at this out-of-sync clarity: it is there in her visionary, looming
sense of scale, and in the difficulty of knowing, from painting to
painting, whether she wants to be photographically precise or
abstract.

In the memoir, you are constantly aware of this sleepwalker's
realism. It is often hard to be sure whether she is being sarcastic,
or deliberately funny, or simply getting to the point as directly
as she can. And what are we to make of Juan Hamilton's
photograph of her on the back of the book's jacket (which one
assumes she planned, or at least wanted)? We see her from the
rear, standing on a small rise of earth, with the desert landscape
and sky spreading out before her. Her left arm is planted on her
hip, and her right arm holds a wooden cane, which, at its sporty
angle, hardly seems to be for support. Her only company is a
chow, and the dog is turning its back on us, too. Sensing that the
photograph must have been taken recently (O'Keeffe is ninety
now), we can't help feeling a dramatic nobility in the moment.
But it is also a very stagy photograph. It could have been meant
as a parody of the last scene in a Western. There is an unattrac-
tive Cheshire Cat archness about it, as if O'Keeffe were being as
sporty with her own public image, and with her public, as she is
with the cane. Yet no one "meaning" seems more right than any
other, and you are left swimming with them all. The last plate in
the book is another, though less ambiguous, photograph of
O'Keeffe, this time showing her in a darkened pottery studio,
touching one of the pots on a plain wooden shelf. (All the pottery
is Hamilton's.) The pots are each a different shape and size, and,

placed in the foreground and background, they enframe O'Keeffe. Dressed in black, with a black kerchief on her head, and with a bit of white shirt showing at the throat, she looks like a member of a monastic order; as she reaches out to feel the shape of the pot, she also could be a gardener making rounds in a greenhouse. Poised and easy, she appears at home in a world of simple, elegant, well-made objects.

You go back and forth between these two O'Keeffes—the tomboy with her angular feelings and her back to us, and the serene high priestess of aesthetic decorum, a work of art in her own person. They don't intersect neatly and coalesce; like the elements in her painting, they remain separate. Between them, though, you can gauge how much theatrical blood she has in her; you can see how Stieglitz could want to keep photographing her again and again for years. In the portraits he made of most of his friends and family, Stieglitz showed both what his sitters were and what they imagined themselves to be: he exposed and poeticized his subjects. But O'Keeffe didn't allow that much of herself to flow out, and he never got one definitive, psychologically rounded image of her. What he did get was a performance. In these pictures, O'Keeffe is the one great actress of still photography. She can appear as a madonna or a clown, an icy romantic princess or a waif, and throughout the series the mood is never more than surface-deep. Yet the photographs of her aren't superficial, and you don't question her sincerity or Stieglitz's, because she seems so lost in that surface. She isn't mugging or impersonating, she's entrancing herself. She may be wearing masks, but they have been brought up from within— they are her own. In the memoir, she personalizes the qualities that give her such an elusive, mysterious presence before the camera. But while she lets you draw closer, she doesn't reveal any more than Stieglitz was able to get. Writing about her life, she is still entrancing herself.

1978

▶▶▶▶

Lucas Samaras

I

LUCAS SAMARAS TAKES a widely known pride in being the most solitary—and prickly—cactus in the landscape of contemporary New York art. He may be the most unpredictable art world personality since Eilshemius, the difference being that Eilshemius comported himself as if he were a lunatic, frightening or alienating his contemporaries, and was profligate with his talent, whereas Samaras doesn't act crazy, and doesn't misuse an ounce of his talent. Samaras may like to think of himself as the odd man out of his generation, and he literally is an outsider: he was born in Greece and came to this country as a boy (and became a U.S. citizen, at age nineteen, in 1955). But he is of his generation in a crucial way: though a bit their junior, he shares with Roy Lichtenstein, Alex Katz, Claes Oldenburg, Dan Flavin, Jasper Johns, George Segal (whom Samaras knew at Rutgers), and many others a belief in the virtues of a well-conducted career. He is very much a member of the generation that rejected the lofty striving and self-conscious emotional, physical, and artistic recklessness of the preceding generation—the Abstract Expressionists. Samaras, Segal, Katz and the rest admired their immediate forebears for their struggle and for finally giving American art an international distinction. Samaras and the members of his generation were well aware that a great highway had been newly paved for them. But they saw no romance in being at loggerheads with critics and dealers, or in being visited by alcoholism, spurts of activity followed by years of indecision, suicide. They wanted to be professionals as much as heroes—professionalism was a kind of heroism to them. Many of the Abstract Expressionists felt they would compromise themselves or lose their thrust if they put their energy into anything other than grand signature pieces. Besides, most didn't have the means, until relatively late in their careers, to do anything other than make

those signature pieces. But their successors have given themselves freely to experimentation. They've spurred new and adventurous printers into existence, and have taken advantage of a variety of print and multiple techniques, without hesitation or concern over what that might do to their chosen major art forms.

The most dextrous experimenter and medium-hopper of his generation is Samaras (Robert Rauschenberg is his only rival). Over the years, while maintaining the same Samarian presence, he has touched on nearly everything: orthodox Surrealism, "body" art, "process" art, Minimalism, figurative art, photography. He has made boxes that recall Joseph Cornell; good-size abstract sculptures in cor-ten steel; a room the viewer can walk into, mirrored on all sides and top and bottom; pastels; silhouette cut-outs that are affixed to the wall. Now he presents us with "Reconstructions," a series of large machine-sewn wall-hangings which, formally, could be compared with Cubist/Constructivist abstractions, though, as objects, they're more like patchwork quilts. Most 7 feet long and more on a side, they are assemblages of wildly crisscrossed strips of fabric—polka-dotted, patterned, striped and solid, glittery and matte, black, white, and multi-colored. Framed with barely noticeable pale wood stripping, the works lead a double life as quilts and as paintings, though they aren't exactly either.

Historically and biographically, the "Reconstructions" are attractive stuffs. They are a new venture for Samaras (who rarely works so big), yet they fit right in with all his concerns. Samaras is an instinctive and classy inventor of abstract decorative patterns, but he has usually kept the patterns (literally) in the background. His foreground has been the human face, or parts of the body, or common things—chairs, forks, glasses, birds—that he doesn't have to invent, but which sit there, at the forefront of his mind, ready for use, as they sit at the forefront of most people's minds. Here, though, he lets the decoration take center stage. Having set this art historical table, he has given us, it must be said, a meal that is a letdown. The catalogue for the show includes a long interview between Samaras and Barbara Rose, who has the strength to ask, "What are you angry about?"

and, later, "Why are you so mad?" He gives roundabout, allegorical answers to both questions, but most of the interview isn't roundabout. Like Katz and Donald Judd, Samaras has a critic's sensibility; he is a canny judge of his competitors, living and dead, and of where he stands in relation to them. He says at one point that the problem with Duchamp is that his work "didn't have this thing we call plasticity or painterliness—something that Rembrandt had that some dry person doesn't have." Samaras puts himself on the side of Rembrandt, as opposed to the dry people, which is understandable. It's even warranted. In his photographs, he toys, like Rembrandt, with being a ham. Yet these fabric paintings are dry. They don't have "plasticity," and it's more of an issue than it is with Duchamp, for whom plasticity is largely beside the point in the first place.

The problem with the fabrics is that they don't assert their own fabric-ness. They seem to be stand-ins, as yet characterless, for some other medium. The pictures have more lustrous, luxuriant life in reproduction, where the lines, chaotic as they are, are fairly readable and dimensional. When you look at the photograph of "Reconstruction # 26," say, before it occurs to you that the point might not be near and far, or in and out, you assume that there is conventional deep space to the image. When you stand before the actual pictures, though, the lines don't compose themselves with any depth; the different fabrics sit equally—and blankly, airlessly—on the surface. In formalist terms, this up-frontness would be the seal of approval, but Samaras's purposes have never been served by those terms. When his art suggests most and feels most personal—in his pastels and SX-70 Polaroid photographs—there's a different kind of palpability to his surfaces. You look into them the way you look into marble, or the surfaces of Fabergé boxes and pieces of jewelry, or German Renaissance and Flemish primitive paintings—you want to let your eyes roam down into an enameled or powdery iridescence, one that suggests layers of color beneath it. In his pastels and photographs, Samaras is at his most old-fashioned and most daring; he rescues from shallowness the colors you associate with childhood and with fairy tales, hues that feel embered rather than distinctly hot or cold, tapestry-like

rather than naturalistic. He makes these too-rich colors emotionally dense.

But it is more than the fabric, in these "Reconstructions," that doesn't sit right—it is the conception. The great energy that has gone into making quasi-paintings out of sewn crazy quilts seems misplaced, even a bit ostentatious. By their large size and scope, they ask to be judged in the company of a tradition of American abstract painting now going back over several generations, and, in that company, their fancy, intricate energy is tinny, insufficient.

Lucas Samaras doesn't seem to face what for many artists are stumping, crucial questions—What should be done next? How can a jump be made into a new area? He has jumped effortlessly from one thing to another; but, recently, the jumping has come to seem almost mechanical. His ideas, with their regimented titles ("Photo-Transformations," "Reconstructions"), tend more and more to march by, in formation. Every Samaras show now seems to be another neatly wrapped package, out of which comes yet another immediately perfected new medium. Behind the unconvincing energy of the fabric paintings you feel the pressure of someone who believes he owes it to his audience to continually do something different—who believes that we would grow restless if he did the same thing for more than two consecutive shows.

This isn't to say that he should stay with one idea forever. Obviously, he doesn't have the temperament of someone who grabs onto one thing and wrestles with it until he gets it right. And this hasn't been a bad period for him, either. In the seventies, he produced the series of SX-70 Polaroid photographs, among his most perfectly realized works. Wedged in between was a strong show of 1974 pastels, at the Museum of Modern Art. But there have also been many works with the toneless appearance of manufactured products, both slight pieces (plaster reliefs with forks and spoons; a group of elaborate drawings entitled "Matrix"; wall plaques with letters in them; a series of cut-outs pasted on the wall) and more ambitious ones (the new fabric paintings).

Samaras draws his strength from a show-off's dare. He bets

that he can make presumably unusable, artless materials and "minor" mediums go beyond themselves. The dilemma of the "Reconstructions" and other recent work is that he's so clear about what he wants to say, and can make the new materials bend so easily to his will that he's riding right over his sources. He's erasing whatever might have been artless and coarsely powerful about them to begin with.

1978, '81

II

THERE IS A REINED-IN QUALITY to Samaras's work. Partly that's a product of his having grown up in the shade of the Abstract Expressionists, many of whom, with an often overbearing insistence, staked all on finding an art that sprang from the unconscious. Such an endeavor didn't have to be repeated immediately, and the most independent sons of such fathers thought it was best ignored. Lucid self-knowledge and the ability to talk matter-of-factly about one's work and to predict its future course have been prized by Samaras and his peers. Many have long attained worldwide fame and the status of master, yet many have liked to think of themselves as masters in journeymen's clothes. Samaras, though, is hyperconscious even by the standards of his peers. Yet, depending on the medium, this is what gives his art its extra life. He is reined-in even in his pastels, where he is at his most intimate, and where he touches his deepest theme: imagining what it would be like to be different.

There was a roomful of these pastels in his 1972-73 Whitney retrospective, where, for those who hadn't been aware of the early phase of his career or had only seen an odd one here and there, they were a revelation. They had a warmth you didn't expect in him. They left you with more, they had more body, than his objects—his Surrealistically transformed chairs, boxes, table settings. Exquisitely crafted and absorbing as many of those pieces were, they seemed a little ephemeral; they had the weight of end products of his imagination, whereas with his works on paper—the pastels and the "Autopolaroids," hung in

the last section of the maze-like installation—you felt, "This is what he's about."

Samaras has turned to pastel periodically from the late fifties on. In the seventies, he began working on durable Bristol sheets, but before then he used the most ordinary color construction paper, in 12 by 9-inch pages. Children use it to draw on in school—you can pick it up in plastic packets in stationery stores. He has immersed himself as fully in other mediums, specifically photography; but his photographs don't have the variety or quite the resonance of his pastels. In his "Autopolaroids" and his later, finer series of SX-70 Polaroids, he is the only subject—the lone man in his undisguised kitchen studio. He pirouettes in states of undress, mugs with a cigarette dangling from his mouth, draws himself up, in a black robe, like an imperious archbishop, dons wigs, crouches in a fetal position, cries, grins, snarls. Sometimes, wearing a surprisingly schoolboyish red plaid shirt, he simply sits and looks blankly at the camera. He appears to be a little tired, but there's also a witty, sardonic dare in his face. Something in the slight lift of his brows seems to say, "So you want to do battle with me?" It isn't Rembrandt he reminds us of in these photographs—Samaras isn't a homely, fleshy man who plays up his homeliness, or a man who, from middle age on, gradually transcends his bulbous bad looks. If Samaras's self-portraits resemble anyone's it is Dürer's. Samaras radiates the same self-loving hauteur—which we like, which is funny, not intimidating—the German master does. Samaras obviously knows he's romantically handsome; he is aware that there is hardly an angle where we don't get a sense of the beautifully stepped but not bony planes of his face. That may be why he sometimes looks at the camera blankly, or attempts to uglify, to contort his image. He wants to escape from his handsomeness. Bathed in colored lights, peering out from under his decorative scratching of the Polaroid emulsion, he makes himself into a modern version of Merlin in his lair—he has an encyclopedia of visual effects at his disposal, and he is also trapped, isolated by his wizardry.

The pastels show a larger world. (In the late summer of 1981 the Denver Art Museum mounted a virtually comprehensive

exhibition of them—a little over a hundred, all drawn from his own collection.) They're populated by boys and girls and young people who are anonymous, almost faceless. They're not real people, but we feel we know them from the way they hold their bodies, droop their heads, or sit on a sofa, legs and arms crossed. There are pastels of individual figures who sleep in bed, naked, face down into the pillow, and of couples who lie awake in bed, eying each other. There are images of exquisitely proportioned, elegantly muscular nude bodies, and of puppet-like naked ones, as ethereal as El Greco's visionary waifs, as leggy and gangly as the stick figures on a Romanesque church portal. There is a pastel of a ghostly white, clothes-less body, marked with wounds and dripping blood, hanging above a path that makes its way through a forest that an American-born artist might not have created so easily or masterfully. This forest is the dangerous and magical one of European literature and art, where fairy tale and legendary characters lose their way or are held up or transformed. In another work, a headless body stands before us with stumps for arms and its chest cut open. There are pastels of ice cream sodas that become faces, and others of classically perfect tapering torsos that start, at the top, with female breasts and end with penises. There is one of a boy on the toilet— behind him is the same lush, tangled forest setting that is the backdrop for many of the naked bodies.

Some of the loveliest works are of girls and women wading in the water, their skirts pulled up to their thighs (a quote of Rembrandt's "Woman Bathing"?) And there are many still lifes—it seems second nature for Samaras to draw a vase with flowers in it. He makes each slightly different from the next, but they are all the same in spirit: they feel to be alter egos of the artist in his most well-behaved, watchful mood. The flowers are often seen in interiors that would be perfect settings for Edgar Allan Poe stories. These bedrooms and boudoirs, living rooms and waiting rooms are lit by low, unearthly light; on the walls, there are paintings of mountain peaks and kissing faces and sunrises. Although, in these dream settings, you can't tell—the paintings might be windows.

But the most consistently successful pastels are the heads.

Something illustrational clings to a few of the still lifes and interiors, and you often want their scale to be bigger; you feel you're looking at a painting reduced to a full-page color illustration for a children's book—a more sophisticated, private version of an Arthur Rackham or an Ernest H. Shepard. But with the heads, Samaras' scale is always big and he is more spontaneously abstract. The only thing he has to pay heed to is the basic layout of a face—mouth, nose, eyes—and he obviously responds to a situation where there are details he must include. That small dose of restriction seems to give him his fullest freedom to invent. There are cartoonish, bug-eyed, upside down faces; faces that look as if the smeary, lemony light of a motel's colored neon sign is reflected on them; fat faces with tongues sticking out at angles that recall Northwest coast Indian masks; faces that have toothsome, firm, tiny vaginal mouths and toothsome, firm, vaginal eyes. The spirit of these faces could be called Expressionist—one face, turned to the side, in the process of having its parts woozily rearranged, might be a homage to (or parody of) Francis Bacon. But Samaras, by birth and in spirit, is a Mediterranean, show-business Expressionist—his feeling for deformity has a gargoylish, let's-pretend quality behind it. We don't feel that there's a suppressed fury in these heads; they don't seem to cover up some ugly, pinched inner spirit. Samaras's heads are slightly different from masks: they're more the product of someone who plays with the thought of having different identities and plays with different formal, stylistic identities at the same moment. You don't have to know that Samaras later made photographs of himself making faces to feel that these pastels are imaginative versions of someone looking at himself in the mirror and trying on a new face.

Samaras made perhaps the most stunning of his pastels between 1960 and 1962, when he was in his early to mid twenties, and the reckless dissimilarity of each one from the next suggests early work. But they don't feel as if they're from the hand of a young artist, and it comes as a surprise to learn that he was that age when he did them. In tone, they are the work of an older man who has long since polished his techniques and thinks back on a time when expressive and personal freedom was his for the

asking. These images of boys and of young lovers, of domestic happiness and of rooms with windows that open out onto nighttime views of the sea and the mountains, seem to be the work of someone visualizing a past for himself, for the faces and scenes have a what-if, made up quality to them. The pictures might be called memories of imaginary times.

Samaras's greatest gift is that he brings a surprising mixture of voluptuousness and innocence to contemporary art, which hadn't thought there was room for either. The voluptuousness doesn't only come from the tropical lusciousness of his color or from the way you feel him taking pleasure in rendering bodies of late-adolescent, unused perfection. He gets the note of about-to-be-sprung sexual energy even in abstract pastels that are no more than tinted vapor, or in his images of vases of flowers that are placed on tables next to lily ponds. Rather like a therapist who sits listening to a patient, the domesticated and prim cut flowers seem to preside over and also share something with the aroused pond, with its shimmery reflections, its reeds standing erect, its feeling of being whipped by wind in the moment before a summer shower. But without the neatly bunched flowers, the pond wouldn't appear so aroused. Pastel is perfect for Samaras because it has a fiery livingness to it, and also because it suggests something opaque, sluggish, as yet unlit. The most breathing of mediums but also the most dryly dormant, pastel has been especially suitable for artists of fierce, even aristocratic, independence of mind who are also, or so we imagine from looking at their work, people of some hiddenness, shyness, untestedness, almost, we sense, emotional virginity. Degas and Mary Cassatt, the first to make pastel as brusque and imposing a medium as oil painting, were people of such temperament, and so is Samaras. You feel that he loves pastel because the act of rubbing the medium into the paper with his fingers gives him the most direct, unimpeded way of creating a rippling, pliant but firm musculature. Rubbing in the powders, he seems to be massaging different skin-like densities into being.

Yet he also preserves the pebbly coarseness of pastel. He makes that coarseness suggest a child's vision and hand. A little

like Edward Hicks's "Peaceable Kingdoms," Samaras's pastels give a child's idea of how the world looks—one where gestures are frozen; heads are a touch too big or too small; eyes stare out at us with theatrical ferociousness, like guardians of the temple; and the settings, whether they're forests, rooms or ponds, have a sheltered-from-all-storms, Garden-of-Eden beauty. There's something lost and imploring about these faces and settings too, no matter how veiled or off-putting they may seem at first. I don't think Samaras deliberately aims for these feelings—they seep in, and not only to the pastels. The feelings are in many of the things he does. The mood is only more evident in the pastels.

Voluptuousness and innocence is a mercurially unsteady mix; it could easily become overrefined or sentimental, but Samaras gets away with it, perhaps because, with his natural distance from things, he makes the elements reveal themselves slowly, layer by layer. He is a spectator, not only of his command over materials and ability to put images through a set of fantasy paces, but of human responses, functions, desires. But in his recent work he is too much of a spectator: the two series of fabric "Reconstructions" have the weight of so many exercises, and he is a very removed master of ceremonies in the 8 by 10- and 20 by 24-inch Polaroids called "Sittings." He is trying to bring more of the world into these photographs, the largest he has done, made in the late seventies and early eighties. In each picture, taken in his barely disguised studio apartment, we see him, fully clothed, by the side of a nude model who poses in a setting of colored lights and sheets of patterned fabrics. As usual, Samaras is cavalier about where the "setting" ends and the unintriguing details of his apartment begin. And he makes no pretense about what he's doing in the pictures: holding the cable release in his hand, he is clearly the photographer. Carter Ratcliff, who wrote the introduction to the "Sittings" catalogue and was one of the many models, describes how Samaras told him to remove his clothes and assume any position he wanted. Though it wasn't spelled out so clearly, the point was for the sitter gradually to lose his or her self-consciousness. The idea was that as Samaras took a second, a third, a fourth long exposure, the individual

would become more comfortable and take the opportunity to act a little, to reveal something of who he or she is.

But while Samaras captured (or prompted) a wide variety of poses on that chair, he and his sitters together revealed little. There is something hollow, artificial about the undertaking. If you are familiar with these models, who are predominantly art-world personalities—Sidney Janis, David Whitney, Arnold Glimcher, Chuck Close, Jasper Johns, and Diane Kelder are among them—you may have added curiosity to see the un-clothed article, and you may contemplate how you would present your unclothed, to-be-exhibited self. You wonder if you would cover your genitals, as most of these sitters have. But after you have gone around the gallery walls and checked off Jasper Johns and Chuck Close and Sidney Janis and the rest you are left with very little. The issues and feelings that are stirred up—the shyness and discomfort of people who want to be natural while posing in the nude and obviously cannot; the play-acting narcis-sistic bravado of some of them; the desire of others to take contorted, tricky positions—these strategies don't make for pic-tures that you want to go back to. The viewer feels he has seen these responses before, in other situations, when people are put on the spot and perhaps embarrassed for a moment, but divulge no more of their true selves than they do at their office desk or at a dinner party.

The one picture with real mystery and tension is the image used on the catalogue's cover, of the somewhat homely wood dining-table chair the subjects sat on. Placed at an angle on the little platform used for all these photographs, the chair is lit with rays of green and red light; striped and patterned fabrics are on the floor and wall behind it. This picture has the flavor of a real place: we could be in a Mediterranean or South American small-town restaurant-bar, one where the door is always open, the village dog walks in and out at its leisure, a tiny, crudely decorated stage is against a wall, and on the stage there is a chair that is only used on the weekend visit of a local singer or magician. Enframed by spotlights, the sturdy, simple, glowing chair has more presence than any of the subjects who posed, or

than Samaras does himself. Though his is the face, in each of the photographs, that you look at longest. Even when he's most detached you suspect he is hiding some response. But he is a little too unengaged, and his uncertainty gives these photographs their static mixture of the naughty and the bemused.

Samaras stepped into a genius-like control of his talent and feelings when he was very young, and this assurance has enabled him to make art without really having to come in contact with the world. He has been able to be inventive and fresh about his most fleeting instincts and urges. Along the way he has fashioned a many-segmented autobiography that has as its hero more of an Everyman than one might expect. Beneath the exotically opulent, peacocky surface of his work, there is a chronicle of unexotic, down-to-earth feelings. He recreated a childhood and youth for himself in his pastels from the early sixties, then fashioned an image of his more grown-up, mocking, bristly, bearded self in his early sets of Polaroids. His pastels from the mid-seventies, more silvery, black, blue and green in tonality than the earlier ones, are more sparsely populated, filled more with images of empty rooms and the ocean. In them, he seemed to be imagining his own absence—what the world would look like without him. Together, these works chart a boy's desire to be different, an adolescent's desire to be in love, a young man's impudence, a grown man's anger and sense of isolation.

His challenge now is to bring another stage of himself into his art: the middle-aged Lucas Samaras, the man who, with increasing years and fame, finds himself more at home in the world. There is a glimpse of this less prickly self in the "Sittings," where, peering into the scene from the side or looking out with mock-fatuous blankness, he seems relieved to not have to be at center stage, happier than he can bring himself to show. But Samaras has long thought about his non-solitary double. He appears even in the early pastels, in those occasional images of encounters between people—in bed, in rooms, in looming close-ups—that leave them, so it seems, wedded forever.

1982

Photographers

▶▶▶▶

The Boy Artist

JACQUES HENRI LARTIGUE's early photographs represent one of the reigning marvels of the medium. That some of the most memorable and exciting pictures ever taken were done by a small boy, who had no formal training in any art, between 1902 (when he was six, though it wasn't until he was nine that he was fully underway) and the time of the First World War, "poses," as they say, "certain questions" about photography. Lartigue, the subject of exhibitions at the Witkin and Neikrug Galleries, was naive about what he was doing but he wasn't a primitive or "naive" artist. He didn't have the determined seriousness that characterizes the primitive; there is nothing awkward about his approach. These photographs of Parisian life before 1914 show a boy living his life—from childhood to mid-adolescence, from roughly nine to sixteen—through his camera. A daily journal by a girl or boy that age might be charming and flow along, or it might have a stiltedness beautiful in itself. It might present the awarenesses and frustrations of that time in one's life through the phrasings and attitudes of great (or not-so-great, even terrible) writers read, loved, and appropriated the next day. But it's hard to imagine a child or adolescent writer achieving the mastery with words that Lartigue achieved, almost immediately, as a photographer. In photography, a looser, more instinctive kind of learning, a bodily self-confidence, is often the only thing needed to make one's feelings count. This confidence guarantees that a way of seeing will be imposed on the machine.

Jacques Henri Lartigue, who makes you feel that, in his eyes, every person and thing is truly splendid, didn't know enough not to be self-confident. He had, of course, a glamorous and vivacious subject: pre-war Paris. Not many photographers are blessed with the fashionably opulent, style-obsessed society that observers from Lartigue, at one age and level of innocence, to

Marcel Proust, at the opposite pole, had to work with. The outgoing, stunning appearance of that society seems to have been conceived after patterns set by artists. People dressed for the streets, they dressed for gardens; they appear to have got especially done up for the race courses, where, in staring at, talking about, and pretending not to see each other, they did as much work as the jockeys and horses they were ostensibly there to see. These elements, plus the then beginning excitement of sports cars and motorcycles and attempts at flying—and the festivities surrounding the meets and trial runs for each—are inseparable from Lartigue's success. What make his pictures expressive of all this at its most glittering are those qualities of his that are literally childlike. His decisions about how to make good pictures are based on intuition. And the happy, embracing intuitions sprang from his trusting relationship with his family— sportsmen and inventors who had become wealthy as bankers. He seems to have had no doubts about his family, except the small doubt that made him pull back from being a sportsman himself, and become instead a recorder of the sporting life. He must have felt that he had an important position: he was official recorder for a court of hard-working hobbyists. His trust in his parents passed smoothly over to a sense of partnership with the relatives, servants, retainers, and mechanics who made up the Lartigue family entourage, and then with the larger world of total strangers. There doesn't seem to have been much difference for him between his family and society.

Lartigue's reactions are physical: he responds to the rhythms in the auto races, the glider events in the fields, the promenades on the beach, and the strolls on the Avenue du Bois de Boulogne as a would-be participant or, beyond that, as a hero-worshipper. His perceptions go no deeper than his belief in the beauty and thrillingness of what is before him, and the perceptions are so intense and uncomplicated that there is no room for any other feelings to slip in. It is as if in *Remembrance of Things Past* the narrator Marcel were never to grow up, never to get a vantage point on the people that seemed so extraordinary—so god-like and huge, smiling, handsome and fair—when he first saw them. In Lartigue's case the images are mastered by his exuberance: the

camera eye can't wander off on its own, as it often does with photographers who are less adamant in their feelings or who know more, perhaps, than they have the means to put down. Lartigue uses the machine with the impetuousness, the blithe daring, that children and adolescents have in a lot of the things they do, and the camera, the litmus-paper art, responds to his touch. Just as children rarely put unnecessary, unfelt details into their drawings, so Lartigue's photographs rarely have flat, unliving patches; there is a tension even in the empty spaces between figures, or in the stretches of blank sky he chooses to include. His youthful, inexperienced sensibility dominates everything; perhaps this is why his pictures have little of that sadness—that sense of the unrecoverable past—that old photographs usually have. It probably never dawned on him, especially in the first five or six years he was using the camera, that he was making pictures which he would be able to look back on, which would come to be mementos; he had no unconscious nostalgia in him, and his pictures, today, don't make us think of how far we are from those days. Some of his photographs are so vivid and immediate that we feel we are looking at ourselves in costumes from the Belle Epoque.

He went on making photographs after the War; he has been at it now for over fifty years. But the total embrace of the camera left him after his adolescence. He became professionally involved with painting, and his later photographs betray less inspired snapshot origins. Among them the ones of women, known and unknown, girlfriends and bathing beauties, stand out. They are a little too close to magazine illustration, and the autochromes often verge on a pastel-soft pornography, but there is a love of picture-making in them, and you want to look at them, if only for a moment or two. They are charming photographs by a boulevardier who was also, in spirit, a cuddly youth. Lartigue's real maturity, like an athlete's, came when he was young in years. As those years passed the simpler, more boyish boyhood, which he hadn't had time for as a boy, finally caught up with him.

1973, '81

▶▶▶▶

Frederick Sommer

THE WORK OF THE photographer Frederick Sommer represents
Surrealism at just about its most purely experimental, coldly
uncanny pitch. His brand is of the genuine, Parisian thirties
variety; he shouldn't be confused with the many younger
surrealist-type photographers, trick-obsessed manipulators of
the great possibilities of the medium, who rarely bring to what
they're doing, as Sommer does, an equal interest in automatic
literature, psychoanalysis, abstract painting, atonal music. If
you look at Sommer's work with a prior interest only in photog-
raphy you might find his range of subject-matter confusingly
unanchored. His pictures mean more if you're familiar with the
Surrealist spirit of dream-mining, automatic art-creating, and
material-defying experimentation, and if you know the work of
Joseph Cornell, Man Ray, André Masson, and Max Ernst (a
neighbor and close friend of Sommer's in Arizona, in the forties,
and the subject of a fine, frequently reproduced, shirt-less
portrait by Sommer). In this company, his pictures take on a
much richer, much more understandable (though not, of course,
completely understandable) life.

Sommer's exhibition at the Light Gallery was his first one-
man show in New York since 1949. He was born in Italy in
1905, to Swiss and German parents, and brought up in Brazil.
His father was a landscape architect, and by his early teens
Frederick Sommer was working as a draftsman in his father's
office. Architecture and landscape and city planning absorbed
him throughout his early manhood. He received a degree of
Master of Landscape Architecture from Cornell in 1927, and
was a practicing architect in Brazil in the late twenties, when he
was in his twenties. Out of this terrain he moved into studying
Cubism, which he found aesthetically related to his professional
work. In 1935 a key encounter with Alfred Stieglitz (one week's

148

time) made Sommer think that he could accomplish even more in photography, and this feeling was strengthened with the friendship he began with Edward Weston the following year. (Weston himself had had such a decisive, short meeting with Stieglitz in 1922, a meeting that, he said, sent him back to California with a new confidence in what he was doing and a more profound understanding of his medium.)

The recent New York exhibition included a number of Sommer's extraordinary early-forties landscape photographs of the Arizona desert. It's impossible to situate yourself in these pictures. As Gerald Nordland, who wrote the catalogue for the large 1968 Sommer exhibition at the Philadelphia College of Art points out, because the horizon is left out, these views have no beginning and no end. Exactly what is going on in many of the landscapes is hard to tell at first; as your eye becomes used to the actual space and immense amount of finely textured detail—the pictures are quite small in size and printed with an awesome perfection—you find yourself crawling up the picture plane. That is the only way to get your bearings. Sommer photographs junk piles in the same "all-over" way; we're put in the position of hovering over a floor that's far below us, but instead of being securely above it we're made to feel we could easily slide down into it. We don't know where he was when he made the shot. These images have the same frightening, nightmarish power as the landscapes. The experience of both of them is like finding yourself thrown out of an airplane and falling into the sea. All of this disorientation is brilliantly thought out and achieved, and not only as an example of Surrealist madness. The light in them is unique to Sommer, though we feel as if we have always seen photographs with this light before. It's a sunless light, not bright or brilliant, but sufficient to enable us to think we can see and feel the contour and texture of every rock or bit of grain or the skin of every cactus. We want to run our hand over these pictures, not because they ask to be caressed, but out of the same desire that makes us want to pop seaweed bubbles, or scrape barnacles off wood, or itch or scratch. They are irresistible without being beautiful.

Slightly less amazing are the collage pictures of small bits of trash—toys, skin, artificial legs, magazine ads—which Sommer fastidiously and complicatedly assembles or reassembles and then shoots, pinned up on a highly textured background wall. These are jewel-like, hyperrealistic studies in ambiguity. They don't seem to be the work of a man whose vision is photographic; but the art of photography was stretched when Sommer made them. Jan van Eyck would have liked them.

Sommer's most disturbing pictures are the photographs of decaying bodies of desert animals. Most of these startling pictures are taken so close up that we can almost feel the rotting body of the animal becoming one with the soil; sometimes they look as if they're already *in* the earth. We don't have a sense of the animal's body—Sommer is not a photographer who makes us feel the roundedness of things. His eye goes for the complexities of flat surfaces. Edward Weston photographed dead animals too, but, so it seems, with a different aim. His purist obsession with form is so strong that we absorb the picture without being literally aware of the subject matter. Sommer occasionally achieves Weston's formal concentration; Sommer's 1939 "Jackrabbit" is reminiscent of Weston. But these cases are rare, and it's fair to say that that is not what Sommer is after. His photographs of decaying creatures (this is also true of many of the collages) feel as if they're mostly experiments in Surrealist effrontery, though not the scandalously naughty kind of Buñuel or Dali. They feel calculating, but of nothing you can put your finger on. They express notions about something other than the thing photographed. That is horrifying, considering what is being photographed. The fanatical precision with which these animals have been recorded only adds a layer of repellentness.

The same stuff could be easily dismissed as fantasy if it were painted. It would be easy to forget that the artist probably used an actual dead animal in his studio for the model. If they were paintings, Sommer's creepier images might be felt as dream allegories. As photographs, though, the sheer physical presence of the rotting animal or the wooden leg hanging on the wall takes things out of his hands. The subtle or bizarre ramifications don't

reach us. We just wonder, and not exactly in aesthetic terms, about the man who was compelled to take pictures like these. Of course this same kind of scrutiny has to be applied to Weston too, but he escapes, I think, where Sommer doesn't. A Weston photograph of a dead animal doesn't make us cringe the way one by Sommer does. We never feel Weston's lingering over the body in order to soak up the quiet, unnerving horror of the spectacle. Whether, say, the pelican he photographs is dead or alive is not what counts (for him). What matters is that he find a way to communicate the pelican's extraordinariness. For Sommer, the point, whatever it is, has to do with the *corpseness* of the subject.

Sommer's later work, where he blurs the images, often of nudes, or forsakes images altogether—when he shoots the designs made by smoke on glass or paint on cellophane—communicate very little sense of the uncanny, his strongest point. The grisly animal photographs don't have this quality either, because the subject matter doesn't create its own, private atmosphere—we judge it on our terms, not on its own. Sommer's semi-automatic creations are dull to look at (as is the case with most found-object, automatically created Surrealist art). There is no formal thought behind them, yet the only way we can appreciate them is as pure design. Even as you're looking at them, you know that Sommer's intentions have become lost. The description of the way they are made is more involving than the way they appear. Even next to other Surrealists, Sommer's work is suffused with an awful lot of esoteric, scientifically-oriented learning. Most of his images feel like experiments in finding hidden layers of consciousness, but too often we are left in the lab of his thinking. It's only in the landscapes and the related views and some of the collages that we can get outside the lab, and find ourselves groping, with him, in those hidden layers.

1973

►►►►

Lee Friedlander

LEE FRIEDLANDER'S PHOTOGRAPHY is a chronicle of the look and character of recent American life made by a man who is always on the outside and always looking in. This may be said about any photographer whose work comes under the label of social commentary, but the description fits Friedlander as it does no one else. Repeatedly, he photographs what it's like to be, happily or regrettably, outside the flow of everyday life. Sometimes you feel his happiness and regret simultaneously. In his self-portraits, probably his most jam-packed and original works, the role of the outsider becomes the literal subject-matter of the image. The often barren, inhospitable, lonesome appearance of Lee Friedlander's pictures derives not only from the absence of people in them, but from the way the pictures suggest that people were just recently a part of the scene. From such a description one might imagine that his photographs risk having an edge of the maudlin, or skirt being essays on the theme of how people let themselves live in spiritually and aesthetically empty settings. But neither tone makes itself felt. You are more aware of the photographer himself, on the prowl, looking for images.

In a recent show at the Witkin Gallery, the only person to make an appearance in the many prints was Friedlander. He's seen obliquely; we catch his silhouette reflection as he trains his camera on a window, or we see his shadow as it falls on someone's back. Yet what matters in the self-portraits is the milieu and the situation this photographer—not this particular personality—finds himself in. Friedlander is a demanding and complicated photographer. This has to be said, because his work can annoy people by its apparent "easiness." On a quick viewing, it's possible to feel that his subject is banality itself, untrans-formed by thought. It is true that his pictures—of dusty win-

dows of untenanted stores; of Victorian monuments in American towns that have long lost their charm and are now crisscrossed with telephone poles and power lines; of passing traffic, as seen from the partially blocked-off vantage point of a seat on a bus or a pay phone booth; of crossroads in western United States towns, where all the buildings have been torn down and only a lot or a bit of sidewalk remains; of suburban dwellings seen through a net of trees and shrubs—appear to be casually lifted from reality. But Friedlander, you feel, has worked hard for a certain pitch of casualness. He likes his images, on initial viewing, to appear as empty and uninviting as possible. He wants the fruits of a purely photographic way of chopping up space—a way that forces us to see many unrelated things simultaneously—to reveal themselves very slowly. Friedlander uses his camera as if he were accumulating notes in a journal, whereas Walker Evans or Robert Frank, for example, make more individually assertive, self-sufficient photographs, using the camera as if they were producing novels. Most Evans pictures say, "This is it." Most Friedlander pictures say, "This is tentative." For these reasons, his prints are best seen in numbers, where his haphazard and "unartistic" touch can be judged as something deliberate, a distinct and developed photographic style that uses shallowness as a mask or a tease.

The recent exhibition might have been selected to give a greater sense of his range than it did; if this were anyone's first view of Friedlander he would probably have walked away with a generalized image of a parking lot in his mind. Even a few more self-portraits or some interiors would have helped lighten the load. It was good, however, to see that Friedlander's latest pictures are as disquieting and haunting and obliquely humorous as those he was making a decade ago, when he first became known. In 1962 he made the since then much reproduced photographs of televisions, some turned on, some off, in drab, inexpensive hotel bedrooms. The most recent pictures are of flowers. These pictures are even "emptier" than the television ones, but they seem more a product of his own way of seeing. Some of the flowers, taken from a garden or a flower show, are

menacing; they're a bit like the sturdy, suspiciously anonymous ones in science fiction movies. Some flowers are weighted down, over-petalled; others are lank, forlorn. Still others protrude in our line of vision. We feel as if they've been shoved in our face, and that the real subject of Friedlander's attention is what has been pushed to the side of the leaves or branches. We peer closely, but then return to the chaotic flowers or ferns in the foreground, and wonder if they themselves could be telling a story. Friedlander's flowers and plants and branches come across as essentially a comment, somehow both bitter and touching, about the people who have fussed over them so much, or ignored them. Depressing and pathetic as some are, these still lifes are among the most living any photographer has made.

1973

▶▶▶▶

Diane Arbus

THE DIANE ARBUS EXHIBITION was one of the most bewildering and, on first viewing, frightening shows put on at the Museum of Modern Art. It presented the work of a woman who made some of the most bizarrely unforgettable portraits in the history of the medium. The majority of Diane Arbus's pictures are blunt, glaring close-ups of transvestites, nudists, female impersonators, people whom we detect to be mentally retarded; there's an "albino sword swallower" (shown at work), an overbearing tattooed man from the circus, and a "Jewish giant" at home, looking down at his parents, who, it's surprising to see, are still a mite apprehensive in his company. There is a "Mexican dwarf," "Russian midget friends in a living room on 100th Street, N.Y.C.," a hermaphrodite with his/her dog. Arbus brought a

great variety of people before her: she shot babies, children, teen-agers, young people, middle-aged people, the elderly and aged; she photographed couples of all ages and couples with babies and kids. Almost all are made to appear, if not freakish, then threatening, sleazy, gross—wrong, somehow, though never dissipated. She didn't photograph people who look imploringly at us. Her people seem to be at home in their lives; they grin or laugh or look preoccupied, and that makes the pictures more brazen. There is a photograph of a topless dancer in her dressing room who sits facing us, in her laméed work outfit; her legs are luxuriantly crossed, and one hand is turned back to touch her neck gently, while the other is delicately held under one of her exposed breasts. Her left index finger lifts her left breast ever so slightly, making a little crease in it. The gesture and her eyes say, "Here it is, the prize, I love it." The mustached Mexican dwarf, photographed in his hotel bedroom, his shirt off and hat on, his arm resting calmly in the center stage of the picture, smiles knowingly and seems to say, "You could stomp on me but you don't have the courage for it. I've got your number." But we aren't sure. Possibly his smile is a dignified and courteous one, and he is only saying, "I appreciate this attention, and I like you."

Arbus isn't the first photographer to be attracted to such normally overlooked material, and the frozen manner she gets isn't new to the medium, but the creepy intimacy of these pictures is her own. Some of the creepiness and the intimacy are built into the pictures by our knowledge that she committed suicide (in July, 1971, at age forty-eight). During the sixties, when she did her most serious and personal work, her approach was so fixed that even in her occasional non-portraits—"A castle in Disneyland, Cal."; "Xmas tree in a living room in Levittown, L.I."—she conveys the same feelings that she does in her pictures of people. These non-portraits take away your feeling that her work springs up from nowhere. The suburban Christmas scene, with the carefully bedecked tree stuck in the corner of a neat and impersonal motel-like living room, has something in it of the sardonic social commentary of Robert Frank or Lee

Friedlander, and the ghoulish loneliness Elliott Erwitt photo-
graphed in Miami Beach. Yet there is a difference. These
photographers often seem secretly in love with the barrenness
and random junkiness they train their cameras on again and
again; you feel that Robert Frank was buoyed by the people and
the sites when he toured the country making the photographs
that would comprise *The Americans*. Those pictures communicate
a sense of someone who was ignored and even, on occasion,
mistrusted by the people who were his subjects and yet who felt
free precisely because of that.

Arbus wasn't an ambivalent outsider, though. She didn't look
at that glacially cold living room, with its pathetic Christmas tree
hitting its head on the low ceiling, or her people, with their
shellacked bouffant hairdos, their pimply skin, their haggle-
toothed expressions, and their dead, reptilian eyes, and say,
"This is unfortunate, it's a lousy situation, but I understand why
you are the way you are." She wasn't there to understand; she
liked being with and looking at the monstrous or the merely
"off." She wanted to keep it intact. When Robert Frank photo-
graphed Hispanic street queens, twitching their hips, giggling
and tsking with nervous pride, he kept his distance, and made
the picture balletic and romantic. He made these boys exquisite.
But when Arbus photographs her "young man in curlers at
home," she gets very close and stares the way a child would, at
the obvious things: the young man's long, polished fingernails,
the effeminate way he negligently cocks his cigarette, the creamy
uncleanness of his skin. He's not remotely exquisite, he isn't
charming; we aren't won over to him for his courage in doing
what he feels like doing.

Confronted by her pictures, we may feel confused—embar-
rassed, even a little revolted. Children may be frightened by
them, because Arbus, who liked to photograph people in repose,
sitting on a bench or reclining on a bed, caught the moment that
bothers some children most, when ugliness is inactive, when it
looks back at us. Snakes tend to be most frightening when
they're coiled up, behind cages, at the zoo, and Arbus's people,
though often photographed in their homes, look as if they're in

hollow approximations of homes—home settings prepared for
them, as if by a zookeeper. But our strongest reaction may be
suspicion about Arbus herself. We may hate her, initially, for
tracking down her "Jewish giant" (in the Bronx, as the title
informs us). Towering over his parents at eight or nine feet, his
head hitting the ceiling, his body subtly misshapen throughout,
his face unshapen, his feet encased in shoes that look like coal
sacks, he is a hobbling monument to senseless fate. We want to
sense her exploitation of this giant and the rest of her people; that
would diffuse the unsavorily magnetic power of the pictures and
enable us to feel superior to her. The pictures, though, never
make it seem as if she were above her material, or pitied it, or
that she was smugly identifying with outcasts. Had she been, we
would feel her emotional distance physically; her camera would
be further back from her subjects, or else there would be a
jarring closeness. Sometimes there is a frigid distance, as in
"Four people at a gallery opening, N.Y.C.," where she turns her
subjects into wax museum effigies; but generally it's the oppo-
site. There's an unusual sense of weight to her pictures; you feel
she didn't move with the nervous rhythm of a social satirist. In
tone, her pictures are comparable to the calmest, most pre-
possessing 19th-century western landscape photographs. She
worked with a square format camera and large print sizes
(though never exaggeratedly large ones, like Irving Penn's or
Richard Avedon's). She often used a flash, which gave her
pictures a smooth but impregnable, patent-leathery surface, and
the effect of an imposing, bulging center. The flash also left the
edges of the pictures unlooked-after. The edges are dim, pale, a
little chewed sometimes. They seem to float off. Her pictures'
serenity and massiveness make them fishy and confusing at first.
But these qualities draw you to her, too; they give her work its
sense of being realistic in a new way.

Arbus' realism has a spartan near-emptiness about it—there
are seemingly fewer details and less movement in her pictures
than in the best photography before hers. She removes the
angled, unstable, often crowded look that has characterized the
most modern urban picture-making, from Helen Levitt and

Cartier-Bresson through Robert Frank. Yet Arbus gets details that we aren't conscious of having seen before in photographs: clunky redwood deck furniture; hair curlers; poodle dolls; spindly metal plant racks; styrofoam straw boaters; a baby's drooly chin; lipstick that's put on with such emphasis that it goes over the lip line; the matte oiliness of mascara; costume jewelry and synthetic fabrics; bright, shiny, hard things like portable electric fans and wall clocks with dagger-like sun rays. She's hardly the first photographer to notice the assortment of fake, tacky and cheesy things people live with and wear, but no other photographer has made us so desirous of simply looking at these surfaces and objects. And we're drawn in, not in a spirit of ridicule or condescension, but out of the same unforced hunger to absorb that we'd have if we could go back in time and were presented with, say, the people, clothes and rooms of a Renaissance court.

One thing heard at the time of the show was, "What is this? Weegee did this kind of thing years ago"—the point being that Arbus needn't be taken seriously because her photographs are only a chic revamping of the photo-stories that Weegee, the *Daily News* photojournalist, caught in the forties. It's likely Arbus knew Weegee's pictures, responded to and got something from them. She must have liked his blam-blam way of shoving his big news camera into the face of his subject, firing at will, and letting the scene compose itself as it might. (What serious photographer doesn't envy Weegee's—or any good photojournalist's—courage in shoving the camera in?) But they're very different photographers. Weegee revelled in the infinite number of nightmares possible in what he called, in his first book, the Naked City; he was an ironist attached to the gruesome, and his underlying message was that life stinks. Arbus may have felt that life stinks, but her imprint, in her photographs, isn't exuberantly rancid or desolate. It's closer to something comic, with a desolate undertone. Her pictures are more delicately conceived than Weegee's; she's often after the tiniest details, as when she photographs identical twins, who wear identical outfits, standing side by side. She narrows our vision. We become conscious that our eyes are moving back and forth, scrutinizing the features of the twins to

25. Jacques Henri Lartigue: *Avenue des Acacias*. 1911. Photograph, 15³/₄ × 11⁷/₈″. The Museum of Modern Art, New York. Gift of the photographer

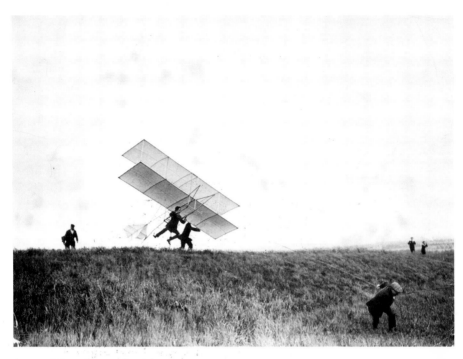

26. Lartigue: *Glider Constructed by Maurice Lartigue, Parc du Château de Rouzat*. 1909. Photograph, 9¾ × 13¼″. Courtesy Photo Researchers, Inc.

27. Helen Levitt: *Untitled* (New York). 1959. Photograph. Courtesy the artist. (The original is in color.)

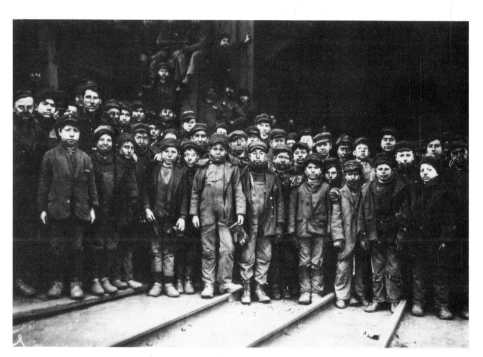

28. Lewis Hine: *Coalbreakers, South Pittston, Pennsylvania, January, 1911*. Photograph, 4½ × 6½″. Private collection, New York

29. Baron de Meyer: *Rita de Acosta Lydig*. Photograph, 16 3/8 × 12 1/4″. The Metropolitan Museum of Art, Gift, Transfer from the Costume Institute, 1968

30. Paul Strand: *Portrait. Five Points Square, New York, 1916*. Photograph. Copyright © 1981 The Paul Strand Foundation. Museum of Fine Arts, Boston. Sophie Friedman Fund

31. August Sander: *Peasant Children (Westerwald)*. 1923. Photograph. Courtesy Sander Gallery

32. Diane Arbus: *Woman with a veil on Fifth Avenue, N.Y.C.* 1968.
Photograph. Copyright © 1968 The Estate of Diane Arbus

33. Arbus: *Untitled (7).* 1970-71. Photograph. Copyright © 1972
The Estate of Diane Arbus

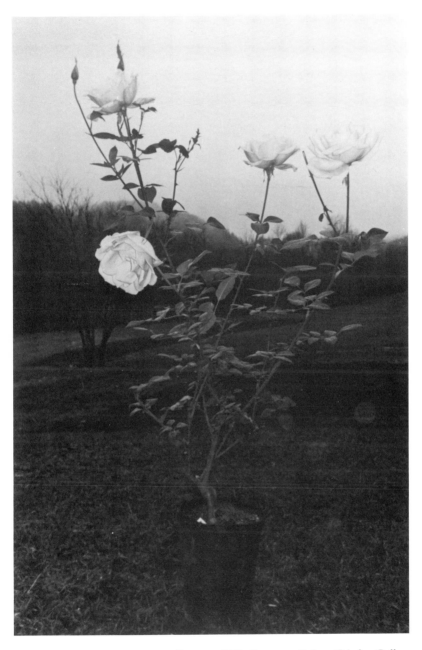

34. Lee Friedlander: *Potted Rose, Vermont.* 1972. Courtesy Robert Friedus Gallery

35. Frederick Sommer: *Arizona Landscape*. 1943. Photograph. Courtesy Light Gallery, New York

36. Harry Callahan: *Cape Cod*. 1972. Photograph. Courtesy Light Gallery, New York

see how different they are from each other, and that the image, in the process, has lost its freaky edge.

Weegee's images are sloppy and helter-skelter in appearance; in texture, his photographs are as hard, raw and stained as city pavement. They're the work of someone who learned how to dodge falling bricks and fists, and became agile enough to know how to get a peek in even as the bricks were falling. Arbus's pictures are cleaner, stiffer, neater. When you look at Weegee's photographs you feel that the man was kicked around as he made his way from the Vienna of his birth to the Manhattan and Coney Island of his maturity, and grew to enjoy the kicks. But when you look at Arbus's photographs you feel that she must have moved through life without intersecting with anybody, for no experiences she could possibly have had would have equalled her intuitions.

Reading the transcribed tapes from some of the classes she gave in 1971, which are blended in with pieces of her writing and clips from interviews—these remarks are the only writing in *Diane Arbus*, the monograph accompanying the exhibition—I was reminded of the youthful heroes and, more often, heroines (usually they're the narrators) of Grace Paley's stories about bruised people who still have time for jokes. Even more, Arbus reminded me of Holden Caulfield, the teen-age hero of J. D. Salinger's *The Catcher in the Rye*. Arbus talks about how she made her pictures and why. She's very engaging, a pleasure to spend time with, as Holden might say, in his most cocktail-lounge manner. There are no dead spots, there is nothing dry, nothing that doesn't flow swiftly by, in these pages. She buttonholes you, as her pictures, in a room with other photographers' work, pull you to them and obliterate the competition.

Like Holden, she continually appears to be seeing the world of awful, embarrassing or merely just "adult" things for the first time. She becomes glued to what she calls the "flaw" in the person before her as fast as Holden could spot what he called a phony; but, like him, she also wants to applaud. She likes the idea of being sentimental, innocent. She filters her thoughts through a net of blandness:

Recently I did a picture—I've had this experience before—and I made rough prints of a number of them. There was something wrong in all of them. I felt I'd sort of missed it and I figured I'd go back. But there was one that was just totally peculiar. It was a terrible dodo of a picture. It looks to me a little as if the lady's husband took it. It's terribly head-on and sort of ugly and there's something terrific about it. I've gotten to like it better and better and now I'm secretly sort of nutty about it.

It's possible that she felt, when she was young, that being bland was like being a grown-up. That's how kids who are uncomfortable with themselves sometimes believe that the adult world must have to see everything—that adults deliberately glide by things, with blinders on. Underlying Arbus's born-yesterday innocence, there seems to be the belief that if you superficialize—if you reduce the world to what is nice and what is boring—you can avoid facing how complicated and awful you feel it to be. That's why she seems to get a charge from softening her judgments—she is giving herself a moment of relief from the pressure of always having to be guarded. You feel her desire to be accepting not only in her remarks but in her photographs, where she continually puts herself in unsettling, even threatening situations—places where her first response might be "No, this is not for me, I've got to get out of here"—and then sticks it out, to master her desire to leave.

Holden liked to soften his judgments, too. He periodically wanted to toss aside his innate wariness and present himself as a kindly old gentleman, dispensing praise to kids who were courteous. Yet his guiding idea—his belief that the world was made up of only two kinds of people, phonies and those, mostly his family members, who were good and true and a little broken in spirit—was too firmly fixed in his mind. Seeing the world in such a reduced, adamantly innocent way made him prematurely aged; real life was going to have less and less of a chance to break in on him. It keeps dawning on you, as you read *The Catcher in the Rye*, how fragile and troubled, even crazy, Holden is.

Perhaps Arbus became hemmed-in by her conception, too. Her voice and attitudes have such a child-like mixture of surface whimsicality and inner determination that she also sounds pre-

maturely aged. In the text you sometimes think you are listening to a dotty old lady. Her guiding idea—in her life, in her photography—was her devotion to the upsetting, which she kept wanting to turn into the benign. It wasn't a large idea, and it didn't make for pictures of much variety. Her photographs are clamped in place, they radiate the same spirit. Yet she honored, without reservations, her sense of how the world looks, and that stays with you as long as your memory of her individual pictures. She must have had that sense since childhood. By the time she was ready to go out on the street and photograph people as she saw them she was in her late thirties. Having held her feelings in for so long may account for the fact that her career, though it lasted little more than ten years, leaves a distinct sense of something that comes to full bloom almost immediately, expands to a point just beyond ripeness, and then, before withering sets in, is over.

When you look at her last pictures, of presumably retarded people, standing, probably, on the grounds of the sanitarium they live in, grinning and attempting to do somersaults, or parading by, hand in hand, in disheveled costumes, you feel she couldn't have gone further in recording breakdown and deformity. These people seem cauterized top to bottom, incapable of any real feeling. Yet the photographs aren't cauterized in tone. In their pale, blowzy light, and in the casual but graceful way the subjects plant themselves before the camera, these are Arbus's most released and pacific images. She makes us see life in her inside-out way, and we sense that, for her, these pictures must have been glimpses of peacefulness and freedom.

1973, '81

►►►►

A Note on Harry Callahan

HARRY CALLAHAN'S SHOW of recent work at the Light Gallery included some beach scenes that, although they don't feel like "important" photographs, are among the most appealing he has taken. Callahan, now sixty years old and one of the most renowned pure photographers (he is in no sense a photojournalist), is well known for his nudes and nature studies but he is at his complex, coldly romantic best when he is photographing people in social situations. Like Edward Hopper's, Callahan's pictures of people in cities have the appearance of hard-bitten social commentary. His people are always so many isolated souls, even when seen in groups; we see them standing in shafts of sunlight, or walking with mysterious resolution through cavernous, barren streets. With their dramatic lighting and expanses of shadowed darkness, the pictures seem more like stage settings—situations that have been previously worked out in the mind—than on-the-spot social reportage. Hopper and Callahan create a tense mood—we expect something is about to happen that will change everything. Yet we sense that both men are chiefly concerned to find the right kind of emptiness, even repose. In thinking about Callahan there is always an urge to square the photographer drawn to the hidden life of cities with the photographer who takes such glacially beautiful shots of ferns, telephone pole wires, marble-smooth nudes, trees in the snow. Callahan's imperially detached view can't save this side of his work—which might be called poetic formalism—from a tinge of preciousness; and these feats of ultra-refinement have more graphic power than he may intend for them. They're a bit too striking and stark; the point is overemphasized, in the manner of fashion photographers when they turn to their "serious," art photography. But Callahan's desire for shapes to have silhouette-

162

sharp contours and his very individual gauge of how close or how far back he ought to be on any subject give his images of people an authentic mystery.

In the silvery-white new beach pictures that mystery is still there, and a cool charm has been added to it. Callahan's view is from high up and far away—he looks down and sees sunbathers, swimmers, sand castles, volleyball nets, rocks, and boats as equally important parts of the many miniature tableaux. We can hardly see the people; they are so small they are reduced to the forms their limbs make as they walk, or stand idly in the water, or sprawl on the sand. Or else we see them wading out in the waves, a broken row of torsos and heads. Often there are no people, just vestiges of them. Some photographs are simply of water coming in to the beach, or of dunes, their tops crested with sea grasses, seen in bright light. Yet few of Callahan's earlier pictures are so much about people, or feel so tenanted. In none of his pictures, not even those of his wife Eleanor Callahan, which are his most personal, do we have as great a sense of the man himself, behind the camera, there, looking.

Not that he has laid bare his private thoughts. The artistry, the sense of where to put the camera and how to use light, are uniquely Callahan's, but his feelings, in these photographs, aren't exceptional. These may be the least "artistic" pictures he has made. His mood is the one we all have at the beach. He responds to the way, at the water, we are put in touch with our greatest sense of independence and also of aloneness. Though he hasn't explored all the possibilities of this big, evanescent subject, he has made the subject his own, without fanfare. (It is hard to imagine him delivering any of his achievements with fanfare. That isn't his way.) His new pictures embody what Robert Henri says in *The Art Spirit:* "Why do we love the sea? It is because it has some potent power to make us think things we like to think."

1973, '82

▶▶▶▶

The Strand Retrospective

COMPARED TO THE CHECKERED working lifetimes of many of the American photographers—and painters—who got their start in the years before the First World War, the career of Paul Strand unrolls with an awesome self-assurance. This photographer, who since the forties has been considered one of the great—even "legendary"—masters of his medium, didn't have uninterruptedly smooth sailing: there are gaps in his biography, on and off in the twenties and for much of the thirties, when he worked intermittently as a still photographer and as a documentary moviemaker; but these pauses don't seem to have sidetracked him. He doesn't seem to have spent unnecessary time groping for the mood that suited him. Strand's work leaves an impression of great stylistic consistency. That consistency is heightened by the qualities of his sensibility, which could be described as unflurried; monumentalizing; expansive (but not emotionally outgoing); appreciative of the sensuous beauty of people's faces, the natural world, inanimate things (but not sensual). Strand is never comic and rarely tragic, but he is nearly always something in-between: sober. Henry James, in one of his early French travel pieces, describes a moment that is pure Paul Strand—reading it, you feel you are looking at one of his (always) masterfully printed photographs. "As, after my arrival," James writes, from Rheims, "I sat in my window at the inn, gazing up at the great facade, I found something dizzying in the mere climbing and soaring of one's astonished vision; and later, when I came to wander about in the upper regions of the church, and to peep down through the rugged lacework of the towers at the little streets and the small spots of public places, I found myself musing upon the beauty of soberness." Paul Strand's art, for two years now the subject of an enormous traveling retrospective,

currently installed at the Metropolitan Museum of Art, is about the "beauty of soberness."

The retrospective, which covers the years 1915 to 1968, comes with a portable version of itself, an elegantly wrought two-volume monograph, containing nearly three hundred prints, that is the work of Strand, his wife Hazel Kingsbury Strand, and Michael Hoffman. The catalogue contains a bibliography, and excerpts from scattered writing on Strand by Milton Brown, Elizabeth McCausland, Leo Hurwitz and others. There is no comprehensive essay, which has yet to be written. The New York installation included only about half the book's number of prints. Still, that was enough to give an adequate idea of his work. For all the variety of genres he has been attracted to—landscape, portraiture and still life, all of which he treats with the same respect—Strand is not an artist of great range. He has traveled extensively, and made units, some published as separate books, others the size of portfolios, on many of these places: Colorado and northern New Mexico; the Gaspé Peninsula, Nova Scotia; Maine and Vermont; Mexico; the Outer Hebrides; France and Italy. In the past seven or eight years, working faster and faster, as many men of his renown do as they age, he has made series on Rumania, Ghana and Egypt. He has traveled to hot and cold climates, to outpost islands and to settled, ancient cultures. But he hasn't gone for the sake of the sharp differences. He searches out the most rural, economically backward, and primitive parts of wherever he goes, and sees those places in a persistent vision of innate elegance and sedate, almost lordly refinement. His provincial Italian mothers have the stony strength of great Renaissance queens; his Egyptian children look down on us with the seer-like imperturbability of the heiratic sculptural reliefs on the ancient tombs; his New England villagers are characters out of Edwin Arlington Robinson, weathered, stoical, aristocratic. Most royal of all are Strand's Mexican farmers and villagers; wearing immaculate whites, sitting (presumably without work) on stoops, they gaze out at us with a mixture of boredom and contempt worthy of Shakespeare's exiled kings and dukes. Strand's landscapes have a similar

breadth—they're settings for grand seasonal changes. The humble working tools and carts, the aged, usually handmade brooms and jugs, the simply marked gravestones, the patient working animals, the small, rude but clean farmyards, the bits of tender, lace-like foliage, the velvety mushrooms and chunks of caressable driftwood—they are all of a piece with his people. They are the beautiful, used but unsoiled things these people would see and touch, day by day. After looking at a fair amount of Strand's pictures, faces, utensils, carvings, time and pieces of nature become unusually blended. Are we in Ghana or Vermont, the Outer Hebrides or Rumania? Is this 1928 or is it 1964? (One reason for this sameness comes from the reprinting of vast numbers of prints for the show—too many have a similar texture and tonality.)

The effect of seeing so much Strand is to feel yourself elevated to a level of noble and pure sensations. His language—his plain, documentary-like, straightforward style—has a modern feeling to it, but the story he wishes to tell is a 19th-century one, or at least one that is far from us in time. Like other members of the group that periodically clustered around Alfred Stieglitz, Strand was an urban intellectual who, in his work, was more at home with a romanticized dream of a pastoral—or at least non-urban—existence. Strand did make art out of city life. When he was young, New York was his leading theme, as it has been Stieglitz's. But Strand dropped the city, and its pace, from his work. The city isn't, by definition, a more fertile field for a photographer, but it seems to have been in his case. To watch him going off later to African and New England villages, to fishing communities in Nova Scotia and Mexico, and to small towns in France and Italy, is to feel that he is doing something right and something wrong. Right, because part of him responded to the sweeping and austere Biblical beauty of the towns, fields, bays and people he encountered there; his work may not be current in feeling, but his rapport with this material is real. He admired it. He wanted to fix more and more of it on film, and his quest, the willpower he found for it, is a great thing. You feel this no matter how little else you feel when

looking at his pictures. But also wrong, because underlying his grandly-shaped career there is a small note of the unnecessary and obvious. His soberness leaves the impression of being a substitute—however majestically developed in its own right—for something else.

Strand's approach often suggests the distinction and grandeur of the person he's facing. In his photographs of New Englanders and of French and Italian townspeople, taken in the forties and fifties, you wonder if it's possible for 20th-century people to look so grand. But in the early New York pictures there is a real monumentality. There is also—in the look of the prints and in their spirit—a grainy, melodramatic rashness, absent from everything else of his. The photographs could be stills from silent movies, as well as the master prints they are. Made in the teens, predominantly of old and anonymous people he saw in the streets, they aren't exactly portraits: they're closer to being cityscapes that have faces for subjects. None of these people—a lady wearing a flowered hat; a bearded man covered with a sandwich-board sign; a woman with a tin "Blind" sign hanging from her neck; a man in a bowler who turns abruptly to look the other way; a fat woman yawning—sit for Strand; when they look at him, which is rarely, they look through him. Mostly they look away from the camera, or squint at it. We aren't made to care about them as individuals, and it's clear he didn't linger with them for the shots; but these New York pictures, though not moving or affecting, at least not in a direct way, suggest what was deepest and most poetically original about Strand. There is a mood of floating sadness and emptiness to them, a quality of people worn down by the grind of one small unfortunate turn after another. The people aren't failures: the man in the bowler and the yawning woman are two still very alert heavyweight contenders. But nearly every one of them has been coarsened by time. These are the only people Strand ever photographed who look coarse. Their rawness, emptiness and decrepitude is real; it's what is suggested by, but never concretely in, the bulk of his later photography—those many pictures of people whose faces ought to be visited by a more distinct emotion, who ought to

appear raw, but don't. Strand went on to an unusually long and distinguished career; he kept a level of accomplishment, at least by his own standards, that is rare in photography. But his finest accomplishments may be these early pictures of unknown New Yorkers, and the fact that he was barely twenty-five when he made them.

1973

►►►►

August Sander's
Men Without Masks

WHEN CONNOISSEURS PUT together lists of the great photographers, the name of the German August Sander is invariably there, sitting alongside Stieglitz, Walker Evans, Cartier-Bresson, Atget, Kertész, Strand and Weston. Outside of Germany, though, Sander (1876-1964) has for long been more speculated about than known. *Men Without Masks* is the first extensive survey of his work we have had. There are two hundred and seventy-five pictures in this volume, most portraits. They are a selection from a much larger collection of portraits, the chief project of Sander's life: his grandly conceived, only partially completed photo-document, "People of the 20th Century." Sander worked primarily in Cologne and the farming regions around it, and yet, buttressed by the belief that he was a social scientist and historian as well a photographer, he thought all of post-First World War German society was his province. For him, the point was to depict every "type" and "archetype" of his time. Few photographers have had such high ambitions. And the portraits he took, whether or not they tell us what "archetypes" are, are among the most powerful and disquieting in all photography.

German art often appears to be more about life and its problems than art and *its* problems. This is especially true of portraiture. From Dürer's time on, German artists attain a spiritual and psychological expressiveness in this genre that no other national school gets near (or wants). Sander comes at the tail end of this tradition. It's natural to think about him in relation to the painters who recorded the faces of the overlapping pre-war, Weimar and early Third Reich periods, and it's significant that his background is similar to that of the two most important of them, Lovis Corinth and Max Beckmann. Corinth, Beckmann and Sander all came to maturity or grew up under the influence of German culture in the heyday of its affair with the romantic, misunderstood supercreator. This hero could double as a paterfamilias. He had it in him to speak for the nation's soul and, despite his solitude, portray society in all its workings. Corinth, Beckmann and Sander thought in terms of Biblical themes and epic, panoramic projects; their heroes were Delacroix, Rembrandt—no one small. Yet they became commanding, original artists only when they divested themselves of their youthful goals. Beckmann and Sander, younger men, never relinquished the idea that they could create on a panoramic scale—Beckmann's "Triptychs" and Sander's "People of the 20th Century" are not the conceptions of modest talents. But they were able to conceive these imposing projects only after they found less ornate ways of seeing the far from heroic German society of the post-Kaiser years.

Corinth's way was his feverish touch. Beckmann's was his deliberate coarseness and his learned primitivism—he felt he had to take on the mantle of his beloved Henri Rousseau before he could attempt to encompass the confusions of the new Germany. Sander's way was a terse, Puritan directness. His Germany between the wars has a different kind of tenseness than anything we are familiar with from the novels and plays, paintings and movies of the period. We are used to Weimar as an Expressionist melodrama, and Sander refuses to be melodramatic. He virtually never uses special angles, and when he lights his subjects in an odd or theatrical way, he does it so subtly we're barely aware

of it. He photographs everyone—jurists, clerks, beggars, bankers, soldiers, self-conscious decadents, industrialists, crippled veterans, gypsies, merchants—in roughly the same straightforward manner. He worked as an old-time itinerant wedding photographer would, though we can't imagine him cajoling his sitters. We always feel his no-nonsense, somewhat anonymous and strictly professional presence, crouching directly across from his subject, his head and shoulders lost to view in the apparatus of camera and black focusing cloth.

Many of these people are named, while a seemingly larger proportion are identified only by profession, or by a cruder label, as in "Small town man and wife." A few famous faces and names go by: there is a portrait of Paul Hindemith, and he appears in a group portrait too, and Richard Strauss can be caught in another group shot. But Sander is impervious to fame. Strauss' world-wide glamor doesn't faze him. Hindemith's rising star doesn't beckon him (the composer looks as if he stepped in something a moment before the sitting). Preoccupied with his grand design, Sander never sought to make his subjects heroic; he rarely joked with them. His "point of view" is the same for left-wing activists, Nazis or Weimar Socialists. This is baffling at first, then it begins to feel preordained, uncanny. In retrospect, it seems an inspired way to have approached this material. The between-the-wars Germany you draw from these ranks of predominantly solemn faces is a society whose chaotically diverse classes and types have made a nervous agreement not to notice the behavior of any of its members. Few of these pictures are frightening or bizarre, but Sander's impartiality comes to feel nightmarish. We imagine that had he been able to get Hitler for a sitting he would have proceeded in the same fashion that he did for everyone else. That isn't held against him—he would have lost something if he had been a "responsible," liberal, "concerned" photographer. He was entranced, held in thrall to his grand design, blind to the finer ramifications, and his Germany was entranced, too.

He shot people the way lepidopterists pin down butterflies, yet there is a surprising variety to this enormous collection of

portraits. Nearly every face in *Men Without Masks* holds the eye, and many are mesmerizing, though certainly not all these people would be intriguing regardless of the photographer. Although many of the pictures hold up on their own, they were meant to be seen as part of a cycle, and there is a wonderful waltz-like rhythm, slow and swirling, set up in these pages. We turn from stark, almost mug-shot-like studio portraits, to pictures of the pastry cook or court usher at work, in uniform, to occasional shots of someone in a leafy yard or in an empty street or on an empty backwoods road—this is where we see the handsome village schoolteacher, in his Norfolk jacket, with his stiffly attentive German shorthaired pointer at his feet. There are other portraits whose effect is uncategorizable, such as "Young sports pilot (Cologne, 1925)," of a leather-jacketed, mufflered air hero who looks through and above us, as if he's thinking of himself up in his plane, circling. We don't know where this close-up was taken. The shallow surrounding space is dark, but the scant light in the picture seems liquid, shifting, as soft and touchable and ominous as the leather. By Sander's Puritan standards, there is an almost fashion-magazine glossiness and stylishness to the picture. Sander had pockets and pockets of awarenesses in him: he knew when to be stiff and removed, but when the subject called for it, he had the ability to produce as smooth and seductive a portrait as any Edward Steichen. He brings out a fragility in the pilot's face that stands for the fragility of the young man's generation.

Social scientist that he was, Sander may have thought that his methods were class-proof, that no one, looking at these portraits, could guess the origins of the photographer. And yet, though he may not have admitted it to himself or put it in these terms, he was out to conquer German society as much as document it. His own mask was his pose as impartial observer. The role allowed him to bring those fashionable Cologne receptions and garden parties, which included Richard Strauss among their number, to a halt. Sander's sway over all classes of German life was dictatorial. Yet when he photographed the people of Westerwald, where he had grown up, in a land-owning but far from well-to-do

family of nine children, he divulged his origins. He imbued the images with a graphic power and an emotional depth he couldn't get when he worked in Cologne, Berlin, Bonn or Hamburg. His Westerwald people are sadder and more comic than his other Germans, and there is even greater resonance in his photographs of the children and young men and women of the farming region. Neatly dressed and stiffly presentable, these peasant children and adolescents seem much older than their age, as the children of farmers and rural working-class parents often do, and as Sander may have. His immobilizing style feels as though it is the product of someone who was born old. It is a perfect style to record settled middle age and old age, and when you see his portraits of the ancient peasant couples of Westerwald—arranged here as a prologue to the many portraits that follow, as so many German Adams and Eves—you realize how much Rembrandt, the master of the face of old age, meant to him.

But when he photographed the young he got something extra in his images. He had a rapport with them, though maybe not one he was fully conscious of. His three "Young peasants on their way to a Dance (Westerwald, 1914)," who stand on a little path in the countryside and turn and look at us, are the only rakes in this collective national portrait. With their canes and cigarettes and hats worn at an angle, they're the supercilious heroes of the book; they give an idea of how cocky Sander himself, one of photography's master builders, must have been. The four less imposing but more individual "Young peasants (Westerwald, 1927)," who stand in a forest, responded to the less certain part of him. They too all hold cigarettes. They rest their arms on each other's shoulders. They wear suits but only one of them wears a tie. Like their clothes, the young men—we aren't sure of their ages—are casual, rumpled, already worn down. We can't picture them going off to pick up girls; they have no future in their eyes, though those eyes aren't dull, either. The picture's faint light seems to come up from the twig- and leaf-bestrewn forest floor, and to filter in from the pines and oaks in the background. The forest seems to cup these young peasants, to have been hollowed out just to hold them. This photograph may be the classic German version of the theme of young men who

grow up in the provinces and, though they think of moving on to the big city, probably never do.

Sander didn't officially stop work on his "People of the 20th Century." The project was stopped for him by the new Nazi government. His son Erich was actively involved in Communist-party politics, and that made the photographer suspect in principle. When the Sander household was raided the first time, and August's library and archives were vandalized, it was as a warning to the family not to shelter subversives. Before long, the photographer received word from his publishers that *Face of Our Time*—comprised of sixty plates, representing an introduction to the mammoth project that would follow—was no more. His son Gunther, in his accompanying essay "Photographer Extraordinary," says that his father simply received word one day (it was 1934) that the book was "withdrawn and all stocks confiscated. Even the printing-blocks had been destroyed." Furious but incapable of resting idle, Sander abruptly shifted gears and went to work photographing in the Siebengebirge district, a hilly, heavily forested region near Cologne. He became successful as a landscape and regional photographer, but the government felt he was untrustworthy no matter what his subject, and so the Gestapo again tore apart his archives and this time destroyed negatives, too. He was able to preserve his early portrait project, though, in the form of overlooked negatives and positives. They remained with him, carefully catalogued, stored in the cellar of the Westerwald house that Erich implored his parents to take refuge in. Later, Erich was murdered by the SS and the refuge house destroyed in bombing raids on Cologne. When the war ended and the photographer and his wife Anna Sander staggered out from the years of debris, some measure of comfort awaited them. He found himself, in the fifties, an honored figure—first in Cologne, later in other parts of Germany. Eventually he became known beyond Germany, in a modest way, through inclusion in Steichen's traveling 1955 exhibit *The Family of Man*.

Gunther Sander writes that his father never gave up the idea of somehow completing "People of the 20th Century." But he didn't have the energy, after the war, to start photographing again, and, besides, the people—the faces—he knew he needed,

to pick up where he left off, weren't so easy to find. Pride kept him fussing. Gunther says he would "rummage through his archives in search of what he could no longer produce." But the project was complete as a work of art. It might even have been to his disadvantage to go on photographing after the middle thirties. That would have taken him into a climate he probably didn't have the expressive means to master. All along Sander knew he was making a monument to decline. He was on that track from the very beginning. His earliest photographs, of the patriarchs and matriarchs of Westerwald, so much as declare, "We will never see their like again, we are all puny next to them. Our faces will never radiate such grandeur." How did he come to this conclusion? Not, it seems, because he was politically astute and believed that the German soul was in decline. For all the sociological terms with which he vaunted his project, he doesn't seem to have been especially aware of how his society worked. And he wasn't, by nature, a doom-ridden man. It is true that there is a damper to his images, taken individually or as a whole. In its overriding effect, *Men Without Masks* is the work of a pessimist, a man who sees the variety of human life but believes essentially that people are so many types—that people fill roles that have been played by others before them, and can be summed up by the uniforms they wear. Yet Sander isn't remotely cynical, and his pessimism never feels stagy or mechanical. His bleakness blends in, seamlessly, with his naïveté, his presumption, his heroic striving.

His pictures say that he came to his death-knell tone intuitively. He set out on his mission as a photographer with the sense that something big was about to be lost, and that he was going to carefully preserve the little that remained before it, too, was gone. His great subject was the passage of time from what he saw as the golden age of the Westerwald of his youth to the silver age of the Cologne of the twenties, when he was a middle-aged man. What happened to Germany thereafter—the long suicide struggle it embarked upon—is implied by his portraits, but it wasn't the story he set out to tell.

1974, '81

▶▶▶▶

Lewis Hine

WHILE ALMOST ALL photographs are about past time, individual photographs show their age differently. Some get old much too fast. Others continue to look new long after we feel they should have dated. In Atget's pictures of turn-of-the-century Paris, the sense of the past weighs so heavily that the subject of the pictures becomes, for us, not the city, but the photographer's own nostalgia. Looking at his photographs, we are made to perceive things through a double historical filter: there's the Paris of Atget's time we assume we are going to find and there is the even more distant, aged city that Atget believed in. What is immediately striking about the photographs of Lewis W. Hine (1874-1940) is that there doesn't seem to be any historical filter at all. People in Hine's pictures respond to the camera in ways that make them appear closer to us; they are less of their period than we expect to find them. As a man, Hine was exceptionally aware of the social conditions of his own time. He gave his life to recording them. But as a photographer, he unintentionally by-passes the historic drama he was after and finds a drama that seems to take place outside of history.

Lewis Hine is known as a documentary reporter-photographer who, in the years before the First World War, took pictures of immigrants arriving at Ellis Island, of New York beggars and peddlars, and of children, across the country, who were forced to work in factories or who loitered in city streets. In 1918 he photographed European war refugees, and then, later, laborers in heavy industry. In 1930, working on its girdered heights, he photographed the erection of the Empire State Building. Later in the decade, he photographed the life of the rural poor in the South. (His name also appears in the biography of a more illustrious man. It has been said that it was Hine who, in 1907, then a teacher at New York's Ethical Culture School, took his

photography class, which included the teen-age Paul Strand, to Alfred Stieglitz's Little Galleries of the Photo-Secession, 291 Fifth Avenue. This is one of the questioned scenes in history you wish had happened, and would like to have eavesdropped on: Hine giving Strand into the hands of Stieglitz.) Hine isn't consistently thought of as a great photographer who happened to use his camera as an instrument for social reform; for some, it's the reverse: he remains a crusader for reform who took pictures.

He came to New York from Wisconsin in 1901, to teach botany. His biographers tell us that it was Frank Manny, an old Wisconsin friend and superintendent of the Ethical Culture School, who thought Hine would benefit from using a camera in his work. The camera helped Hine bloom. He was about to be thirty. Within a few years he had completed a degree in education at New York University, and was teaching photography, for a student club, as an adjunct to a shop course, at Ethical Culture. Regularly he took the ferry to Ellis Island, in New York Port, to photograph the new stream of immigrants from Eastern Europe. Eventually he gave up teaching altogether, to be a professional photographer—one at the continual service of causes that needed the kind of sympathetic photojournalism he could deliver. For the National Child Labor Committee, from late 1908 on, he traveled primarily through the Eastern United States, though also reaching California, interviewing and getting pictures of young boys and girls who had to work in factories for long hours, at night, or on weekends. He made pictures of teen-age street newspaper-sellers (they were called newsies) who had been turned into cigar-smoking toughs, and of kids, maimed for life by accidents in the mills, who were out of a job and near-derelict by age fourteen. The photographs were meant to be used as sources of information and as propaganda for the child-labor cause. He labeled his pictures carefully, giving, if possible, the name of the subject, where the child worked, how long this work had gone on for, and when the picture was taken. He took many of the photographs, especially those in the mills, at great risk to himself; frequently he had to disguise his purpose entirely in order to get into the mill, and keep his camera hidden until the

moment when, acting conspiratorily along with his subject, he had the freedom to snap his or her picture.

The great Hine photographs move us in ways that go beyond the literal purpose of his picture-taking. He responds to his immigrant factory workers, street people and child laborers not as victims of a system but as individuals—his subjects are vibrant, composed, willful, gentle, cocky. His special province was children. No photographer before him, and only Helen Levitt after him, has been so responsive to the spirit and the illusions of children and young people. André Kertész has made children one of the important themes of his work; he's attracted to their frantic, thoughtless gaiety, and their innocence. His best photographs are of very young children. Hine's view isn't so literary. He despairs over the way his subjects are forced, much too soon, to take on a belligerent, self-protective shell, yet what also comes across is how much he admires them for being able to do it. He allows us to see through the posturings of city toughs, but he shows how those posturings make life bearable. He understands how kids desperately want to be adults; he honors their mixed-up, still undefined moods of sadness and depression.

But it isn't only that Hine photographs children better than most—photographing children released the largest part of him. His later pictures, of the Empire State builders and other series, though felt and sometimes graphically striking, don't seem particularly the work of Hine, or of anybody we feel we know. Even his photographs of immigrant workers and Ellis Island arrivals, taken before the War, aren't as fine as his photographs of children. With adults, Hine likes to get close up, and he becomes too mindful of composition, but with children he is barely aware of the appearance of his pictures; he works more spontaneously, and trusts that the picture will compose itself. Often he's too far away, or at an angle, or peering down—sometimes he almost seems to be sliding in on his proper subject. The more he catches his subjects on the fly, the more awkward the space surrounding them, the more original his pictures. Though he also made classic images by simply lining up his subjects in a row before him. There is also more of Hine in his photographs of children.

You feel that he has fashioned a distinct character for himself in them: he is a visiting stranger. In some, he even includes his shadow—he is a lean man with a brim hat and a long, straight coat. He creates a space, between himself and his subjects, that other photographers don't—a taut, expectant space, where the children and young people, caught before there is enough time to make themselves conventionally ready, wait to see who wants to talk to them.

Hine was almost too attracted to the courage, gracefulness and variety of human personality. He makes us forget that the children, young and older people he photographed worked and lived in humiliating conditions. He's able to do this because, taking their pictures, he made them forget it, too. People trusted the attention he paid them. They liked him. They gave him the strongest part of themselves, their reserves, not the part they lived with daily. This is what gives his pictures their autumnal beauty. He didn't record what his subjects were, he recorded what they might have been.

1974, '81

▶▶▶▶

Helen Levitt's New Color Work

WALKER EVANS SPEAKS for many people when, in his notes on the art of photography in *Quality*, he describes how using color is not exactly the greatest new idea to hit the medium. Sounding the way one imagines Clifton Webb would sound if he were approached for comments on the subject of children, Evans writes, "There are four simple words for the matter, which must be whispered: Color-photography is vulgar." (The last sentence is printed in tiny type, so that it looks as if the author is

whispering.) Making a few allowances, Evans adds that color might be acceptable if "the *point* of a picture subject is precisely its vulgarity or its color-accident through man's hand, not God's." (Evans's tartly-phrased opinions, in *Quality* and elsewhere, should not be thought of as ideological positions. He went on to use color himself.)

For the past number of years, Helen Levitt has worked mostly in color. Her subject is the one she has long been identified with, from her book of black and white photographs *A Way of Seeing*, and one well known for its lively vulgarity and countless man-made "color accidents"—New York City street life. Photographing primarily in the summer, she gets a soft, sunny light. It's rarely harsh or brilliant—it makes the hues appear to be soaked in. Levitt's people are always at ease with their bodies, they're born performers, and a New York summer, which makes many people especially conscious of their physical selves, is her special moment. In one picture, an amply-proportioned woman, her eyes made up so heavily you can barely make out her actual eyes, wears a skintight pink top and skintight yellow pants, and stands before a glistening dark red doorway, which is next to a red-orange painted window. The color is going ninety-five miles an hour, but the woman, with her plump hand bent back on her formidable hip, is monumentally oblivious to it all. Like one of Ingres's boneless bourgeois queens, she doesn't even seem to be aware of how voluptuous she is.

The sour-sharp contrasts in this picture are so discordant that the color doesn't seem naturalistic—it seems abstract. Evans, who looks at junky or aberrant color aesthetically, as if it were a kind of folk art, probably would appreciate the photograph. But Levitt's interest in color is different from Evans'; she doesn't want the colors here, or in any of her pictures, to be savored purely for their own sake. She uses color because it adds a layer of feeling to the human atmosphere she's after, and there are as many conventionally rich or even muddy, neutral colors in her recent pictures as there are glaring, harsh and over-vivid ones. There are pinks, oranges, purples—Mexican colors. And there are also expanses of velvety brick red, weathered pale green, the

tan-gray of pavement in the bright sun, robin's egg and faded royal blue—colors of French and Italian beach towns. Levitt doesn't set out to photograph "color-accidents," just as, unlike many photographers of New York, she doesn't deliberately search for human accidents. There are human accidents in her pictures—a baby in its carriage looks a touch too sallow and wizened; a man who shuffles along seems as if he might be a big-city version of the village idiot; a girl crouching head down, between a car tire and the sidewalk, reminds us of the discoör-dinated way retarded people use their limbs. But these accidents are there, we feel, because Levitt is drawn to people who are able to dramatize their impulses—whether these people are a touch "off," or they're children who strut, chests puffed out, pretend-ing to be gangsters, or they're adults who may not be physically active but have. the light of mental activity in their eyes. The most sedentary of her subjects look as if they could be thinking, "Well, here I am, the image of someone lounging on a New York door stoop."

What remains in the viewer's mind from Levitt's earlier, black and white photographs are her responses to stage-like gestures and split-second body movements. The tone of these pictures is both exuberant and edgy; they're lyrical, but they also suggest that there is a nerve-wracking, destructive energy behind that lyricism. Her color can be stage-like too, but the color photo-graphs aren't the emotional high-wire acts that the black and white ones are. There's less frenzy in her work now, there are fewer fine, small details to catch. Yet the color pictures demand more viewing time. You want to stay with them longer. Seeing six or seven at one time, you almost feel a pleasurably lulling thick summer air rise up from them, slowing down your re-sponses. Her canniness—her wary New York eye—is still there, but indirectly. Her warm colors give New York an aromatic seedy-lush beauty, and it's only after a while that you begin to see her own not-so-lush sensibility interacting with this beauty.

If Levitt's earlier photographs might be characterized as the work of a New Yorker who knows that it's dangerous to get too close to the life of the City, the recent photographs can be said to

complement that spirit—they show how it's impossible for her to be without that life. Although there are days when one would like to, it's difficult to embrace New York now, to hug it in the same adoring way Whitman did, or even to admire it from afar, as Stieglitz did, for its energy and grandeur. But New York can be loved cautiously, with mixed feelings. Few people have had as many of these mixed feelings, and presented them with such delicacy and precision, as Helen Levitt.

1975

▶▶▶▶

De Meyerland

THOUGH PHILIPPE JULLIAN calls the Baron de Meyer a "great artist," he doesn't dwell too long over de Meyer's photography. He prefers instead to give us the glittering world the Baron lived in, and his introduction to *De Meyer*, an orgy of name-dropping which is also an enjoyable capsulated social history of the Belle Epoque, its Edwardian afternoon and its Smart Set twenties aftermath, perfectly complements the photographs. Jullian compares the Baron with Proust's Swann, nattily described as "the most *chic* man in fiction," and we learn that "chic"—or the art of "making a fine display," invented in the mid-19th century—"was the religion of the Baron de Meyer." Out of this religion came a thirty-odd-year career as a photographer, much of it spent working for *Vogue* and *Harper's Bazaar*. The religion also produced two languidly conducted professions, as an interior decorator and a fashion designer, and, at a snappier pace, a glamorous and highly public marriage to Olga Caracciolo, who, in addition to being a famous wit and confidante, was a well-known child model for Whistler, the inspiration for Maisie in

James' *What Maisie Knew*, and probably Edward VII's illegitimate daughter. It was through the Edward connection that plain Adolf Meyer became the Baron de Meyer.

As an artist, de Meyer seems at first not to have had much more going for him than an idolizing frame of mind and the obsession for good taste that only an aspiring outsider can have (not only was he a last-minute aristocrat, he was also, like Swann, a Jew traveling in a non-Jewish society). He probably wanted only to re-do Sargent, but, quite often, he achieved more than his model. His "Sargents," such as the dark, muffled portrait of Rita de Acosta Lydig or the many of Olga, are not only as elegant and decorous as the paintings, they are also more mysteriously remote than many Sargents are. Unlike the painter, who embodies the mood in the clothes, settings and those razor-sharp facial expressions, de Meyer rarely fixes on any one expression, and his people are far from summed up by the clothes they wear. De Meyer called his work "commercial," yet these fashion photographs have more substance than most. He draws his subjects into a cloudy romantic realm, one beyond the fashionably "smart." It seems as if you can cut your way through the velvety sealed-off atmosphere of de Meyerland, and this density of space grows on you to become a density of feeling.

De Meyer wasn't as inventive as contemporary photographers such as Stieglitz, Clarence White or Steichen, though his work is a close stylistic cousin of theirs. Except for a few still lifes, the bulk of which are musty, his pictures generally are portraits of one person seen close-up. Among the best and most well-known are the ones of Jeanne Eagels, Eugene O'Neill, John Barrymore, Lady Ottoline Morrell, Gertrude Vanderbilt Whitney, Alvin Langdon Coburn and the many of Nijinsky. The seventy-two photographs chosen by Robert Brandau for this classy sepia-and-chocolate-colored volume represent about all the de Meyers you probably will ever need to see. They are enough to leave a distinct impression.

1976

Writers about Art

▶▶▶▶

Leo Steinberg's Other Criteria

IN THE WELL-KNOWN ESSAY "Contemporary Art and the Plight of
Its Public," which was originally given in talks at the Museum of
Modern Art, and later published in *Harper's Magazine* in 1962,
Leo Steinberg describes how, in the fifties, when he first saw
Jasper Johns's paintings of targets, with their little boxes contain-
ing colored fragments of the human body, sitting above the
target, he was initially suspicious, then angered, and finally just
frustrated. He was frustrated not only with the pictures—which
were mysterious but blank, and maybe a joke—but also with
those people who immediately claimed to like and, of course,
"understand" what Johns was doing, and with himself, for being
in the helpless position of not knowing what he felt. This essay,
which Steinberg has included in *Other Criteria*, his collection of
"Confrontations with Twentieth-Century Art," is one of the few
attempts to deal with the "difficultness" of modern art as some-
thing more than the "necessary condition" of modernism. He
tries to show how advanced art, if it's going to count for much in
our lives, has got to be a personal issue, has got to involve some
degree of "sacrifice." And he suggests that if the confrontation
with modern art, or with any art, doesn't in some way force us
to give up, or at least question, ideas we had always thought we
wanted to hold onto, there's nothing radical, or transforming,
about the confrontation. The piece is Leo Steinberg at his best—
dealing with a specific work, or idea, relating and analyzing
whatever personal experience he had in coming to understand it,
and then, with a voice that is intimate yet commanding, drawing
the larger conclusions that he believes come from his involve-
ment.

Steinberg, who teaches Renaissance and Baroque art history
at Hunter College, and gives public talks frequently in New
York, is an inspiring lecturer, especially to young art historians-

185

to-be. He makes art history into a noble profession that can matter in the real world. Though he may speak too rapidly when he's on stage, and occasionally gives the impression that he is impatient with the whole idea of lecturing about art, he clearly loves having an audience. He never dilutes his material for the sake of understandability; the audience feels Steinberg is eager to tell everything he knows about the subject; yet his foremost goal is to send his audience away, at the end of the evening, with something tangible and new. He wants to surprise people—to make them sense that the past was different than they thought. Meyer Schapiro's lectures, in contrast, often leave listeners dazzled by his insights but at a loss to describe those insights after the lecture. There are often too many historical, anthropological, psychological and aesthetic facts and perceptions, and Schapiro lets them all fall where they may, like so many pointillist dots that don't form to make a picture. Schapiro addresses people as if he were a scholar-poet; he makes you listen intently to follow the way his mind works. Steinberg is more of a scholar-lawyer. He presents his material as if it were a case and his listeners a jury. His talks have a single theme or thread, and it's important to him that his audience follow that thread, through the complex byways, home to its conclusion.

Steinberg has been writing about modern art on and off for eighteen years. For a short stretch in the mid-fifties he was a regular reviewer for *Arts* magazine. Since then he has written a few pieces on the order of "Contemporary Art and the Plight of Its Public," and long essays on Jasper Johns, Rodin and Picasso. Somehow, he is never at his best on individual artists; in these essays, which make up the larger portion of *Other Criteria*, he often loses himself, and us, in a driving need to prove things irrefutably. The strongest pieces in this collection are those on larger, more general ideas. The common theme, implicit in whatever he writes or speaks about, is that it's time for new approaches—more personal and less formalistic ones—to the way we look at and write about and teach art. Steinberg isn't alone in saying we need to find and apply "other criteria." Hilton Kramer has for long shown how formalism, the dominant

"serious" art criticism, is an inadequate and deadening approach. Harold Rosenberg, in his stress on the "ideas" behind modern painting, has ignored formalism altogether. But these critics are exceptions. Very little art writing is like theirs.

The heart of Steinberg's book is "Other Criteria," a wide-ranging essay (not all of it equally strong) that attacks formalist criticism and the bland, problem-solving art it has produced. Like Randall Jarrell's essay "The Age of Criticism," which it resembles, "Other Criteria" is based on a sense that criticism is too much with us, and that the busy critics might not know what they're doing. Jarrell said we could no longer see literature for the writing about it. He didn't stress the particular kind of criticism he considered so crushing; that was only hinted at. Steinberg says we can't see art, or tell whether it's good or bad, because emotionally we don't ask anything of it any more. Speaking about recent developments, he says that maybe there's no longer any art to see, since so much art now only exists because of the writing about it. Steinberg bases the theoretical part of his argument on showing that the chief formalist critic Clement Greenberg's distinction between Old Master and modernist painting—as two different breeds, with two different demands—is a misconception. Greenberg knows Old Master painting better than Steinberg says he does, but the point is a good one. Steinberg makes sense when he claims that "the interest painters have in questioning their operation," which is always taken as a formalist question, is equally important throughout all art. "The more realistic the art of the Old Masters became," he writes, "the more they raised internal safeguards against illusion, ensuring at every point that attention would remain focused upon the art." Among the most solid and engaging pages in "Other Criteria" are those where Steinberg shows how "modern" and conscious of its own devices older art is.

Steinberg says, "I find myself constantly in opposition to what is called formalism; not because I doubt the necessity of formal analysis, or the positive value of work done by serious formalist critics. But because I mistrust their certainties, their apparatus of quantification, their self-righteous indifference to that part of

artistic utterance which their tools do not measure." How are his own tools? Like other writers whose chief field of endeavor is not modern art but are drawn to it, and like speculating about it— Octavio Paz is one—Steinberg has a free-wheeling, anything-goes approach that isn't found in art magazines. There are aphoristic remarks that stand out even in the reviews for *Arts*, done when he was, as he calls himself, "a truant art history student." "From first to last the artist tramples on his own facility," he says of Jackson Pollock in a 1955 piece. And adds, with the bravado of a brilliant, bookish student—yet making a point that still feels right—"How good these pictures are I cannot tell, but know that they have something of the barbarism of an ancient epic. Does anybody ask whether the Song of Gilgamesh is any good?"

In his later pieces, he strives for new, more personal and informal ways of expressing himself. The writing on Johns, Rodin and Picasso is unorthodox in form—there are poetic and diary-like interludes, abrupt shifts in tone, asides to the reader, confessions. Steinberg writes one moment as an omniscient professor, the next as a groping outsider, attempting to fathom the unfathomable. But these pieces don't add up right, despite the care that he takes with words. The reader is never quite convinced that Steinberg needs his groping tone; his often roundabout methods of attacking feel showy, unworthy of the man's obviously great intelligence. When he's trying to understand his dissatisfactions, as in an early article on Fritz Glarner, he's forceful. But he isn't persuasive when he admires an artist. He writes as if Picasso is such an endlessly rich field of study that he, Steinberg, can only begin to do justice to the tiniest portion of it. That may be true, but it makes for a grating tone. The reader feels that Steinberg's throwing himself at the feet of Jasper Johns or Picasso, and excessively praising every small move each man makes, isn't forthright. What comes across is less the genius he wants us to see in his subjects than his own effort to label the many different routes genius takes.

Steinberg warms up when he can discover meanings most art viewers or historians had thought nonexistent. He seems happi-

est and most assured when he can make a case for art that has been disparaged. It almost seems as important to him to show that his subject has been ignored or disparaged as it is to make that subject newly fresh. His visual, literary and cultural explications can be awesome in their reverberations, especially when he can tie those explications to history—as he does, for example, in his analysis of Michaelangelo's "Deluge" (presented in a lecture at the Metropolitan Museum in 1970). But in *Other Criteria*, writing about more recent personalities, he feels he can dispense with history. He's very good, in his essay on Rodin, in describing how the sculptor came to his current reputation. Since 1914, he tells us, Rodin's "greatness has rarely been questioned—only his taste, his good judgment, and his significance in the present." But things sink a little after that witty beginning. The historical setting and Rodin the man keep shifting in and out of focus. There are sympathetic observations throughout (and the essay is profusely illustrated with many superb photographs). This is probably the most intelligent and scrupulous case that will be made for the French sculptor for some time. But it has a fancy tone that doesn't really do him justice. You feel that Rodin would have liked the elegantly formulated analyses Steinberg lavishes upon his pieces. Yet they profundize what doesn't feel profound. They serve to keep pushing away from us what we can't help coming back to when we think of Rodin: his vulgarity. If Steinberg had tapped Rodin's coarseness—if he had taken the discussion out of the realm of art—he might have made Rodin more one of us, more of a modern.

Steinberg's greatest strength may be his ability to describe bodily movement in art. He sees the smallest physical gesture as a dance critic would, as having a life of its own. Talking about one of the figures in Rodin's "Gates of Hell," he says of the "groping arms" that "They are wrongly plugged in at the joints, so that paralysis creeps down from their very shoulders; the strength of gesture in them suffices only for dying away." Much of Steinberg's writing on Picasso concerns the painter's presentation of the human body. "Ambiguous simultaneity is part of

Picasso's essential approach to the rendering of the external world," he says. Using sketches that aren't often reproduced as well as examples of known paintings and prints, Steinberg convincingly shows how "ambiguous simultaneity" was a constant, preoccupying theme for Picasso. The three Picasso essays here are the strongest of Steinberg's writings on a modern artist. They're recreations of specific works and of the artist's sensibility, seen from the vantage point of one or two ideas that Steinberg believes contain the essence of the painter. These pieces are best read after you have had your own experience with Picasso—after you have seen a lot of his work and formed your own conclusions. Otherwise, you may be baffled and annoyed with Steinberg's reflective yet somewhat doctrinaire approach, and his harping on the notion that, contrary to general opinion, Picasso's late art is as rich as his early art.

There is obviously a discrepancy between Steinberg's performance as an art critic and the ideal new critic he imagines in his other essays. This is disheartening, but it doesn't deflate what is invigorating about the best essays. Essentially, whether he's looking at the teaching of art history or the state of recent art or recent art writing, Steinberg says, "Let's find some new windows to open, let's see if we can get more air to circulate in here." He doesn't say what those windows will look out on, and that doesn't matter much. Simply by calling for more air he seems to have done something, perhaps because his voice has such authority and confidence. You admire him for his underlying liberality. He doesn't betray the principles he sets down for himself in his lead essay, "Contemporary Art and the Plight of Its Public." He doesn't do the expected thing—that is, when he calls for "other criteria" he doesn't mean that earlier, more literary methods of describing and judging ought to be brought back. He sees that the spirit of the toughest recent art won't be served by looking at it in terms of earlier art or literature.

He is right to look critically at the goals of formalist writers such as Roger Fry and Clement Greenberg; many of the problems of recent art interpretation stem from their approach. But Steinberg doesn't make clear the difference between Greenberg's

formalist criticism, which still stands as a creative response to new art, and the mechanical, witless version of that response which holds sway in the prestigious magazines today. The new practitioners have neither Greenberg's discriminating eye nor his ability to show how a formal advance may have some wider, cultural reference. Current art writing, as Steinberg says, is indifferent to too much art being made. It's also, as Greenberg has exasperatedly said, indifferent to taste—even about the art it's for. Personal sensibility, like "interpretation," is the enemy for many serious, committed young art writers. They prefer to be impersonal, and their stylistic goal is ideally suited to describe the goals of the artists they write about. Their theoretic vocabulary allows them to deal with only a certain kind of art; all the rest is contemptuously thrown aside as "unserious." In a way, there's no difference between this situation and the situation of the mid-19th century, when academic critics were perfectly sure Salon art was the only art, and said that what Manet was doing was a preposterous joke. When art and art writing keep on congratulating themselves, maybe the product has got to be stale, dull, airless, "academic"—even if all the congratulations are being handed out in the name of avant-gardism.

Avant-garde ideals can get tired and sour, and this is where Steinberg steps in. By nature, he is a conservative critic; he loves history and loves speaking of—and for—its triumphs. He sees himself as a spokesman for the greatest intellectual glories of the past, the Renaissance past and the near past of Picasso. But his effect on the current scene is that of a radical. He's attracted to the powerful individual, not the powerful art idea, or the triumphant generation. His heroes are generally isolated figures, not so much out of sync with their time as oblivious of it. As he presents them, Picasso, Rodin and Johns are not believable, real men—they are ethereal supercreators. Despite that, Steinberg makes his audience ready to see that demanding new art can be the product of individuals, not schools or ideas about styles. This is what gives his message its special allure right now.

1973, '82

▶▶▶▶

An Aristocrat of Life
and Culture

LINCOLN KIRSTEIN'S *Elie Nadelman* is a cranky, demonic, magisterial book—not exactly art history, biography, or art criticism but closer to a preachy monologue on style, sensibility, aesthetic choices, the way an artist "conducts" himself. Kirstein wants us to believe that the Polish-American sculptor Elie Nadelman (1882-1946) is one of the most brilliant artists who ever lived, and he has two styles for expressing this—the rhapsodic (when he writes as if he were in a trance, in love with his own eloquence) and the combative (when he throws around his immense learning, like a bully). This is an exasperating book; it's loaded down with enough references to different cultures, artists, and aesthetic theories to sink a ship and, annoyingly, the references are flat, the air is vacuumy, all the conclusions are foregone. And it has far too many rhinestones: "It was perhaps the last period of a genre of private patronage in this country which, while still imitating European precedent, proposed an exuberance in luxurious collaboration freed from precise pastiche or the prestige of specific precedent."

Yet the book is not a forgettable reverie about artistic greatness—one of those productions, like Aragon's two volumes on Matisse, in which the reading experience is like eating air. Kirstein is more than beside himself with adoration; he sees Nadelman as a heroic figure: the heir to Phidias and Praxiteles, the last artist who consciously carried on the tradition of classical art. Many of the claims are impossible to swallow, but the portrait Kirstein draws is coherent in a lordly way, and he gives works of art a special dimension. It's hard to say what this dimension is, perhaps because the descriptive tone is what is remarkable, not the individual points, which blend into one another. Kirstein elaborates on the metaphoric meanings of art

styles the way people fondle things they love, picking them up again and again, admiring them from different angles. He creates a heady atmosphere, in which culture is more precious and powerful than it is normally thought to be, and in which Nadelman has the power and attraction of a seer or a prince. *Elie Nadelman* should be the great work on an American artist's career (there still isn't one commanding biography on any of our artists—at least, none with the scope of Fry on Cézanne, or Sidney Geist on Brancusi); Kirstein is after a grand, irrefutable appraisal, and his essay has an outsize epic scale that is missing from most art writing. He is a dictatorial writer: he reminds one of Ruskin, or Henry Adams on French architecture. The pressure he puts on the reader to believe, to be swept along in the tide of his prose, is infuriating, but it is awesome, too, and here it is appropriate for his larger-than-life conviction about this sculptor's achievement. The problem is that the conviction is not enough: the all-or-nothing manner takes over, the dogmatic spirit becomes stifling. The reader is left wondering—not whether the arguments make sense about Nadelman but why they matter so much to Kirstein.

While Lincoln Kirstein, now sixty-eight, is best known as the general director of the New York City Ballet (his account of the company's history, *The New York City Ballet*, was published concurrently with the Nadelman biography), and as a critic of ballet—his *Nijinsky Dancing* is about to be published—he has been writing on American art, mostly sculpture and photography, for forty years. He wrote the catalogue for the Museum of Modern Art's Gaston Lachaise retrospective in 1935, and contributed an essay to the Modern's 1938 book, *Walker Evans— American Photographs*, which is still the strongest writing on Evans. He began writing about Nadelman in 1948; his catalogue essay for the Modern's memorial show, *The Sculpture of Elie Nadelman*, was the first detailed critical account of the artist; in 1949, he brought out *Elie Nadelman Drawings*, a book of plates that contained a more personal and idiosyncratic essay on Nadelman than the one in the Modern catalogue. The two slim volumes, warmups for the present book, have stood on the

library shelf as the only substantial references on the sculptor, who often seems to be the creation of Kirstein. Certainly, if it weren't for Kirstein's suggestive essays, Nadelman might not have held even his shadowy position in 20th-century art history. While, as a young man, he was living in Paris, he was momentarily considered part of the "modernist" movement when his analytic drawings and sculptures attracted the attention of Picasso, the Steins, André Gide. But by the time he moved to New York, in 1914, it became clear to his contemporaries that his abstract interests were outside the sphere of the School of Paris—he was working toward a new formal purism, not Cubism. Nadelman took on New York society, married well, dropped out of the modernist movement for good. After 1929, when his wife's fortune was lost, he dropped out of the New York art and social scenes, too; if he was known in the last sixteen years of his life, it was because, in the twenties, he and his wife had assembled one of the earliest and greatest folk-art collections in America—a collection they were afterward forced to give up.

Nadelman is now the subject of a large and beautiful retrospective at the Whitney, complemented by a smaller show, primarily of the late work, at the Zabriskie Gallery, and it's likely that these shows, along with this book, will make him a permanent star. But most of the attention he has had is of the perfunctory, historical-note kind. Certain critics—Henry McBride, Hilton Kramer—are admirers, but many people who know modern sculpture are puzzled, even annoyed, by this dainty, elegant, superstylized art. Sam Hunter, in his recent *American Art of the 20th Century,* does not find the slightest thing relevant or satisfying about Nadelman (given Hunter's petulant tone, which seems mostly directed against Kirstein's praise, though he is not mentioned by name, it's weird that the frontispiece is Nadelman's most famous bronze, "Man in the Open Air"). The complaints against Nadelman are that he is derivative, mannered, and bloodless. Kirstein turns the complaints inside out: he shows that Nadelman is mannered and bloodless because he has to be. Kirstein totally embraces the aesthetic of

classic, ideal art; he believes some aspect of it is necessary for any serious creativity. So for him Nadelman's untouched-by-human-hands manner, his suave surfaces, the subtle, controlled bodily movements depicted, and the bland expressions on the faces of his figures are a glory. He lovingly describes Nadelman's feeling for mathematical perfectibility and predictableness; he says with admiration that, for Nadelman (whom Apollinaire had already, early in the century, nicknamed Pheidiasohn and Praxitelmann), "procedure held sober order in detached control, cool as the stones he buffed."

Kirstein's Nadelman, master of unchanging rules and overriding discipline, is not everybody's Nadelman; one can admire the artist and see qualities in him that Kirstein does not see. There is an expressive side to Nadelman that Kirstein touches on much too briefly; he doesn't want there to be anything unconscious or unintended about Nadelman's creativity, because that would make him a "romantic," and for Kirstein that is like being ill. Yet while Nadelman's classicism can be greatly satisfying, like Piero della Francesca's or Seurat's, because it communicates a timeless poise, there is a bizarre, uncomfortable aspect in his version of it. Nadelman's art has echoes of bodily gestures from many cultures and periods—the antique Mediterranean world, folk art, dolls, toys, Indian cult figures, burlesque queens—but all the echoes are indistinct; looking at his work, one gets a physical suggestion of features and gestures rubbed away—not just softened—almost to the vanishing point of distinguishability. Something of this flattening can be seen in his most widely known works—the two monumental double figures at the New York State Theatre (though these 19-foot-high pieces, which were made after the artist's death, are not quite what he intended; the originals, one of which is in the Zabriskie exhibition, about 5 feet high and executed in a delicately faded paper-and-plaster, are mysteriously bloated, hazy, and withdrawn, while the State Theatre versions, too big and milky, are just placid and friendly). Brancusi, who also deals with pure sculptural forms, makes everything clear-cut and sparkling; Nadelman is the negative of this—he muffles it all. When Brancusi smooths form

to a state of "perfection," we're dazzled by the clarity, we're
given the feeling that forms can't be made clearer than this; when
Nadelman is "perfect," ambiguity and nostalgia creep in, be-
cause he makes the viewer aware that it is the perfection of a
certain time, and that that time is eroded. Brancusi is the
sculptor of immediacy and newness; Nadelman, his dark oppo-
site, is the sculptor of slow changes and history. This "pastness"
in Nadelman can be wonderful, as in the big "galvano-plastique"
circus figures, or the wood carvings, with their slight gesso
rubbings for faces, which represent clothed contemporary fig-
ures (among the best are "Host," "Seated Woman," "Dancer,"
"Chanteuse," the couple in "Tango," and the "Woman at the
Piano," all of which are in the Whitney show). The woods are
from the teens and the twenties, and they have the jazzy,
streamlined profiles of that time. They recall, too, the doll-like,
sprightly brainlessness of Seurat's afternoon strollers, and their
weathered look makes them similar to the 19th-century Ameri-
can folk-art carvings Nadelman loved and collected. Hovering
over all these resemblances is Nadelman's peculiar faded, dim
sweetness of mood. The figures are represented as if they were
relics or mementos: they always appear to have just been found
in the attic; there is a feeling that dust is clinging to their rounded
surfaces. This quality is lovely and appropriate in the big circus
ladies and the representations of people "in society": it gives
them their marvellous, spooky wit. But in other places it is
unsettling.

There is a tenseness in Nadelman: when an artist leaves, as a
finished work, something that has clear marks of having been
rubbed too smooth, or rubbed out, one feels that a sort of
destructiveness is part of the experience—his experience, and
ours. Nadelman might be described as a connoisseur of past
styles who erases all the distinguishing characteristics from the
things in his collection, so that the past loses its many distinct
flavors, becoming instead a series of bemused, maybe too private
memories. Was he aware that, in his world of reduced tiny
gestures and slight expressions, what is charming can turn into
something revolting? There is a little of James's character Gil-

bert Osmond, of *The Portrait of a Lady,* in Nadelman: like Osmond's, his feelings are so refined, measured, and secretive that they seem 'inhuman, even frightening. Kirstein sees this disquieting element in Nadelman, but because he believes that it comes only at the end of the sculptor's career, and as a reaction, not convincingly explained, to "modern morality," it is made incidental. Yet one can also see Nadelman's strangely intimate relation with the past as a quality that is in his work all along—a basic part of his success and his failure.

When Lincoln Kirstein writes about artists, he makes them seem to be the last word in civilized learning. Sometimes he overdoes it; few artists are capable of knowing as much about as many different styles and cultures as he likes to think, and artists are rarely so conscious of the sources they use. In his essays on the 19th-century sculptor William Rimmer, or on the 20th-century painter Pavel Tchelitchew, he fallaciously equates the artist's personal knowledge of things with talent and vision. This doesn't happen with Nadelman: his work radiates the dazzling intelligence and taste Kirstein ascribes to it. Nadelman might not be, as Kirstein implies, the fulfillment of classical Greek and Hellenistic art, but he is certainly the greatest modern neoclassical figure after Seurat, and his art mirrors the complexity and richness of the many traditions Kirstein shows were in his blood: Nadelman, he says, "was heir to all the cultures, religions, and imagery of old Poland—'True Slav,' Jewish, Roman, Germanic—but a conformist to none. Born into a climate of intellectual liberalism, he became a citizen of the world. . . . To comprehend Nadelman as a creature in tradition one must link West European cave murals with Alexandrian carving, Byzantine painting with medieval handicraft." Kirstein is right when he says that Nadelman presented "theatre ritual more originally than anyone had since Toulouse-Lautrec and Seurat." One can believe, too, that Nadelman's rethinking of "historic styles from pre-history to Staffordshire" made him "the single sculptor of his time who convincingly essentialized contemporary man clad in the dress of his day." Like Ruskin, Kirstein is at his best when he's describing work he loves. (When he puts something down,

he resorts to sarcasm, and his sarcasm is plodding and school-masterish.) Kirstein makes great leaps in his writing; from what he assumes the sculptures meant to Nadelman he switches to his own interpretations of these forms in folklore and mythology, vaudeville and classical art. He mixes up the associations so much that it's difficult to know when he imagines he is in Nadelman's mind and when he is speaking for himself. Talking about the sculptor's reasons for depicting certain "types," he says that Nadelman had a feeling for "dignity incarnate in actor, dancer, acrobat." Then he takes off: "Professional skills are protection, even salvation. Mask or mirthless grin is armor. . . . The security of balance in profile, form, and volume, the modest elegance of rubbed and painted wood make their small scale majestically noble." These thoughts on "professional skills" are Kirstein's, not Nadelman's; the sculpture doesn't immediately make one think "mask . . . is armor"—that is Kirstein's aesthetic attitude. Nadelman never said that the professional skills of actors, dancers, and acrobats represent "salvation." Still, Kirstein's responses coincide with the *spirit* of Nadelman; Kirstein's ideas are refreshed when he looks at the art, and that makes it seem as if he were bringing out its possibilities. It's like Ruskin's trying to account for everything in Turner and being carried away by his description, so much so that he winds up saying that the paintings force us into new conceptions of "realism" and "nature." Ruskin makes Turner into a vision, but it is a believable vision because you can see what it is in Turner that drives Ruskin to his conclusions. Kirstein on Nadelman is the same kind of collaboration.

How good is Nadelman? When is he at his best? Where does he stand in relation to the sculpture of his time? Kirstein doesn't tell. He's not interested. He is one of those art writers for whom quality is irrelevant. He doesn't base his interpretations on what is visually there. For him the value of art is the artist's idea; he assumes that the artist has the whole vision in his head before a work is created. He doesn't appear to understand that the art work is devalued when it is turned into an illustration of a larger concept. When he refers to one of the plates in his book, he

rarely means "My point is made by this specific piece"; he means "My point is made by this kind of thing." Nadelman certainly had lows, but you would never gather this from Kirstein's approach. You would also never know that Nadelman was a contemporary of Brancusi, Arp, Miró, and Matisse. Although there are passing references to 20th-century artists who resemble Nadelman, Kirstein never follows through on the connections. "If Nadelman can be placed beside a poet," he writes, "it is not by Racine, Pushkin, Lermontov, or Baudelaire, whom he loved above others, but near Ezra Pound, whose versions of Propertius, troubadours, Chinese, Théophile Gautier echo ideas of dandyism which Nadelman fixed for an identical era through the lens of Tanagra, the Dordogne caves, Bavarian folk toys, Guys, Seurat, Pascin." That sentence is all that Pound, the one contemporary writer Kirstein thinks compatible with Nadelman, gets. Not much is learned on how and why "Guys, Seurat, Pascin" appear; at another point, Kirstein says that Pascin was the contemporary artist Nadelman admired most, but he does not bother to explain why.

Kirstein is obsessed with Nadelman's work at the time when the sculptor was most involved with Greek and Hellenistic form. Classical art, its history and aesthetic, is a very live, immediate issue for Kirstein, and his most extraordinary writing always deals with how Nadelman works as a classical artist. When he can describe the meanings behind different bodily gestures and postures in the sculpture, Kirstein carries the reader along into new, expansive feelings about art; Nadelman's final pieces, strange small terra-cotta figurines, are "indecisively aged, they seem rooted in fixed immaturity, however ripe their forms." The galvanos are "people of pneumatic plumpness. . . . They are deftly posed, benign, even cheerful, fulsomely content, alert in amplitude, waiting poised or momentarily seated before launching into their act. Columnar rigidity appropriate to the wooden figures is now succeeded by a fluency, as if the volumes were poured into articulate sacks of molten metal. They seem taut with air." Kirstein's feeling for the moods, rhythms, and outlines of the body is like Ruskin's for rocks or the weather: he can evoke

it and draw meanings from it long after we think that there is anything left to say.

But because Kirstein keeps returning to Nadelman's classically derived sculpture, the reader loses a sense of how important the less classical works, principally the wood carvings, are, and how they distinguish the artist. The woods show his greatest sustained interest in contemporary life and folk art, but folk art doesn't do much for Kirstein. It is never made clear that the carved woods and the galvano-plastique circus women, and not the too-Grecian marbles, are the pieces that put Nadelman in the class of the greatest sculptors in modern art. Kirstein is so absorbed in describing Nadelman as a "modern" who turned down "modernism" to rethink classicism that he totally overlooks art judgments. He even has good words for the sculptor's commissioned salon portraits, and their aesthetic quality is near zero. It is unfortunate that Kirstein draws back from modern art history, because that is where Nadelman, if he is going to count for us on less mythic terms, will have to be situated.

Elie Nadelman, designed by Martino Mardersteig and printed at the Stamperia Valdonega, in Verona, with hundreds of plates in velvety sepia tones, is one of the most elegant art books ever produced. (Compared to most expensive art books, the Miami Beach hotels of the publishing industry, this one looks chaste.) It is to be hoped that the definitive aura of the volume will not scare off others from writing about the sculptor; there is more, and less, of Nadelman than this grandiose portrait suggests (also, the *catalogue raisonné*, admittedly a "draft," is confusing and haphazard). Anyway, the essay belongs to Kirstein's biography as much as it does to Nadelman's. It pulls together and elaborates on the themes Kirstein has presented many times before (besides Nadelman, Rimmer, Evans, Tchelitchew, and Lachaise, he's written on Henri Cartier-Bresson, W. Eugene Smith, Eakins, Whitman, and Frances B. Johnston, the photographer of *The Hampton Album*, a record of the Institute, and, most recently, Augustus Saint-Gaudens, in *Lay This Laurel*, an account of the Robert Gould Shaw Memorial, in Boston. *Lay This Laurel*, as physically beautiful a book as *Elie Nadelman*, is a curtain-raiser for a

proposed monumental biography of Saint-Gaudens). The way Kirstein presents an artist, he is more talented and visionary than most of his contemporaries; he also suffers more, usually because of public neglect and his own great pride, though the suffering, we are repeatedly told, is never made part of the art. He is a worldly figure, but he eventually becomes weary of and depressed by society, and removes himself, to work (as Kirstein says of Eakins) in "secrecy and silence." He is never troubled by the conflicts many modern artists face—problems of self-doubt and identity. He looks at his role ironically, maintains a stoical "good humor" about himself. He is often debonaire, he is urbane and widely cultured; in his art he prefers to deal with ideal form or everyday realism, anatomy or perspective—anything, in fact, but his own personal life. There is a bit of Baudelaire's Dandy in this concept, especially in the idea that the artist is a man-about-town, an observer of society who glides in and out without people's being aware that he is an artist, or that he is even "there." Kirstein is describing an ideal practice when he says of Cartier-Bresson that "sometimes and somehow, almost out of a superior craftsman's good manners, he seems able to leave his lens out of the picture. His portrait subjects are not shot; they get themselves taken at tactful intervals, by eavesdropping or absorption."

Baudelaire's *flâneur*, with his sober uniform and bland, forgettable, anonymous ways, is a kind of undercover agent for art. Kirstein picks up this theme and interprets it with a moralistic flavor. He is defensive about an artist's being an artist; he writes as if the artist's career, unlike the lawyer's, industrialist's, or scientist's, *needs* to be undercover. He implies that simply making art works isn't serious enough (and there's the connotation that, as for characters in Thomas Mann's stories, life for an artist is wasteful and decadent). Kirstein gives Nadelman higher-than-art stature by showing that he is part of a great *professional* tradition stretching back to the Renaissance and antiquity, that he thinks of himself as a craftsman-artisan, that he is a willing servant to important social figures, and thus serves a public function. (About some of the garden sculptures Kirstein wist-

fully writes that they "were done for merchant princes by a princely artist. It was the last sigh of that aristocratic patronage which had been born in Tuscany four centuries before.") It is for these reasons that Kirstein cannot separate Nadelman's hack-work—the stiff, neoclassical portraits of the wealthy—from his real achievements; without irony, Kirstein says that Nadelman's "position in New York was exceptional; few men since Saint-Gaudens or Sargent occupied a place which was at once that of preeminent professional, taste-maker, patron." In Kirstein's view, the artist's "position" is far more than a sidelight: it is an important part of why Elie Nadelman means so much to him. Kirstein juggles between thinking of the art work as a holy object, a piece of salvation, and thinking of a career in art as an ironic proposition. When he says that Nadelman was, like the Byzantine artist, "an actor-maker seriously playing at work," there are so many roles and masks flying forward and backward that they almost cancel one another out. Kirstein prefers his artists to be, as he says of Cartier-Bresson, eavesdroppers on their work; the couldn't-care-less attitude is a way of saying "As artists we're amateurs, we're only playing at it." Yet he wants us to know that the result of this casual performance is deadly serious, partly because it is built on professional know-how, skill, hard work. Kirstein trusts only art that is ritualized; all other art is egocentric, a matter of individual whim and inspiration.

Kirstein's artists are above art, and they are outside the "art world." They don't care whether their art is ever exhibited, or recognized by fellow-artists; they move in history, not art history. They are removed from "art" because they are labelled craftsmen, artisans, photojournalists, historians, scientists, "actor-makers." And what they make or do is removed from "art" because of its impersonality, anonymity, "unoriginality," conformity to a higher and older set of rules. Nadelman is shown to believe completely in the Greek standard: that artists are "neither innovators, reformers, nor revolutionaries." The codes of symmetry and proportion Nadelman follows are presented as if they were a form of protection—he can't be accused of anything

that is in his work, because he isn't "responsible" for it. Kirstein is satisfied only when he can show that artists are proud of their bondage, like members of an élite medieval craft guild.

Over the years, Kirstein's Platonism has come to sound like a glib policy. He falls back on it to attack art he doesn't like, and he carts it out to defend art he admires, even when the scheme hardly applies—as in his introduction to the Museum of Modern Art's 1943 exhibition *American Realists and Magic Realists,* in which he inflates academic realism-meets-Surrealism painters such as Paul Cadmus, Peter Blume, and Jared French. For him, the case is black-and-white: the opposite of impersonal, ideal art is "expressionism" or "self-pity"; this spirit, he says in the Nadelman essay, "magnetizes and titillates mindless compassion, a comfortable sympathy with personal tragedy, at safe remove." Self-pity, like originality for its own sake, is "alien" to Nadelman because he is "an imagemaker attached to received or preconceived criteria of perfection." Kirstein never explains what makes these "preconceived criteria" intrinsically valuable; he assumes that if there aren't any rules the only alternative is chaos. He says that artists who train themselves to see in a disciplined, impersonal way gain a moral toughness. They don't fall for anxiety, which is cheap; if they despair, at least they are quiet about it. He is smugly inflexible about artists who don't operate within ideal systems; he suggests that in their romantic, self-absorbed way they are morally spineless. Nadelman, the ironist and dandy, "did not aspire to Van Gogh's saintliness, nor did he communicate fever charts of his own anguish. He was no genial monster, like Lautrec, nor destroyed by sensual obsession, like Pascin, to whom he felt closer than other contemporaries. His own fate was that of a patrician under Nero or Elagabalus." Kirstein becomes nearly hysterical when he deals with modern non-classic art; he might have in mind all abstract art, but it's hard to tell exactly what he is talking about when he says, in the "Postscript" to the Nadelman book, "Rationales of fragmentation attached to timely romantic notions of chaos or apocalypse led to productions that battened on abrupt turns, shifts, and reversals. In all this, neurasthenia was accredited as a

compassionate aesthetic norm, and self-pity, under several signa-
tures of vested interest, replaced metaphysic." Kirstein here
speaks as the Mary Baker Eddy of Platonic aesthetics. He makes
the case simplistic: significant art has a metaphysic (ideal, perfect
form); insignificant art, romantic trash, has only its self-pity.
True artists rise above their psychic selves and are at one with
the Absolute. Second-rates flaunt their sick "originality." It is
understandable that in Kirstein's moral universe artists don't
simply make distinguished art, they go all the way to personal
salvation. (Do we as viewers experience the artist's salvation
when we look at his work? Are we supposed to be edified when
we look at Nadelman, depressed when we look at Pascin?
Kirstein doesn't say, but it is likely that he would accept this,
since his view of art is moral, not aesthetic.) Nadelman resists
the "anarchic power" of "metaphysical suffering" with his "im-
moderate passion for formal purity. Acceptance of the inchoate
was sin. Salvation lay in wholeness alone." Eakins lived through
the Gilded Age, which "deepened the sombre density of an
imagination which made of his unnatural isolation and natural
resentment images superior to rage or indignation." Whitman,
not generally thought of as a selfless personality, is acceptable to
Kirstein because in *Specimen Days* he, like Eakins, developed an
"objectified, exteriorized, 'realistic' " view of the world. Kirstein
tries to show that Whitman the poet learned from the imperson-
ality of the camera; in the photoportraits for which Whitman
posed late in life he is "at first debonair, always self-assured;
finally Jovian or Homeric, never self-pitying, self-indulgent nor
sad."

No matter whom Kirstein deals with, he always wants to tell
the same story: The scene is invariably some version of the
Gilded Age, when all values are shot to hell, and his protagonist,
an aristocrat of life and culture, stoically endures it all, and, in
his work, triumphs over it. In *The New York City Ballet* Kirstein
describes an experience that sounds as if it might have been his
conversion to this courtly, ceremonial view. In 1919, at Lake
Sebago, in Maine, there was a girl at his summer camp who
"taught rhythmic exercises disguised to look as little as possible

like dancing. Marking my interest, she confessed that actually a few steps further on would almost amount to 'real dancing,' and that if I truly wished, I could be a dancer. This seemed like admittance to a secret society. She also prepared me as hierophant in a ceremony, around a campfire, in which younger boys were admitted to a higher order. From this I recognized something of the ritual essence of bodily movement—designed for repetition, hence: repertory." Everything Kirstein has learned since then has confirmed that early realization: the meaning of experience can be found only in the "essence" of things, and the essence is ritual. Understanding it is like "admittance to a secret society." Kirstein's writing about art seems to derive from the desire to keep illustrating this lesson. (He gives the same course in the essays on ballet, too.) He is receptive to artists only when he sees his themes buried within their careers; he is always on the lookout for *his* figure in the carpet.

Reading Kirstein's descriptions of art, one has to continually check the perceptions against the work he is talking about. Half the time, his feeling for an aloof, aristocratic sensibility does connect with something in his subject's sensibility; in spite of the many overstatements, who else will ever write with such grandeur and sympathy about Elie Nadelman? The rest of the time, Kirstein simply re-creates that Lake Sebago campfire, when "younger boys were admitted to a higher order"; he is only retelling, on the framework of a given artist's career, the legend that has given his own life—as director, guiding spirit, and patron of American ballet, as essayist, and as poet—its "higher" meaning. This is the way Nadelman is presented in his last years: "distinguished, impersonal, courtly, he appeared as a pleasant gentleman in retirement. If he hid his *métier*, at least he made a nice neighbor." It is a sweet picture of the sculptor; one wants to believe it, but the loaded terminology—impersonal, courtly, *métier*—makes one uneasy. Is this history and biography, or is it another little memo Kirstein has sent himself? Too much of the time he seems to write only to hear his own views come back.

For all his harangues against "personalism" in art, it is para-

doxical that Kirstein is most valuable as a critic when he describes art as a reflection of an individual's life and temperament—unlike Baudelaire, whose ideas about dandyism are remembered but whose actual "painter of modern life," Constantine Guys, is forgotten. What we carry away from Kirstein's most extraordinary portraits—Walker Evans, Nadelman, Cartier-Bresson—is a distinct feeling not for the art but for the men who were able, as Kirstein would put it, to do important work in a bad time. In these men, he shows anonymity and classical discipline growing out of the particular situations, and these qualities not only are vivid but make us see more in the art. Walker Evans has a "purely protestant attitude: meagre, stripped, cold"; he is a "visual doctor . . . also the family physician, quiet and dispassionate, before whom even very old or very sick people are no longer ashamed to reveal themselves." Cartier-Bresson, with his "cheeriness, his dispassionate curiosity, his stubborn attention and self-effacement," is "sympathetic toward his sitters or assignments in the way of a good nurse with a fractious patient." The photographs of Evans and Cartier-Bresson tell how we can understand brutal everyday life; their work is exemplary because they are exemplary men. And then Nadelman, thought of in the spirit in which Kirstein has always thought of the ballet, is an "orchestrator of gestures, a symphonic conductor of plastic silhouettes. His statues propose standards useful in measuring the still limitless dynamics of humane virtuosity."

Kirstein is lost when he tries to prove a case. With his crusader's zeal, he overlooks what is limiting in Nadelman's classicism and Evans' detachment. With his suspicions about art, and his lofty, supercilious feeling that criticism is a form of dilettantism, he bulldozes his way so far past necessary critical judgments that he is stranded all by himself, alone with his rhetoric. His power lies in his ability to relate art to what he feels are wise, virtuous, humane intentions. When he stays away from aesthetics and sticks to character, he has an urgent, unexpectedly moving way of telling how artists can be heroes.

1975

►►►►

Henry McBride, an Era's Critic

For forty-odd years, out of a mixture of love, wonder, amusement and fascination, Henry McBride (1867-1962) reviewed art in New York. From the early teens through 1950 he wrote primarily for *The Sun* (later *The New York Sun*) and, all during the twenties, for the monthly *Dial* as well. His last pieces appeared between 1950 and 1955 in *Art News*. He hardly missed a thing, and he kept the same chatty, deliberately slight, glancing and impromptu-sounding voice all the way through. McBride wrote to be read fast, and he still reads fast, though now there is a pleasantly dated edge to his writing. He was much closer to his readers than art writers are now, and he alternately hovers over you like a dignified uncle or gives you pointers like a fussy aunt. In a typical piece, he moves back and forth from a throat-clearing gentlemanly dryness to a mock-gossipy, confidential, this-is-between-us spirit. Although his individual pieces can be fragile and wispy to the point of hardly being there at all, his collected writing adds up to a single personality speaking—a man who knew that to make the points he wanted to make, he needed that glancing, wispy voice.

Henry McBride had a spontaneous love for works of art, and he collected them when he could, yet he didn't have many original perceptions about them, and his language often becomes routine when he talks about how things look and what makes them beautiful. After reading a large selection of anyone's criticism it's often difficult to remember exactly how the writer felt about individual works or personalities. With McBride—whose "Essays and Criticisms" have now been selected and introduced by Daniel Catton Rich, in *The Flow of Art*—the distinct opinions slip out of your mind even while you're reading him. This doesn't happen because he's vague: though he might not be emphatic, he is crisp and direct. It's that he didn't write to settle issues—he thought of himself more as a prompter and

coaxer. He enjoyed letting the ironies in any situation build up; he liked to leave with the issues still in the air. Writing in 1925 about the great popular attention given to Paul Manship's sculpture, he says that Manship's success could be "an encouraging or discouraging fact, according to your viewpoint. I occupy a middle ground which approaches indifference, but which permits me to look at the work from two angles." McBride was loyal to many artists—he was known especially for his support of modern art—and he was also able to say when, as he would put it, a show was "not a triumph." But the effect of his criticism, and not only in the case of Manship, is that he writes from the "middle ground." Even if he's crazy about someone's work, he toys with how it would look "from two angles," and this coats his opinions, in spite of his sincere and easily aroused enthusiasm, and his bubbly prose, with an emotional grayness. He'd rather skip an authoritative statement on Manship's sculpture, which he doesn't think significant, and say something about what there is in Manship that makes him attractive to others.

McBride was well known for being able to spot talent ahead of most people. Yet perhaps out of a personal modesty, he doesn't make it seem as if his finds are distinctly his and nobody else's. Reading him now, after so many of the people he was among the first to support in print have become well-known or accepted as masters, you have to remind yourself that his choices were often radical and courageous. He doesn't have the language to give his readers the sense either that he has encountered something overwhelming or that he thinks something is awful or trite or dumb. He doesn't want that badly for his opinions to count. When he praises an artist, you don't feel that he's the least bit scared that he might be proven wrong. Praise glides out of him. Though he's not quite in that category, he gets close to the school of writers who think they're writing criticism when what they are more literally doing is congratulating artists on their accomplishments.

Throughout McBride you come across wonderfully full, sharp observations that are like floodlights suddenly being turned onto a subject. In a few phrases he gets an artist from a to z,

impressionistically bringing out all his limits and aspirations (he is particularly impressive on Demuth, Nadelman, Pascin, Sloan and O'Keeffe). The trouble is, these bursts appear without warning and don't build toward anything. You wonder if he knows he's being that good, and, if he does know, why he buried his strengths, why whole reviews aren't as suggestive and power-ful as separate paragraphs are. Just how modest McBride is is made clear when you read Lincoln Kirstein's preface, which was originally written for a 1947 show at Knoedler's of pictures McBride wrote about and admired. Kirstein wants desperately for his beliefs—on Henry McBride as a critic and personality—to count, and, next to McBride's graceful, skipping prose, Kirstein, with his defences and tightly wound-up sentences, seems violent and harsh. It's like reading Dostoevsky after Jane Austen. Kirstein gives you the sense of having fought and won a victory, whereas with McBride you never knew there was a war.

The Flow of Art is a vacuous non-title (and it can hardly be seen on the book jacket's face because it's been set sideways up and down, in a dark margin, so that the only thing that stands out is the subtitle). Ordinary as it is, though, it applies accurately to a McBride collection. The "flow of art," rather than individual careers, ideas or movements, is what he felt most. Whether he's describing something he thinks weak and inflated—say, Sargent's portrait of Woodrow Wilson, which was shown in 1918 at the Metropolitan Museum with, as he noted, an "altar rail" in front of it—or whether he's recounting the career of someone he admires, part of him is always floating a little off to the side of the topic. For him, the real subject is the amazing, almost refreshing silliness of certain art events, or the mysterious beauty of others; his writing is most personal and quirky when he's describing the steady hum of activity that comes up from the art world. You finish a McBride piece thinking that you have read a vignette in an ongoing story, and that the point of his being an art reviewer is so that he can tell the ongoing story. His standard length is seven to nine hundred words. This gives him all the space he needs to tap the subject here and there and then take off.

Probably no other critic has devoted as much attention as McBride to the patrons, collectors and dealers, the openings and parties, the catalogue statements, the visits to studios, the reactions of art students, the failure of most commissions—and the tragedy of no commissions—and the public's response to all this. Beginning with a report on the Metropolitan Museum's unveiling of its first Cézanne (in 1913), and ending with the death of Dr. Albert Barnes and Jackson Pollock's 1951 show at Betty Parsons, *The Flow of Art* is the most informal guide to what happened in art in New York in the first half of the century. (One assumes that Daniel Catton Rich chose a representative selection of McBride's work; Rich doesn't say on what basis he picked these particular reviews, and he doesn't include a bibliography, so you don't know what percentage of McBride's writing this selection represents.) Reading *Flow* is like getting the history of 20th-century art in a phone conversation. It's more enjoyable than any available history of the period and, unlike both the histories and most collections of criticism, which have everyone neatly and abstractly labeled as major or minor, it shows how equal, in terms of their immediate public impact, major and minor can be.

But McBride wanted to accomplish something more than being an art-world chronicler. He savored the ironies, rules, triumphs and jokes of the art scene as a poet and, in the end, his reviews have the weight more of poetically-felt impressions— mild, light, dry and sunny impressions—than of criticism or history. Talking about Pascin's 1931 memorial show, and how much Pascin needed the admiration and encouragement of fellow artists, McBride says that these artists "surrounded him with the atmosphere of belief and interest that go so far to fortify an artist. It is this atmosphere of 'belief' that is so readily obtainable by all artists in Paris and which is the real secret of that city's supremacy in the arts." The spirit of Paris animated McBride. He was in love with the image of the art world as a city of friends. He wanted to see it alive in New York, and he was happy to pinpoint, in his reviews, the stages by which Paris began to lose its position as the center of the art world and New

York began to gain momentum (he felt the first inkling of change in 1922!). McBride's criticism is what it seems Frank O'Hara's should have been. O'Hara responded to the same Paris-in-New York mood—to the "atmosphere of belief." He caught it in his poetry but, in much of his art criticism, he felt something more definitive was necessary and this was a mistake, because there were no definitive bones in his body. O'Hara's art writing is wooden, overcrowded with words. You keep waiting for him to stop writing and just chat a little, but he never does.

O'Hara wrote from deep inside the art world—perhaps too deep, since he didn't manage to keep his own voice. He sounds like the art magazines. McBride wrote from the outside, and knew that he had to stay outside. He might be described as a man who goes to a party, becomes giddy with excitement as he first encounters a room of celebrities, and then leaves before the immediate thrill wears off, so that he can preserve that thrill. A Quaker by birth and a gentleman by temperament, he didn't think of himself as an artist or as one of the people who financially and socially support the arts, and he wasn't a member of his *Sun* audience, either. (He was closer to his *Dial* readers in the twenties, and yet he wasn't, strictly speaking, a writer for monthlies: he wanted a bigger, more popular audience.) He was independent of them and needed them both—the glittering, complex world of talent and society, the Paris of his mind, and his "dear reader," whom he liked to think of as "unprogressive" and dubious, though tolerant. McBride was inspired by imagining himself to be their go-between. He wrote about art by believing that, in his column, two worlds met. Interpreting one for the other, he had to be nimble enough not to step on feet in either world. He must have realized that the situation he invented was a drawing-room comedy. Did he also see that he was its central character?

1976

►►►►

Mr. Moderation

FROM THE ALL-PURPOSE, nondescript title and the solemnity of
the subtitle, *Art and Act, On Causes in History—Manet, Gropius,
Mondrian* sounds as if it might be nebulous and theoretical, and
the ghost of theory does hover over it, but it's far from nebulous.
Peter Gay, Durfee Professor of History at Yale, and best known
for his work on 18th-century intellectual history, is a brisk,
ardent, polemical writer. His portraits of Manet, Gropius and
Mondrian are the work of a mind at home in the world of ideas
and eager to show people living out their lives according to the
ideas of their era. Gay turns each of these three figures into
walking, talking, psychoanalyzed symbols of a different type of
"modern man." The 19th-century French painter Edouard
Manet becomes the supreme embodiment of the urban bourgeois
liberal—an optimistic, sociable and socially responsible person-
ality. Walter Gropius is shown to be decent, honorable and
"humane." Though the German architect is always threatened
by the forces of myth and cult-thinking, especially at the
Bauhaus, the institution he is most identified with, he manages,
with his liberal-democratic instincts, to repel the "Utopian"
spirit and keep things on a "tough-minded," businesslike level.
Mondrian, in this scheme, is Manet's deformed brother. Mon-
drian represents Manet's total opposite, being naively optimistic,
unworldly, stupidly, "ideologically" urban (as opposed to admir-
ing city life for itself), personally illiberal and unyielding, sexu-
ally repressed (whereas Manet's sexuality, at least in his art, is
candid and uncomplicated). Gay is out to get Mondrian.

What is uncanny about *Art and Act*, what makes the book
fascinating whether or not you agree with the conceptions, is
that so many details from the lives of his three subjects fit the
ideas Gay wants to work out. He doesn't stretch any of the
details, though he does magnify and enhance certain ones. He

212

puts a new slant on known facts. That he is investigating artists in the first place, rather than philosophers, statesmen or historians, happens to be, as he says in his breezy way, "an accident. I chose my illustrative materials from painting and architecture because I thought them appropriate to my host and audience." That is, Dore Ashton and Cooper Union, where *Art and Act* originated as a series of lectures in 1974. Gay has no ambition to write as an art historian. Nor does he intend for these portraits to stand as the last word on their subjects. *Art and Act* is supposed to be about background "causes" of events; he addresses himself to the question "What accounts for an artist's (or any historical figure's) career developing the way it does?" Trying to sort out the ingredients, Gay zeroes in on three categories which he feels are all-encompassing: "culture" (by which he means the spirit of the day), "craft" (which for him is an artist's sense of the traditions and techniques of his art), and "the private sphere." He uses all three to build up the portraits of Manet, Gropius and Mondrian.

The three-tiered world of culture, craft and the psychological inner life might be a way to suggest the messy, non-linear underside of an event or a personality—if all three could be shown to exist simultaneously and equally in the subject's mind. That's the way Richard Ellmann made it seem in "Love in the Catskills," a charming, novelistic account of how Washington Irving came to write "Rip Van Winkle" (it appeared in *The New York Review of Books*, February 5, 1976). Ellmann's conclusions are exactly the same as Gay's, right down to the terms he uses (the coincidence is spooky). Except that, unlike Ellmann, Gay is certain that we can pick our way through the different motivating forces of a person's life, impartially weighing them all, and then settle on the one force that is greater than the others. The titles of his individual essays give it away: the Manet is "The Primacy of Culture," the Gropius is "The Imperatives of Craft," and the Mondrian "The Claims of Privacy." Gay tries to show how, in explaining Manet's art, the artist's private and professional lives, though significant, count for less than his receptivity to the public, social forces of his era. Gropius and Mondrian are

scrutinized in the same three-sided way, though, of course, their motivations are resolved differently. (The unfortunate thing about the Gropius is that the three sections blur as you read them, you can't remember which one you're in, and you aren't sure whose fault this is, Gay's or Gropius'.)

Gay believes it's possible for the historian to be scientifically objective, though that isn't the effect he gets. *Art and Act* seems to have been meant as a scholarly investigation, but it reads like a run-through of an already existing vision. For Gay, words like "culture" and "private" are loaded and magical; each one calls up a set of attitudes before his eyes. (The idea of being "scientifically objective" is magical too—it comes with "culture.") In a footnote from the Manet essay, he quotes a sentence from a letter Zola wrote to Cézanne, when the two were school-age friends. "In the artist there are two men," Zola says, "the poet and the workman. One is born a poet, one becomes a workman." Gay comments, "He should have added a third dimension—the social being, the citizen." This dimension is the most crucial part to Gay. He is amazed to find so much of it in Manet, he thinks Gropius intuitively grasped at it at the right times, and he is convinced that Mondrian, with everything he had in him, was opposed to it. To be such a "social being," in Gay's view, means that you keep yourself open to and appreciative of the modern industrial secular world, criticizing it when that becomes necessary, prodding it along, but, essentially, willing to support it. Not to be a "social being" or "citizen" is, all too often, to let yourself become the pawn of ideas and theories, which have a way of taking on a life of their own, separate from and untested by everyday reality, and that is pernicious. Soon, you have surrendered yourself to a belief in myths, you have withdrawn from the workings of modern society—you no longer participate, even on the artist's imaginative, metaphorical level of participation, in seeing that the greatest good goes to the greatest number—and you have become, in Peter Gay's eyes, a menace.

This is perhaps an inexcusably primitive presentation of a major historian's ideas. Certainly these ideas are given more texture and complexity, not only in *Art and Act*, but in every-

thing Gay writes, perhaps most vividly in his *Weimar Culture*, 1968, where he shows the forces of mythical, anti-social, apolitical thinking going beserk, destroying the chances of the "citizen" or "social being"—his true modern man—and paving the way for Hitler's takeover. Yet, no matter how layered Gay makes the situation, the reader always feels that, if he scratches beneath the surface, he will touch some scene in this drama, the tension between the modern "citizen" and his opponents.

Citizen Manet of *Art and Act* strolls by us, his aim to preserve the ongoing life of his culture. Surrounded by dreary, pompous Salon "machines," he uses past art, in his quotes from Titian, Velasquez and Goya, "to criticize the practice of the present." Yet he doesn't totally repudiate the Salon. Who else but Gay would take the relationship of Manet and his academic Salon-style teacher Couture and try to show that Manet wasn't Couture's rebellious student but, rather, Couture's proper heir—the artist who accomplished what Couture hoped to do but couldn't himself do? (Gay does the same thing when he analyzes Gropius and his teacher, Peter Behrens.) Gay is fascinated by the fact that Manet is left-wing politically, right-wing socially, and has friends from every sphere, all of whom, as Gay presents it, are impatient with the painter's nondoctrinaire, pragmatic, open-minded spirit (it doesn't occur to Gay that Manet might also have been politically confused, or complaisant, or a careerist). In the history of art, says Gay, Manet has been written about as if he were "the intrepid David, facing down the Goliath that was the establishment, and fathering an avant-garde that built modern art." This, he feels, is mythical thinking and writing, an exaggeration of reality, which shows Manet to have been much closer to that "establishment."

Gropius too has been written about unrealistically, according to Gay. The architect has often been linked with movements and buildings that, to Gay's mind, have distressingly "symbolic" overtones, so he goes to some trouble to prove how unsymbolic Gropius' thinking actually was. Gay realizes that Gropius had a few "anxious moments" when his "need to cajole and persuade overrode his natural inclinations" and "he would speak of a

Bauhaus style." This sounds innocuous enough, but Gay is upset. Setting the record straight, he tells us that Gropius was more like the "embattled Naturalists in late-nineteenth-century France" who "feared labels like *school* or *style* as straightjackets fatal to all creativity." Meanwhile, the embattled Naturalists managed to produce at least two styles, Realism and Impressionism. And these happen to be the art movements closest to Gay's heart, no doubt because they are the most skeptical of and sympathetic to—the most concerned with—bourgeois and industrial society. Naturally, Gay hates Art Nouveau, with what he calls its "mechanical sensuality." In fact, he could live without the whole fin de siècle, a period shown to be dragged down in its infatuation with "aestheticism, symbolism, and Roman Catholicism"—highfalutin, socially unengaged and reactionary movements which turned "the world of business, science, mundane styles like Realism and Impressionism" into drab-looking, philistine preoccupations, movements which "dramatized a widespread need for escape from everyday experience, from the visible, the vulgar, the material, to some thinner, purer air."

Into this drama walks Mondrian, the child of a decadent fin de siècle religious theory, Theosophy, who came to maturity as a 20th-century Puritan. (In Gay's eyes, this couldn't be more perfect, one deranged period producing a monster who is a throwback to an earlier deranged period.) Mondrian was proud to call the spirit of his work "modern," and Gay points that out only to disparage it. If Mondrian's nature was esoteric, secretive, mystical and symbolic, if he was prurient, compulsive and sexually repressed, asks Gay, trying to prove that Mondrian was all those things (and there is plenty of evidence to support the contentions), how could the painter have been truly modern? Lip service is paid to Mondrian's work, and Gay recognizes Mondrian's high place in 20th-century art. But when Gay tells us, in conclusion, that Mondrian's "paintings offer impressive evidence" of "how much beauty the talented can wrest from fear," it's the "fear" that the portrait has been leading up to, and that carries the weight of the sentence, not the "beauty." Besides which, when you read that the "inexpressiveness of Mondrian's

art has its own eloquence," and when you remember that he has also called Mondrian's painting "illegible," "unreadable" and "inarticulate," you can legitimately wonder just where it is that Gay finds Mondrian's "eloquence" and "beauty." What is apparent in his Mondrian essay is that Gay isn't comfortable with any abstract art, and this follows from the fact that his interpretations of art works are literary and sociological; he sees them primarily as illustrations of moods. His view does allow him to find qualities that art historians or art critics might miss; his description of Manet's "The Railroad," which he calls an "urban pastoral" and a "poem about speed contemplated in tranquility," and about which he says, "I know of no nineteenth-century painting that celebrates modernity more unreservedly than this," is wonderful, it makes this a grander painting than one might have imagined. But he doesn't understand, even with Manet, whose work inspires him, that pictures are physical objects with a sensuous life of their own, a life that doesn't always coincide with subject matter.

Gay's call for bourgeois moderation and cool-headed social responsibility has its own passionateness. Gay is romantic about rationality. He's the man who listens to Haydn with the ardor that people in the 19th century had when they listened to Wagner. With his enthusiasm, he makes Manet into a big, memorable personality, a great upper-middle-class gentleman, in love with speeded-up, mechanically hectic modern Paris, busily rejuvenating stale French painting, cheerfully going to the Tuileries and the Folies-Bergères and the barricades and making art out of all three. But on Mondrian Gay's values break down. These ideals do no more than leave Mondrian dangling like a psychoanalyzed puppet. Without any initial sympathy toward him, Gay fails to understand that, when an artist consciously creates, and therefore needs, the role of Puritan schoolmaster for his personal style, he doesn't necessarily make Puritan schoolmaster's art. It can be the exact opposite. Gay misses the fact that, in spite of Mondrian's admittedly pompous and arid desire to purge his art and life of nature ("The recognition of Mondrian's pervasive and overpowering hostility toward nature pro-

pels us toward the core of his character"), Mondrian wasn't obsessed with the sea, flowers, dunes, trees, clouds and plains all his early years for nothing. Gay takes Mondrian's pronouncements too much at face value. "Nature" never left Mondrian—a man doesn't banish his instincts by writing a pamphlet. Gay's world of "the visible, the vulgar, the material" might not be there in Mondrian's art; but the structures of half-consciously remembered landscapes are there and, though perhaps it was nowhere else in his life, Mondrian's virility is there too. This is why, forgetting what you've read about him, his proportions and balances affect you with such an immediate kinesthetic rightness and solidity. This is why his paintings don't seem quite like sermons for the repressed but, instead, models of emotional honesty and directness, not unlike Chardin's.

Peter Gay is so adamant about cleaning the House of European Culture of dogmas, doctrines and myths that he doesn't see how much his own approach, with its own language ("The Primacy of Culture," "The Claims of Privacy"), has come to resemble a myth. One that, not content with recreating a hero in Manet, needs a villain in Mondrian to feed on. Gay has always admired the way in which the 18th-century philosophes invented and then kept alive a spirit of criticism, criticism of life, politics and art, from which no one was immune. He has tried to show how healthy such a spirit is. But the tone of the Mondrian essay isn't criticism, even moral criticism. It's closer to vilification. In it, Gay is protecting his property from an intruder, a repressed monk who has deluded people into thinking of him as a modern.

Living through Weimar and then Hitler Germany before coming to the United States as a young man, Peter Gay has had his fill of what he calls mystic, Expressionist, anti-social art— what he labels, at the end of the Manet essay, the "alienation, ambivalence, and anxiety" of "Waste Land" modernism. Somehow, he refuses to see this art, with its "hatred of the modern world," as a complex human response, or even as plain art. He sees only its hysteria and its blackness, its desire for "some thinner, purer air." He points his finger at it: Nihilist, despair-

ing, unworldly modern art, he would have us believe in *Weimar Culture*, only made the ground more ripe for Hitler. In *Art and Act*, Gay wants his modernism but he wants to be sure it's the liberal bourgeois brand, modernism that is the "heir," not the "adversary," of liberalism. When Gay left Germany he took his idealism, and maybe some of his innocence, with him. Out of that idealism has come his insistence, in his affectionate portraits of the 18th-century philosophes, that human perfectibility is possible and that the philosophes were right to be optimistic. Rationality works, he's said again and again. All life needs is more of it, and you can't argue with that. But now he's too intent on getting even with the forces of irrationality.

One of Peter Gay's great gifts is that he can frame the most dated historical issues in contemporary, partisan language. Perhaps it's the experience of having had to grow up in nightmare Germany, followed by having had to resettle, with those members of his family who made it here, as an American, which gives his view some of its edge and its pressure. When he says society can't have too much "modernity," the reader knows that he also means "sanity." The "culture" he's after isn't only bourgeois and rational; the underlying assumption is that it isn't vengeful, totalitarian, criminal—it won't kill you. But along the way his emotional arteries have hardened. He writes less like a man reaching out to embrace new "moderns" than a man wanting, in a pinched, judgmental mood, to preserve the old ones. *Art and Act* may have been intended as a look into the future. What it feels like is a dead-end dream of the past.

1976

▶▶▶▶

Trouble in Paradise

"THE NATURAL PARADISE," the Museum of Modern Art's nod in the direction of the Bicentennial, is a show many people looked forward to with real anticipation. Subtitled "Painting in America, 1800-1950," expected to present mostly landscapes and to emphasize "American Romanticism," the show seemed like a chance for the Modern to walk away from most of this year's dreary, historically well-padded, aesthetically small-time Americana exhibitions. It also sounded as if it would be the first New York museum show in years to deal imaginatively with American art from the 19th and 20th centuries as a single body. Usually the only occasions for such events (and they aren't always so imaginative) are when private collections hit the road, or in scholarly graduate school exhibitions, and neither makes it too often to major New York museums.

But this Modern exhibition, curated by Kynaston McShine, doesn't quite deliver the goods. Yes, there are great and fascinating less-than-great pictures to look at, but, in its selection of works and installation, it is such a departmentalized, mechanically theoretic show that you can hardly see the pictures for their follow-the-numbers setting. "The Natural Paradise" is weighed down by a more complicated task than being a mere survey of American painting or American landscape painting or even American Romantic painting (the kinds of exhibition where it's up to the viewer to make the connections). It's an attempt to show how a mythical spirit—a romantic infatuation with heightened, "sublime" states of feeling—pervades American art. The "sublime" and its connections with modern art, especially Abstract Expressionism, are associated almost entirely with the art historian Robert Rosenblum. He first wrote about this un-Parisian, un-formalist current in contemporary American paint-

ing in an influential 1961 *Art News* article, "The Abstract Sublime," and he amplified his account to include many of the major figures of 19th- and 20th-century art in his recent *Modern Painting and the Northern Romantic Tradition, Friedrich to Rothko.*

Rosenblum is the programmatic brains behind the Modern's show. In "The Primal American Scene," his essay for the show's catalogue, he makes clear what the viewer already suspects from the exhibition—that the motive for finding this metaphysical mood in 19th- and early 20th-century American art is that it's an important ingredient in Abstract Expressionism, especially in the work of Jackson Pollock, Mark Rothko, Clyfford Still and Barnett Newman. Rosenblum wants us to be more hospitable to the "frequently awkward, indigenous traditions" of pre-Pollock American painting. He finds that artists as diverse as Augustus Vincent Tack, Arthur B. Davies, Milton Avery and Morris Graves, to name only a few of the figures he refers to, and who are in the show, tell us as much about the emotional tone and imagery of Still, Newman, Rothko and Pollock as do the Euro-pean modern masters, from whom the Abstract Expressionists are thought to have absorbed the majority of their ideas. He thinks of the literally big fields and wide metaphorical spaces of Still, Rothko, Newman and Pollock as extensions of the pano-ramic vista space and awe-struck content of the Hudson River School painters and the second-generation landscapists Church, Bierstadt, Moran & Co., figures who are also at the Modern. Rosenblum is convinced that mystical, nature-worshipping blood has flowed through the veins of American artists since the early 19th century, and that it is still flowing; in our culture, he tells us, "elemental nature is still a source of myth and energy." He points to such "Earthworks" figures as Robert Smithson, Dennis Oppenheim, Walter De Maria, Christo and Michael Heizer and says that they "have found yet another way to establish contact with the deities of American landscape that have now reigned for two centuries."

"The Primal American Scene" is not one of Rosenblum's more solid performances; he covers too much ground too quickly, and assumes attitudes he doesn't stay around long enough to explain.

His original interpretation of the character of some Abstract-Expressionist art as monumentally passive, religious and remote, was different. "The Abstract Sublime," sketchy as it is, has made a lasting impression because there is a poetic truth to it—it's an art-historical insight based on intuition. The formal and temperamental correspondences he found between, say, Rothko and European Romantic painters such as Turner and Caspar David Friedrich enhance those fuzzily expectant qualities one instinctively responds to in Rothko. Rosenblum's might not represent the last word on the meanings of Abstract Expressionism, but, looking at this art in relation to European Romanticism, he has given it greater intellectual clarity and depth; he's conferred on these painters a touch of that European high-culture, museum status which, in spite of what some of those who have written about their achievement contend, one feels they yearned for.

But Rosenblum's intuitions have taken him over. He has become too willing to see these mythic, primeval overtones suffused through a wide range of art, first European art, in *Modern Painting*, and now American. The issue is not that his view of American art is farfetched. Much of what he says has been said already, by art and literary critics, by historians and political journalists. Finding a "key" to the national character is an American specialty, and many writers have come up with a version of Rosenblum's mythic American mind. Besides, it's reasonable to speculate about how American art, even the first "International" form of it, Abstract Expressionism, might derive from earlier American art. Yet there is something so easy, unquestioning and sweeping about Rosenblum's formulation that you pull back from it.

In "The Primal American Scene," he is so busy making a case for American painting as a cohesive family of related sensibilities that, in the course of linking everyone, he rubs out everyone's distinctiveness. Here is a typical Rosenblumian moment, a description of Andrew Wyeth:

Thus, Wyeth's *Spring Beauty* . . . a view of the springtime burgeoning of flowers, and his *Hoffman's Slough* . . . a desolate, scraggy wasteland, restate, with their lean and parched literalism of botanical and geologi-

cal minutiae, the kind of nature motifs universalized in Tobey's and Pollock's profusions of infinite, microscopic complexities, as well as offering records of the kind of bleak American terrain that was often metamorphosed in the abstract configurations of Clyfford Still and Barnett Newman (whose postcard photographs of Maine, taken in the summer of 1963, select Wyeth-like sites).

Weaving in and out of disparate works and showing how they resemble each other, Rosenblum ends up with a system where what counts most in a painting are illustrational values—Wyeth's "geological minutiae," Tobey's "microscopic complexities." And what happens when illustrational resemblances are emphasized is that, whether it's intended or not, all art is reduced to the same weightlessness. Rosenblum's method allows you to talk about the museum masterpieces and the schlock classics in the same tone. He extracts the "mood" and the "look" of a work and doesn't judge the level of feeling in either. With such criteria, Wyeth's "geological minutiae" easily relates to Tobey and Pollock. Probably it relates to Leonardo, too. Is this really the method Rosenblum wants?

Of course there are significant unities in the art of any culture, just as there are between cultures. Rothko admired Avery and there are resemblances between their work, as there are between Marsden Hartley and Ryder and Pollock and Ryder and so on. Even when an artist doesn't "know" an earlier artist's work, you can point to genuine resemblances in temperament. Rosenblum, however, isn't interested in the complexities of these relationships. In "The Abstract Sublime," he wrote that "The line from the Romantic Sublime to the Abstract Sublime is broken and devious, for its tradition is more one of erratic, private feeling than submission to objective disciplines." Reading his "Primal Scene" piece, where, to account for Cole, Davies, O'Keeffe and Still as kindred spirits, one aspect of the "sublime" slides into another, you feel that, perhaps unwittingly, he has lost touch with that "erratic, private feeling," and that his sense of the romantic temperament is closer to an "objective discipline" than he thinks.

This slurred vision carries over to the exhibition, which, in

methodically trying to illustrate Rosenblum's connections, manages to make those connections look less convincing than they do in print. Rosenblum is sensitive at least to the underlying tone of pictures, and he moves from point to point with stylish fluency; this show plods along. In an exhibition where what we expect from the installation at the very least is a feeling for the majestic bigness and grandeur of the American land, we get the opposite. Except for one baronially dignified hall hung with two works each by Gorky, Pollock, Still, Rothko and Newman, the René d'Harnoncourt galleries look like an antiques store or museum study center. In the pre-Ab. Ex. rooms, paintings of many different sizes are packed together, and watercolors, oil sketches, even a charcoal and chalk drawing (by Heade) are thrown in. This discrepancy is theoretically proper, of course, since the show and catalogue hold to the view that the Abstract Expressionists are the chief dignitaries of American art, and that the rest of the participants, starting with the Hartley-Marin generation and going back in reverse to Cole and Allston, have the character of newly discovered, surprisingly sophisticated, country cousins. This is a legitimate attitude for a museum to take, though some may find it patronizing. Not every legitimate attitude, however, can be transported to a museum's walls.

"The Natural Paradise" is stymied by subthemes and subdivisions, prompted by Rosenblum's distinctions, that dribble off on their own, usually because either the selections in the subthemes don't have the right inner balance, or, taken as a whole, there is no sense of flow set up between these themes as you move from one to the next. There are units of Niagara Falls paintings; moody nocturnes; New Mexico scenes (by Hartley, O'Keeffe, and Maynard Dixon, one of the show's "finds," whose picture here is posterish); dreamy meditations (by Davies, guest star Maxfield Parrish, and Gottardo Piazzoni, another so-so find); a wall of primordial squirmy underground-life paintings (by Graves, O'Keeffe, Dove, Newman, Stamos, Baziotes—this unit being the most convincingly integrated in the show). One half-wall is only 19th-century oil sketches; these Catlins, La Farges and Bierstadts are attractive, but they relate to each other in a

pathetic, left-over way, as if they were a group of people at a party who, though they don't have much to say to each other, are standing together because they know they have even less to say to anybody else. Then, drifting by on another stream, presumably there because they couldn't fit in anywhere else, are bunches of work by one artist—three Burchfields here, five Marins there.

The final gallery, which seems at first as if it's the spill-over collection, is even more of a jumble—it could be called the Strangers in Paradise room. Here are three Whistlers of England, Duveneck on the subject of Ophelia, Sargent in Switzerland, Dewing's characteristic dream of diaphanous lost ladies, Bradford in the Artic, Heade in the Andes, escaping slaves, a magnolia still life, icebergs by Church, Indians, the Panama Canal. Maybe all this represents the Natural Paradise in its domestic and Empire phases. Naturally there's a rationale for these particular things in Rosenblum, but on the museum wall, when it's up to the pictures to do the work, the rationale conks out.

Though it's far from what the organizers had in mind, "The Natural Paradise" makes most sense simply as a chance to see individual good pictures, a fair number of which aren't too well known. Drowsy, horizontally-minded Martin Johnson Heade always gives you something to look at; Pollock's "Seascape," 1934, soaked in Delacroix blues and browns, has the turbulent life that Delacroix himself so rarely has; Eilshemius' "Surf at Easthampton" (dated an amazing 1889) makes you long for a retrospective for this eccentrically brilliant painter, and Rothko's candy-colored "Slow Swirl by the Edge of the Sea," 1944, contains the complete repertory of all the drawing Rothko had in him—the element he took years to drain out of his art. The wall of Fitz Hugh Lane seascapes, with their magically precise pockets of light and sculpturally solid darks, pulls you toward it like a magnet. George Caleb Bingham's "The Storm," ca. 1850, is so perfectly composed and has such a brainy economical well-tailored snap to it that it makes most of the airless Hudson River School landscapes around it look like piles of vegetables. And

Hartley's "Evening Storm, Schoodic, Maine," 1942, holds up as one of the emotionally deepest classics of American painting. Built like a bulldozer, "Evening Storm" belongs to the Modern, but the Modern is uncertain of the work's stature—as, for a long time, the museum has been uncertain of Hartley's—so for years now the picture has been off the gallery walls. If and when the Modern decides to enlarge its pre-Pollock American painting section from its niche-like present condition into something roomier, and this wouldn't be a terrible idea, "Evening Storm" should be installed for good.

1977

►►►►

A Box of Jewish Giants, Russian Midgets, and Banal Suburban Couples

SUSAN SONTAG'S *On Photography* must be one of the bleakest views of its subject on record—a truer title for it would be *On the Limitations Of Photography*. Sontag is far from the first to look at the dilemmas and built-in problems in photography, but few writers have ever made such a grand tour of those dilemmas. Her approach is an inseparable blend of the political, moral, aesthetic and sociological. She looks at photography and judges it as a hobby, a "compulsion," a business, an art, a form of "knowing," and in each case she sees unattractive, unsatisfying ironies. She begins and ends on the same note. We're living in a world, she says, that gets its information chiefly from "photographed images," and she wants to warn us that those images are not to be trusted. They distort reality, confuse our sense of the past, and make us emotionally detached from experience.

Presented in a nutshell, *On Photography* sounds as if it's a diatribe, but it doesn't read that way. Sontag doesn't set out to deliberately attack the photographic way of seeing—she writes to find out why photography disturbs her. With its semi-polemical, semi-introspective manner, her book has the weight of an 18th-century essay which speculates on the nature of a certain kind of education or science, and tries to pin down its qualities. *On Photography* is made up of six articles that originally appeared, in a somewhat different and shorter form, from 1973 through 1977, in *The New York Review of Books*. (A seventh, which also appeared in the *Review*, on Leni Riefenstahl's *The Last of the Nuba* and on Riefenstahl's career in movies, has not been included.) The pretexts for Sontag's articles, except for the first and last of them, were specific books to be reviewed, and she wrote during a period when plums were dropping. Among those she picked up were the Aperture monographs on Diane Arbus and Paul Strand, the Museum of Modern Art's Walker Evans catalogue, August Sander's *Men Without Masks*, John Szarkowski's *Looking at Photographs*, and Edward Weston's reissued *Daybooks*.

Using these books as touchstones for the ideas she wants to work out, she gives a reasonable account of photography's major themes and personalities. Even if you don't agree with all of her conclusions, you admire her fairness, even courteousness, toward those with whom she disagrees theoretically. In a decade when we've been swamped with people finding ways to say Yes to photography, it's almost a relief to have someone saying No, and Sontag has the right tone of sincerity for the job. One never questions her sense of uneasiness, and much of what she says is grounded in mixed feelings we have all had about photographs. Yet she doesn't analyze those feelings in ways that seem freshly her own. Her perceptions and intuitions are always meshing (rather too neatly) with one or two large, overriding ideas—that photography is the ideal expression of capitalist cultures, or that a photograph cannot tell the "truth." She has every right to look at photography from what seems to be roughly a Marxist and/or roughly a Platonic point of view; but she uses these views in a

manner that smothers issues more than it clarifies them. Even though important questions are raised in *On Photography*, you don't feel that they are resolved—you feel that they have been replaced by a set of literary and political metaphors, and it's the metaphors that are resolved.

Sontag doesn't put it in these terms, but the key to her many overlapping arguments is that, unlike a painting or a novel, a photograph can never fully be a work of the imagination. The photographer "captures" a slice of reality, but that reality will never be entirely his; every photograph, be it the masterwork by Atget or the dullest, most banal snapshot, is a collaboration between a human being with a machine and the real world, and the real world is an unpredictable partner. No matter what the photographer's intentions, whether commercial, documentary or artistic, the extra, uncontrollable life in a photograph—the nugget of reality—will subvert, if only in a sly, subtle way, those original intentions. A good example of what Sontag means is what happens with a Lewis Hine photograph of children working in a factory. What for one generation was a picture of social injustice and human suffering eventually becomes, whether we want it to happen or not, an image that has less to do with suffering than with the poignancy of time past.

She's right to say that all photographs, regardless of their subject, or who took them, or what they were meant to express, eventually take on this quality. She's also right when she says that, regardless of whether one chooses to call photographs works of art, most photographic images eventually become "interesting" or "aesthetic" or "touching" to us. She admits that there is something magical and fascinating about this transformation; but, in her mind, it's fascinating the way a cobra is. Photographs are untrustworthy to her because, in time, she sees them coating all experiences—the extraordinary and the trivial, scenes of wartime horror and records of family outings—with the same kind of indiscriminate, valueless fascination. They "turn the past into an object of tender regard, scrambling moral distinctions and disarming historical judgments."

This is her trump card in almost every case: that photographs

can't be responsible to "history," "morality," "ethical and political knowledge." The underlying assumption is that true works of the imagination—paintings, poems, novels, operas, etc.—are responsible to those values. "Strictly speaking," she tells us in a typically doom-laden and all-encompassing declaration, "one never understands anything from a photograph," the reason being, presumably, that a photograph means different things to different people at different times. Whereas she implies that, in what she calls the "traditional arts of historical consciousness," the meanings stand fast. These arts of "historical consciousness" are, therefore, politically responsible and ethically constructive. Unlike photography, they "attempt to put the past in order, distinguishing the innovative from the retrograde, the central from the marginal, the relevant from the irrelevant or merely interesting."

No one questions that a photograph produces a different effect than a novel, a painting or an opera. Anyone will grant that a photograph has a more mechanical and anonymous nature, and demands to be judged on more than aesthetic merits alone. The question is, do we always judge novels, paintings and operas on aesthetic merits alone? The way Sontag argues, it's as if every time we encounter a painting we know we're in the realm of moral, political and historical truth—but it's more complicated than that. She never deals with the fact that cagy, dishonest feelings may be buried within the "traditional arts of historical consciousness" too, though they may be buried differently from the way they are in photographs. She seems to be forgetting that, on some rough, instinctive level, the same process of testing a work, to see how much of it is emotionally and intellectually fake, and how much true, goes on with whatever we look at or read or listen to. Don't we expect that most conscious, complex works of art will have a shifty, uncertain relation to the ethical and political values of their time? Doesn't the same thing hold true for the many works that aren't necessarily intended to be art but give us some of the feelings we get from art? And don't we expect that all these works will change in value over many generations?

Of course photography fails to give us "ethical and political knowledge." Judged by such moralistic, Platonic criteria, everything else fails, too. She could hand down the same judgments about paintings, newspapers, television, movies—anything. When she tells us that "only that which narrates can make us understand," we know what she's driving at, and can agree with her; but certainly we also "understand" something from paintings and sculpture which, like photographs, are unnarrative. Sontag would agree to that. But she doesn't face the logical discrepancy.

With her belief that no photograph can be taken at face value, she's either skeptical about the achievements of the well-known photographers, or else approves of them in guarded ways. Sometimes this pays off. She's good on why Weston is a distant figure for us now, and she's even better on why Arbus's pictures, for many people, seem shallow and coy, even false. Sontag writes differently on Arbus than on anyone else; her prose has more punch and speed. She argues more directly from her feelings. Arbus' work angers her, and, in trying to explain that anger, she gets into Arbus' skin. Even though she dislikes the photographs, she makes what Arbus was doing psychologically and poetically real—more real than any other critic has.

Sontag writes almost to rid herself of Arbus, and you can see why: there is something of Diane Arbus in Sontag's approach. As a photographer, Arbus says to her subjects—her "Jewish giant," her "Russian midgets," her banal suburban couples, her nudists and transvestites—"You know, you are horrible in our eyes." But then, lingering with them, she goes beyond her fear and hostility; she says, "If I can creep into your embarrassing life, if I can contain all that is wormiest about you, I'll have a moment of relief. Photographing you, I'll lay a fear to rest." Arbus's photographs may be forms of exploitation; but they also look as if they provided her with solace—that's why many have the radiance of visionary things. For Sontag, photography is a box of Jewish giants, Russian midgets and banal suburban couples. She's drawn to the medium because, you feel, it gives her a chance to describe processes that may have been in her

mind before she thought about photography—processes whereby the trivial is magnified, the beautiful is shrunken, and whatever is left is deadened.

No other photographer infuriates or engages Sontag as much. No other one contains, for her, the same ambivalent depths that she wants to dive to. Walker Evans, Sander, Strand, Atget and the many others she mentions in varying detail are all, in comparison, ghosts to her. She sees them only as illustrations of moments in intellectual history—19th-century idealism, Surrealism, modern "optimism" and "heroism." That she wants to see nearly every photographer as a dated, paltry, misguided or naive exponent of these ideas isn't the problem. The problem is that photographs for her have little life apart from ideas. Sontag sets out to take on photography in all its aspects; but it is a visual medium, and she doesn't treat it visually. When she refers to the specifically visual, or even the story-telling qualities of a photograph, it's as if she's supplying a footnoted reference.

Atget is one of the few she admires, yet she can only give herself to him after she has converted him into a class-conscious, socially subversive figure. To do it, she has him follow in the "footsteps of the ragpicker, who was one of Baudelaire's favorite figures for the modern poet." Atget is sent on his anti-bourgeois way, picking up "marginal beauties of jerry-built wheeled vehicles, gaudy or fantastic window displays, the raffish art of shop signs and carousels," etc. Sontag's point would be valid if we knew that Atget was attracted to the shop signs because they were "raffish," but from what we know of him, we have no idea that that was his motive. And since she wants him to be concerned only with "marginal beauties," she leaves out of her list of his subjects over half the things he did: the pools and walks at Versailles, the Austrian embassy, the Luxembourg gardens, the court at Fontainebleau, scenes of the Marne and the Seine, modest and neat middle class interiors, and so on. Atget, who made his photographs for their possible use by professional historians, and was documenting an old culture beginning to look frayed, could be called a "ragpicker" of sorts. Except that, in their range and feeling, his pictures seem to say that those rags

were precious and grave to him. Making him into a collector of kitsch, which is what Sontag means by rags, misuses his spirit.

Walker Evans is misused too. Without fully explaining why, she calls him the "greatest photographer of America." Then she casts a shadow over that estimation by implying that the social and moral climate of his work is dated. Quoting his phrase about wanting to make his photography "literate, authoritative, transcendent," she announces that, the "moral universe of the 1930s being no longer ours, these adjectives are barely creditable today. Nobody demands that photography be literate. Nobody can imagine how it could be authoritative. Nobody understands how anything, least of all a photograph, could be transcendent." It doesn't occur to Sontag to compare Evans's photographs with his phrase, to see if they match. Nor does it occur to her that there may be something rhetorical about that phrase. She has to make Evans and the "moral universe" of his pictures a dead issue because it squares with her idea that we live in a demoralized, devaluated culture.

But there is a catch here. We're told repeatedly that photographs cannot contain "moral distinctions" and "historical judgments" because apolitical, sentimental feelings always creep in, softening the original point. How, then, can she explain the idea that, when we look at Evans's photographs, we find the "moral universe" of the thirties perfectly intact? By her own logic, shouldn't that "moral universe" have evaporated? And there is a second catch: Since Evans's work preserves the history and politics of its era so well, isn't that a way of putting the "past in order"? Isn't this the art of "historical consciousness" that she asks for?

On Photography ends with "A Brief Anthology of Quotations," a chapter-length collection subtitled "Homage to W. B."—for Walter Benjamin, the German essayist whom Sontag calls "photography's most original and important critic." The quotes she has assembled include remarks on photography—pro, con and mixed—by figures such as Schopenhauer, Baudelaire, Wittgenstein and Kierkegaard; a long excerpt from an Agatha Christie novel, in which people talk about why they keep photographs;

Minolta and Polaroid ads; statements from many photographers on their work; and reports from *The New York Times* that mention photography, such as one about present-day Auschwitz which refers to the fact that postcards of the gas chambers are sold there to tourists.

1977, '81

►►►►

Ben Maddow's Faces

WEIGHING IN AT AN unmanageable 7 ½ pounds, *Faces* represents the second time Ben Maddow has had his text caught in an annoyingly over-produced book. His *Edward Weston: Fifty Years*, 1973, was such a damn nuisance to hold (wingspread: 28 inches) it's likely few people persevered with it, despite the good reviews it got. The best full-dress biography of an American photographer and one of the strongest biographies of any American artist, it was sabotaged by its layout. *Faces* isn't quite so good; it attempts too much for itself, and you put it down wishing it weren't so scattered and jumpy, and that it could be as fine as its parts. Yet those parts are wonderful. A novelist, short story writer, poet and playwright, Ben Maddow has also made documentaries and produced, directed and written feature movies (perhaps his best-known screenplays are for *The Asphalt Jungle*, *Intruder in the Dust* and *The Savage Eye*, which he also co-directed with Joseph Strick). In recent years, without giving up these occupations, he has added photography writing to his list of Renaissance-man activities, and he does it in a grand and endearing way. He gives you the impression that he's talking off the top of his head, and you also feel there's nothing he would rather be talking about. He makes photography into his own miniaturized

234 WRITERS ABOUT ART

kingdom of all the arts combined—painting, history, journalism, biography, fiction, movies and poetry—and he's a king whose greatest delight is in showing you around his domain.

Maddow calls *Faces* an anthology of portraits. He wanted a mainline sampling instead of a selection of his personal favorites only, so here are Steichen's J. P. Morgan with a knife and his Gloria Swanson behind the veil, Gardner's Lincoln (is there a dull photograph of this man?), Frederick Evans' Beardsley, Abbott's Atget, de Meyer's Marchesa Casati, Cameron's Longfellow, Cartier-Bresson's Capote half-buried in plants, Weston's Tina Modotti, Braun's Countess Castiglione with and without the empty picture frame in front of her face, a selection of O'Keeffes by Stieglitz and of Alice Liddells by Lewis Carroll, Eakins' Whitman (the one where he's looking out the window) and the famous Brassais, Brandts, Hill-Adamsons, Southworth-Hawes, Strands, Bradys and Coburns. Blending in with these are not-so-well-known portraits by illustrious and obscure and anonymous photographers, of both recognizable and unknown people.

Altogether there are over three hundred and seventy prints, accompanied by a rambling essay which talks about the individual pictures and more often talks about the lives of the photographers who made them. In *Weston*, Maddow alluded to himself as someone who had been interested in photography "from boyhood on," and it was clear, especially in the early chapters, that he was itching to tell his own version of what happened in this art, beginning with Daguerre and Talbot and going all the way through. In *Faces* he's given himself the chance. He's always hovering around the subject of portraiture, but by portraiture he means pictures of people—even street photographs, where anonymous people are seen from afar—and this gives him considerable latitude. There are few major figures or movements in the history of photography he hasn't been able to touch on.

If Maddow has an aesthetic policy it's to remain flexible; he's willing to look at and be persuaded by quality in anything, and, as a writer, nearly every aspect of photography excites him. *Faces* is decked with descriptive passages and throwaway lines that hit

you with a poetic clarity and rightness, as when he labels the
Condé Nast publications "that Ellis Island of photographers"; or
says of the immigrants in Hine's pictures, that they "have the
energy, not of survivors, but of invaders"; or tells us that
Clarence White had "what is comparatively rare: a great affection
for the women of his town." Often Maddow is only restating the
obvious, but he does it in such a way as to make you feel that he's
getting a notch closer to the truth than anyone else has. Hasn't
he pinned it down when he says that Eugene Smith's pictures
present "the drama of ordinary, simple (one almost thinks: too
simple) human beings"?

As a bird's eye view of photography life and lore, *Faces* fits in
somewhere between Cecil Beaton's and Gail Buckland's chatty
encyclopedia *The Magic Image* and John Szarkowski's elegantly
ironic *Looking at Photographs*—if all three were merged the result-
ing book would be photography's Vasari. Beaton and Szarkowski
keep a witty distance, but Maddow, more of a romantic, wants
to be inundated by the moods of the great photographs and
photographers. Looking at Bellocq's photographs of New Or-
leans prostitutes, he remarks on how unusual it is to find people
smiling when they're posed in the nude (when you think about
it, he's right). Then he knits himself into the scene: "Each
woman has her own particularized character: icy, tender, proud,
or stupid; but they all share a characteristic ease; and that
psychological ownership of a customer, that innate superiority of
the sexual saleswoman over the john. Here is her territory: this
room, this bed, this wicker couch; where you, the customer or
the photographer or the viewer of the photograph, will always be
the somewhat ridiculous stranger."

Passages like these pull you along, and make *Faces* seem like a
better book than it is as a whole. Maddow would have been in
better shape if he hadn't felt the need to cover so much ground.
Listless or curt are the sections on Emerson, Sutcliffe, Adams,
Bullock, Callahan and Gowin, figures whose presence here is
due more to Maddow's desire to run through photography's
entire history than to their contribution to portraiture, which is
minimal. But there's another problem. Maddow has it in him to

render full critical estimates of everyone he covers; this is what you come to expect from him; but he gets more reluctant to do this the closer he comes to his contemporaries, which means that he gradually diminishes in forcefulness. On Penn, Arbus and Avedon, Judy Dater and Jack Welpott, he edges in on what's disturbing to him but shies away from deriving any conclusions from his mixed feelings (or at least any conclusions the reader finds convincing), so both he and his subjects lose out. He has perceptive and new things to say about the photographers closer to his idealistic, street-wise heart—Shahn, Levitt and Lange, Walker Evans and Frank, Friedlander and Meyerowitz—but even here he's a shade too courteous and gentlemanly. He wants to pay too many compliments. He never gets underneath and behind these figures, as he does with Lewis Carroll and Julia Margaret Cameron.

Though he never says so, I think that what's missing for him in the work of these 20th-century photographers is what so many of the 19th- and early-20th-century photographers had: the quality of being gifted amateurs, eccentrics, people obsessed with one theme or another who thought of the camera as a means to gratify their obsession. Speaking of Cartier-Bresson, he announces that "The age of the amateur, the man who devotes his life to a hobby, is nearly over; Henri Cartier-Bresson represents a new breed of photographer. . . ." Maddow is hardly the first to notice the amateur status of so many photographers, or to speculate about the implications this has for photography aesthetics. But he sees a special appropriateness in this quality. "How astonishing, yet how logical," he says, "that photography, in spite of its great and successful use by professionals who declare themselves sole proprietors of taste and intelligence, was born, and developed, and has substantially remained, in the clever, cheerful, persistent, blundering hands of the eternal amateur. This is a huge fact which is rooted in its very technique."

It's not that he isn't sympathetic toward photographers of Cartier-Bresson's generation and after; it's that, with their more consistent, professional approach, he can't be as familiar with

them. He feels he shouldn't kid them, and, whether he knows it or not, that means he can't give them his full admiration, either. Something clicks into place for Maddow when he knows he's dealing with an "eternal amateur," or with those figures from photography's earlier history, Carroll, Nadar, Cameron, Stieglitz and Weston, with their outsize, operatic vanities and eccentricities. On the topic of the amateur or eccentric artist, the artist without professional commitments, the artist as unpredictable loner, Maddow is a writer stretched—perhaps because there is a touch of the amateur in him too, at least in his photography writing. He's an eloquent kibbitzer: lazy, repetitious, haphazard, but with brilliant flashes. Photography has been a lifelong infatuation for him, and when he describes people who have preserved the spirit of infatuation in their work it's as if he is seeing the truest part of himself go by.

1977

Index

PHOTOGRAPHY CREDITS

Robert Brooks: fig. no. 19
Rudolph Burckhardt: 2, 3, 8
Geoffrey Clements: 15, 16
Bevan Davies: 21
eeva-inkeri: 22
Robert E. Mates and Paul Katz: 4
Al Monner: 5
Eric Pollitzer: 20
John D. Schiff: 10
Charles Uht: 6, 7, 9, 11, 24, 27,
 28, 31, 32, 33